COMPLETE
POTTERY
TECHNIQUES

COMPLETE
POTTERY
TECHNIQUES

Penguin Random House

Consultant	Jess Jos
Photography	Nigel Wright
Project Editor	Alice Horne
Senior Art Editor	Emma Forge
Senior Editor	Alastair Laing
Editors	Katie Hardwicke, Megan Lea
Designer	Tom Forge
Jacket Designer	Nicola Powling
Jackets Coordinator	Lucy Philpott
Producer (Pre-production)	David Almond
Producer	Igraine Roberts
Photography production	XAB Design
Creative Technical Support	Sonia Charbonnier, Tom Morse
DTP Designers	Rajdeep Singh, Satish Gaur
Pre-Production Manager	Sunil Sharma
Managing Editor	Dawn Henderson
Managing Art Editor	Marianne Markham
Art Director	Maxine Pedliham
Publishing Director	Mary-Clare Jerram

First published in Great Britain in 2019
by Dorling Kindersley Limited
80 Strand, London WC2R 0RL

A Penguin Random House Company

2 4 6 8 10 9 7 5 3 1
001–314330–Aug/2019

Copyright © 2019 Dorling Kindersley Limited

DISCLAIMER
Neither the authors nor the publisher take any
responsibility for any injury or damage resulting from
the use of techniques shown or described in this book.
The reader is advised to follow all safety instructions
carefully, wear the correct protective clothing, and,
where appropriate, follow all manufacturers'
instructions. For more detailed information on
Health and Safety, please see pages 12–13.

All rights reserved. No part of this publication may be
reproduced, stored in a retrieval system, or transmitted
in any form or by any means, electronic, mechanical,
photocopying, recording, or otherwise, without the
prior written permission of the copyright owner.

A CIP catalogue record for this book is
available from the British Library.

ISBN 978-0-2413-8185-4

Printed and bound in China

A WORLD OF IDEAS:
SEE ALL THERE IS TO KNOW

www.dk.com

Contents

The basics

Forming techniques

Pinching techniques

Slabbing techniques

Coiling techniques

Throwing techniques

Decorating techniques

Finishing techniques

Introduction184

The basics

Design inspiration

FINDING AND DEVELOPING CREATIVE IDEAS

Inspiration can come from anywhere: colours in nature, a favourite piece in a museum, or your daily experiences – there are no limits. You need only keep, follow, and investigate whatever you respond to, and this will naturally infuse your work, making it wholly yours in the process. Wherever you get your ideas from, keeping a sketchbook is the key to realizing and developing them.

Where to look for ideas

Ideas are all around us. Nature is a great starting point, especially as a source of colour and textures which would translate well into clay. From the colour of autumn leaves to the shapes under the dome of a mushroom, nature is full of great ideas. The important thing with inspiration is that it is personal to you. If something interests you, take a photo, make a sketch, or write it down. In order to produce work that makes other people feel, you must infuse it with your ideas.

Museums, galleries, and ceramic collections can provide a wonderful resource. Pots of the past, be it your mother's antique teacup or an ancient drinking vessel, can inspire and inform your ceramic practice.

Experimentation and new ideas

A great way to develop your work is through experimentation. Try doing things a little differently – scale up a design, for instance, or try a different clay mix.

"In order to produce **work** that makes **other people feel,** you must **infuse** it with **your ideas.**"

There are as many endpoints when working with clay as there are sources of inspiration, and sometimes it is the final result that drives you to create. You might search for the perfect handle that feels right in your hand, for instance, or a plate with a gravy moat. Let your daily experiences inspire you.

Keeping a sketchbook

A sketchbook is the first piece of equipment you should buy. It is the place to write down ideas, sketch out designs, or paste in pictures of anything that inspires you. Perhaps at first it will take you a while to narrow down your ideas, but collating everything in your sketchbook will help you to organize them. You will start to notice patterns; maybe everything that inspires you is black and white, or bold and colourful. There won't necessarily be a clear line from what you like to what you want to make, but understanding and noticing patterns will make it easier to organize your thoughts and ideas.

Planning designs

Planning is key with ceramics: if you know what you are going to make, and how it will be decorated, it is much easier to execute your design. Ask yourself how tall the piece will be, what finish to add, what temperature it will be fired to, and so on. Many of these things will need to be worked out before you start making, so that you know what clay to use, which glaze to mix, and if the piece will fit inside your kiln.

Equally important is evaluating how the finished piece turns out. Note down any changes you should make next time to improve on the design, such as a different firing temperature, thinner walls, or an alteration to the glaze recipe. It is a good idea to keep notes detailed enough to allow you to make the same piece again in a year's time.

For larger pieces, maquettes are very useful. A maquette is a smaller trial version of a piece. Think of it as a tiny sculpture, which you can use to make all of your mistakes on before attempting the real thing.

Health and safety

TAKING PRECAUTIONS IN THE STUDIO

Working with clay necessitates paying careful attention to health and safety. Each style of making or piece of specialist equipment will have its own concerns, the main one for all makers being the clay itself in dust form. With the right safety equipment, it is easy to create a good working environment for all.

The key safety equipment

The most common and everyday piece of studio equipment you will use is your apron. The best thing to wear is something easily cleaned, one which you can wipe down and which doesn't attract dust. It is also best practice not to eat, drink, or smoke in your studio space. Wash your hands well before touching your face or eating, especially after mixing glaze.

Clay dust is the most commonly encountered dangerous element in pottery, and the reason for wearing a respirator mask in most instances. Clay includes tiny silica particles, which, if inhaled over a prolonged time, can build up in the lungs, leading to a condition called silicosis, or "potter's lung". As well as being found in clay, silica is also in some common raw glaze ingredients. The dry particles aren't visible, and will stay airborne for hours. It is common practice not to sweep or dust in a ceramic studio; instead, mop your studio daily, use a dust-free vacuum cleaner, and clean up after yourself with a damp sponge. If using powders of any kind, wear a respirator mask with replaceable filters. Activities such as sanding or scraping, where you are potentially creating dust, should be carried out over a bucket of water, in addition to wearing a mask.

Toxic material

You are most likely to come into contact with toxic materials when mixing glaze ingredients. Wear latex gloves when handling these. In addition to wearing a respirator mask, it is particularly important not to eat or drink while working with these ingredients, many of which are harmful if ingested.

Respirator
Use this when weighing out any materials in powder form, spraying glazes, or painting on lustre. The mask should be fitted with replaceable filters for fine dust.

Mask

Mask filters

Heat-resistant goggles

Safety goggles

Goggles
Protecting your eyes is vital. Heat-resistant goggles are important for firing your own kiln; for instance, raku or wood kilns, where you need to assess temperature by looking into a spyhole beyond 1000°C (1832°F).

APPLYING COMMON SENSE

To a certain degree you can let common sense guide you in the studio. If you are operating machinery, tie back long hair, don't wear a long scarf, and make sure your shoes are sensible. If working with any ingredient in powder form, be it plaster or clay, wear a respirator mask. Use a mop or damp sponge to wipe up any spills straight away, and always clean your tools and equipment after use. If a process is smelly or generating fumes, wear a mask and switch on ventilation if possible. It is good practice to work with a bucket of clean water and a sponge next to you at all times.

Ingredients that are of particular concern are cadmium, lead, and barium. These are ingredients which you should handle with extra care or choose not to include in your practice. Store raw materials in closed containers (not food containers), clearly labelled, and out of reach from children.

Kilns of all types should be well ventilated, with nothing flammable kept nearby. Always follow the kiln manufacturer's guidelines for safe operation. Do not keep water near an electric kiln. Extraction should be turned on while firing where possible.

It can be easy to overlook your body and focus on materials when thinking of health and safety. Your hands are your greatest tool, and maintaining bodily health will ensure a happy, long career with clay. Wear appropriate shoes while loading and unloading a kiln, and remember to lift clay or buckets with a straight back and bent knees. Wear protective goggles if chipping hardened drips of glaze from a kiln shelf. Take regular breaks if throwing on the wheel for long periods. Working in a sensible way is absolutely key to making sure you can enjoy yourself in the studio.

> "It is common practice not to sweep or dust; you should instead mop your studio daily."

Latex or synthetic gloves
When handling any toxic raw glaze material it is important to protect your hands with latex gloves, or a synthetic alternative. Wear them while glazing if you have sensitive skin.

Kiln gloves
Wearing kiln gloves to unload a kiln is essential. Even when the kiln has cooled to under 100°C (212°F), pots can still be too hot to touch. Longer welding gloves are required for raku firing.

Setting up your studio

ADAPTING YOUR WORK SPACE

Setting up your own studio can be a daunting task, so start small and adapt your space to suit your needs. When the time comes to scale up, you can use the knowledge gained from your own distinctive pottery practice to help plan a space that will work for you. The way in which you work, as well as clay's natural journey, can inform how you set up your new space.

DIY work space

There are many ways to handbuild that require no specialist equipment, only simple tools. If you have a basement, garage, or shed that is well ventilated, with a water supply and an easily cleaned floor, then you are off to a great start. Simply add a work table, chair, and shelving to get underway. When starting out, see if your local pottery or membership studio offer a kiln-firing service – you can make pieces at home and they can finish them for you in a kiln.

A sink is an essential, whether for washing, cleaning, glaze mixing, throwing, or a whole host of clay-making tasks. A large sink is best, one you can fit a bucket into. Clay

A beginner's table
You can easily get started with minimal tools and equipment. A table is great for many handbuilding techniques; start small and explore which way of working you enjoy the most before buying equipment.

You will need

DIY home	Studio
▪ Chair	▪ Potter's wheel
▪ Work bench or table	▪ Stool
▪ Shelving	▪ Shelving
▪ Sink	▪ Storage – lidded buckets and containers
▪ Mop and bucket	▪ Cleaning equipment
▪ Apron	▪ Sink
	▪ Kiln

Floor plan small studio
The journey of the clay can be traced along the room, starting with the stored clay and moving to a throwing bench and potter's wheel. Ensure easy access to a sink from the preparation area and work bench. Kilns need plenty of space around them, and allow shelves for drying and storage. Substitute equipment to suit your way of working. Position the area where you will spend the most time under a window for good light.

The layout of your studio should follow the journey of clay, minimizing the need to move your work back and forth too much. Making with clay is a time-consuming process, so the better designed your space, the more time you will have to devote to forming, throwing, and creating your pottery.

Pottery-class studio
A bigger space gives the opportunity to open your studio for pottery classes. More wheels, work benches, and the accompanying students will naturally mean more pots and the need for more storage. Shelving should be sturdy and not overloaded, well organized, and easily cleaned. Position kilns out of the way and perhaps protected with a cage.

and glazes are not kind to plumbing and it is best to fit a clay trap under your sink. This is a tank separation system that will stop clay and heavy particles going down the drain (although it is best to avoid putting any clay or plaster down the drain, if you can).

Cleaning is an important part of using a pottery studio; have a wet mop or damp sponge to hand for minimizing dust. A wipe-clean apron should always be worn; look for specially designed aprons for throwers that have a split in order to provide the best protection when working a wheel.

Planning your own studio
Dedicating space to your own studio involves some careful planning. Assess your commitment and calculate the costs involved in buying the basic equipment and tools that suit your pottery style and future needs (see pp.16–21).

> "The layout of your studio should follow the journey of clay, minimizing the need to move your work back and forth too much."

Tools

HELPFUL ITEMS FOR YOUR TOOL KIT

Pottery tools are widely available from ceramic supply companies and are designed to help you prepare, throw, shape, trim, decorate, and finish your pottery. Everyday objects also make great tools, such as a rolling pin, cookie cutter, or even chamois leather for an extra-smooth finish.

Wooden board

Common everyday tools

Although the tools shown here are loosely arranged by different making techniques, many overlap and are used for different purposes. You can begin your journey with clay using just a few key items and relying on your best tools: your hands.

A clay wire is the first place to start as this tool will help you to section off pieces of clay from the bag. It can later be used to separate a pot from the wheel. A wooden board will stop your piece sticking to a table, so that it can then be easily moved and stored.

When making repeats of your pieces, it pays to be precise when weighing out clay to work with and especially when mixing glazes. Accurate scales, either traditional kitchen scales or digital ones, will solve a whole array of kiln disasters before they happen.

If you are storing a piece and want to carry on working with it, then pieces of plastic, such as bin liners or clingfilm, are essential to stop things drying out. Keep a range of clean sponges for different tasks, too – perfect for smoothing and cleaning up when finishing a piece.

Throwing tools

For throwing, to help refine your piece you can employ several tools, specially shaped for adding a rim or a curve where required. Throwing ribs are simple tools that have multiple uses, and can be supplemented with kidney tools in wood, metal, or plastic.

As you progress with throwing, two measuring tools – callipers and a measuring gauge – will help when creating more challenging forms and repeating shapes. A gauge is set up next to your wheel and the arms moved to measure key points of your shape.

Canvas

Wooden guides

Rolling pin

Rolling clay
Whether rolling clay for a base or lid, or creating a slab, use a wooden rolling pin on a piece of canvas or fabric, with guides to achieve uniform thickness.

Sponges
Use sponges in a variety of shapes and sizes. When making deep pieces it may not be possible to reach inside your pot with a hand; a sponge diddler allows you to remove excess water.

Diddler

Fine sponge

Wire
This essential multipurpose tool can be used for cutting clay from a bag, weighing and preparing clay, or releasing a pot from the potter's wheel.

Wooden bat

Wooden bat or board
Use these for throwing, handbuilding, moving, and storing pieces of pottery. A round wooden bat can be attached to the potter's wheel when throwing.

Wooden throwing rib
Throwing ribs come in a range of sizes and shapes, in both wood and plastic, and are used to remove excess clay at the base of a pot, achieve a straight side, or form a perfect curve.

A round wooden board is also useful for making plates on the wheel as well as anything too large to lift by hand; see pp.104–05 for how to attach a bat.

Tools for shaping and sculpting
Trimming tools help you to sculpt and refine shapes, and many potters choose to make their own trimming tools, using items such as bamboo or adapting recycled objects like a plastic credit card. Loop tools lend themselves to many uses, whether sculpting a shape or adding texture with sgraffito (see pp.140–41). Knives and holers also help

with cutting defined shapes, or use a cookie cutter for cutting perfect circles.

The potter's pin is a tool that you will use daily. It can be used to scratch, or score, the surface of clay to prepare it for joining but is also a useful tool for marking out designs onto leather-hard

clay. A potter's knife is pointed and relatively thick so that the clay doesn't stick back together once cut.

Slabbing tools
This technique is one of the easiest to source tools for – all you need is a piece of canvas, a wooden board, a rolling pin, and a set of wooden slats to guide you. Choose a wooden rolling pin, as it won't stick to the clay, and use in conjunction with wooden guides. These come in a variety of sizes to give you different thicknesses of clay.

Sculpting and carving tools
Loop tools are ideal for trimming leather-hard pots on the wheel. Japanese-style trimming tools also make great carving tools. Use cookie cutters, potter's pins, and knives to score or cut the clay at different stages of the making process.

Cookie cutters

Loop tool

Carving tool

Potter's pin

Potter's knife

Hole cutter

Modelling by hand
Use a toothbrush with stiff bristles to score when joining and a metal scraper for finishing the clay surface. A rubber kidney will achieve a super-smooth finish.

Rubber kidney

Toothbrush

Boxwood modelling tool

Metal scraper

Hump mould

Moulds and mould-making
Often used with slabbed clay, a press mould or hump mould helps to shape the clay.

Press mould

Handbuilding tools

The potter's pin and a toothbrush, or any stiff brush, are a great pair of tools to join any two pieces of clay together. Scrapers and kidneys come in all shapes and sizes; they can be smooth or serrated and when working by hand are often used in conjunction with each other. You first use a serrated kidney to rough up or level the surface before finishing with a smooth one.

A boxwood modelling tool comes in a range of shapes and sizes and is excellent for smoothing the clay in those hard-to-reach places. Use a small paintbrush to paint water or joining slip onto leather-hard clay.

Tools for moulds

When working with moulds, a few specialist tools are required. One of the most useful, and most unassuming, is the lucy tool. It is used to trim excess clay from the top of a mould without breaking the plaster. You can shape slabs of clay on moulds, either by pressing clay into a press mould, or laying clay on top of a hump mould.

Making your own moulds from plaster is a very useful technique, especially if batch making, and requires equipment such as a cottle, or flexible plastic, to shape round moulds; laminated wooden boards for creating rectangular shapes; and string or elastic bands for holding multi-part moulds together. Another useful tool is a surform. It can be used on leather-hard clay, but is most often employed to tidy up sharp corners when mould-making.

Decorating tools

Brushes are a key part of a decorator's tool kit. Chinese-style brushes are the best for applying slip and glaze

Decorating tools
Employ a range of tools to impress patterns, apply slip, or make brush marks to decorate your pottery, either onto leather-hard clay, in glazes, or with decorating slip.

Paintbrush

Hake brush

Straw hakeme brush

Slip trailer

Finishing moulds
Use a surform to soften the edges on cast plaster moulds, and the lucy tool to trim excess clay.

Surform

Lucy tool

Dipping tongs
These tongs are especially designed to grip pots while dipping into a glaze, and allow you to fully immerse the pot in the bucket.

Potter's sieve
Use a sieve to remove lumps to create a smooth liquid. A 60- or 80-mesh sieve is recommended for mixing glazes and slips.

decoration. Particularly when brushing glazes, you need a surprisingly large amount of glaze; choose hake or glaze mop brushes that will hold a lot of liquid to cover a large area. Handmade, or hakeme, brushes are great to create texture and gestural effects in slip. A range of good-quality paintbrushes is essential for painterly touches.

To extend your options further, try drawing a wooden comb, serrated kidney, or fork, through wet slip to make a pattern. Slip trailers come with a variety of nozzle sizes for applying slip decoration.

Slabs of clay provide a great surface to experiment with found objects – look for textured shapes such as shells, buttons, or bark, or purchase wooden printing blocks, stamps, carved rolling pins, or patterned wheels (roulettes) to add instant decoration. Use a wooden roller to help impress decoration onto a pot (see Impressing, pp.142–43).

Glazing
The tools required for mixing glazes are relatively straightforward. A sieve is essential to ensure the mixture is smooth with no lumps; potter's sieves

are available in different mesh sizes. Use the sieve over a bucket, propped on wooden slats. Stirrers are also good to have to hand – use clean wooden sticks or purpose-made stirrers or spatulas.

In addition to clean buckets, bowls, and containers for mixing your glaze, a plastic measuring jug will be invaluable for measuring and pouring. Glazing tongs help to achieve a more even coverage of glaze when dipping.

Patterned roulette

Comb

Stamps

Wooden roller

Equipment

INVESTING IN LARGER STUDIO PIECES

From a potter's wheel to a spray booth and spray gun, there are larger tools and equipment that will help you to progress and develop your pottery skills. These pieces will entail some investment but can easily last your career. Look out for second-hand options as most are built to last.

Basic equipment

Your equipment needs will change and evolve, and what you need will largely depend on your space and the method in which you work. A potter's wheel and banding wheel are invaluable to get you started; add other pieces as your style and needs develop, either purchasing them or, in the case of a kick wheel, slab roller, or kiln, making your own.

A potter's wheel can be electrically powered or a kick-wheel style, where the wheel is propelled by your foot and requires a little more work to use. Modern electric wheels are compact, light, and very easy to work. They are often reversible and so suited to both left- and right-handed people. You may decide to choose your wheel based on the model you first learnt with.

Whether used for handbuilding, handles, or other decoration, an extruder is a versatile piece of kit that is very low key, inexpensive, and easy to install as it needs no electricity. It is usually supplied with a die set and you can also customize your own dies.

A pugmill is a valuable, time-saving piece of equipment. Lumps of clay, often recycled (see p.31) are extruded

Potter's wheel

Modern wheels are compact and easy to use and keep clean. It is possible to buy second-hand and potter's wheels are relatively indestructible. If you are left-handed, make sure you can reverse the direction of the wheel.

Slab roller

Although they still require a certain amount of force, a slab roller will save lots of time and effort for any handbuilder. Useful for slab making but also for working with press or hump moulds. Assign canvases to different colours of clay.

> "Your equipment needs will largely depend on the space you have and how you work."

Banding wheel
Alongside your potter's wheel, a banding wheel is perhaps the most useful piece of equipment in your studio for any, if not all, handbuilding or decorating work, allowing you to address every side of your piece without picking it up. You can also spin it gently to draw a line or band.

through rotating blades to a round tube. If fitted with a pump, a pugmill will remove air pockets in the process. It can be an investment but will save you lots of hard work.

When working with slabs and flat pieces of clay, a rolling pin and guides are great for small-scale work (see p.16), but if you work in larger batches or on large pieces, hand-rolling will start to take its toll on your wrists. A slab roller removes most of the hard work from the equation, leaving you more time to enjoy making. Slab rollers are easily adjusted for different thicknesses of clay, with removable canvas pieces for easy cleaning.

Spraying equipment
Investing in a spray gun, decompressor, and spray booth will allow you to glaze in a whole new way. All at once you can glaze in an even coating to achieve the perfect finish, opening up a host of creative possibilities (see pp.202–03). The glaze is sprayed from a gun through a fine nozzle at your pieces while they sit in a spray booth, which is either fitted with an extractor or a wet back to catch excess glaze spray.

Specialist pieces
When mixing your own clay, a clay mixer is an excellent addition to the studio. Suitable not only for mixing clay from powders, it will also reconstitute leather-hard and dry scraps. A blunger will mix continuously and is capable of turning bagged clay into casting slip without the need to slake.

For casting in plaster moulds, a different set of equipment is needed to scale up your production. A slotted bench with a tray beneath will catch excess slip when moulds are poured out and rested upside down.

Extruder
Wall-mount an extruder and, once full of clay, pull the lever to force the clay through a die. These can be used for handles and to make great coils for building (see p.79).

Spray gun
Purchase a spray gun in combination with a compressor and spray booth. This kit will allow you to spray a fine mist of glaze over your pieces.

Kilns

OPTIONS FOR FIRING CLAY

A pottery kiln is an essential piece of equipment. Without firing clay and turning it into ceramic, it is not possible to make your pieces strong enough for use. The type of kiln you decide to use is down to personal preference, but may also be dependent on access to fuel and your studio space. Each type of kiln produces unique atmospheres for the clay and results in finishes not easily replicated in another.

Electric kilns

Available as either front loaders or top loaders, electric kilns can, if small enough, run from a standard plug socket. They produce consistent results and are easy to use. Modern kilns come fitted with a programmable controller, allowing you to set the rate of temperature increase and the length of firing time, as well as the final temperature.

The atmosphere produced in an electric kiln is oxidation, meaning there is always oxygen present, typically resulting in bright colours (see Using an electric kiln, pp.224–27).

Gas kiln

A gas kiln is always front-loading and can be bought or handmade. Firing with natural

Top-loading electric kiln
These kilns are easy to use and popular in schools and membership studios. They are relatively inexpensive to run and produce consistent results.

Small electric kilns can be plugged into a standard socket, making them ideal for a small home studio

"Each type of kiln produces unique atmospheres and results in finishes not easily replicated in another."

Gas firing
Gas kilns are often slightly bigger than electric kilns, to allow for the flame. Modern kilns are automated with a controller similar to electric kilns, but older gas kilns are fired manually with the aid of cones (see p.231).

gas or propane from two or four burners mounted at the base of the kiln, you control the atmosphere of the kiln. Gas firings are usually by reduction where, during the final stages of firing, the kiln is starved of oxygen, producing unique glaze effects (see Gas firing, pp.228–29). Modern manufactured gas kilns come fully automated and controlled, much like electric kilns.

More careful considerations are needed with the location of the kiln in your studio than with an electric kiln. The firing area must be well ventilated as the exhaust fumes from the kiln are toxic, and you will need to install a canopy or hood over the top as well as a flue. Any indoor location will need a powerful exhaust fan to ensure no build up of toxic gases occurs in the surrounding area. You will need to consider your fuel supply, too.

Raku kiln
Although you can buy a raku kiln, they are easily made from found or commonly sourced materials, such as metal drums or containers. Fired with propane, a raku kiln doesn't reach such high temperatures as a regular gas kiln and is always set up outdoors. Pots are fired very quickly, then removed while still glowing and with the glaze molten.

A reduction atmosphere is created post-firing by placing the pots in a bin of combustible materials, covering them completely, and closing the lid. When the pots are starved of oxygen, metallic glaze colours and flashes are achieved (see pp.232–35).

Wood-fired kiln
These kilns, fuelled by wood, are always built by hand and located outside. They come in different shapes and sizes, and typically take longer to fire than regular gas or electric kilns. A wood firing is labour intensive, often taking days and requiring constant stoking (adding more wood). The type of wood is important; while firing, the ash created in the kiln forms a glaze on the pots. Effects are unpredictable and dramatic.

Raku set-up
Raku firings are always done outdoors and you need minimal specialist equipment. This type of kiln can be homemade as it doesn't need to reach very high temperatures.

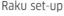

Wood kiln
Set up outdoors, wood kilns need regular stoking. Expect the unexpected with this unique firing method as the ash travels around the kiln to create an individual glaze.

Clay types

TYPES AND PROPERTIES

It is the magic of the material that draws most people to work with clay. Its unique plasticity is unlike any other material. Each clay body is made up of a type of clay plus additions, with a clay for every technique and firing type available mixed, processed, and ready to buy. Here are five of the most common, and useful, kinds of clay.

EARTHENWARE

This is an economical option, as earthenware clays need little processing and fire to a low temperature. Clay colours range from white to red, with bright colours easily achieved in glazing.

Wet clay Bisque fired Glaze fired

Fired to
- 1040–1150°C (1904–2102°F)

Suitable for
- Throwing
- Handbuilding
- Slip casting

STONEWARE

A dense, higher-fired clay that is known for its strength, stoneware is very versatile and forgiving. Available in a range of colours from white to earthy red and even black.

Wet clay Bisque fired Glaze fired

Fired to
- 1180–1300°C (2156–2372°F)

Suitable for
- Throwing
- Handbuilding
- Slip casting

PORCELAIN

Fired high, porcelain is the most expensive and temperamental to use but has enduring appeal. If thin enough it can be translucent; it is strong and has a very smooth surface.

Wet clay Bisque fired Glaze fired

Fired to
- 1220–1300°C (2228–2372°F)

Suitable for
- Throwing
- Handbuilding
- Slip casting

"A clay body is made up of a type of clay plus additions, with a clay for every technique and firing type available mixed, processed, and ready to buy."

BONE CHINA

A clay traditionally mixed using 50 per cent bone ash, an addition that makes the clay translucent and strong. Prone to warping, it isn't ideal for throwing.

Wet clay Bisque fired Glaze fired

Fired to
- 1200–1250ºC (2192–2282ºF)

Suitable for
- Slip casting

PAPER CLAY

A mixture of any clay with cellulose fibre, paper, or cardboard. It is forgiving to handbuild with as it is strong, easy to move, re-wet, and work on again and again.

Wet clay Bisque fired Glaze fired

Fired to
- 1080–1280ºC (1976–2336ºF)

Suitable for
- Handbuilding
- Slip casting

Additions

The two most popular additions to a clay body are grog and colour. Grog is usually fired fire clay, ground up and mixed back into wet clay. This adds strength for building, and improves drying and shrinkage. You can also add silica sand or molochite, which work in the same way. Colour can be changed with the addition of a stain or an oxide. Iron will turn a clay red and manganese will make a clay black.

Grog
Grog can be made from any clay, but high-firing fire clay is most usual.

Sources of clay

FACTORS TO CONSIDER WHEN CHOOSING CLAY

Clay is one of our greatest natural resources. It is not one mineral but is made up of several, together with organic material. A clay body is a blend of clays and additions to suit your requirements and improve the raw material. When choosing a clay, a general rule is if you are working small, choose a smooth clay, and when working on a large scale, choose a rough or grogged clay.

■ Original source

Clay comes from the ground and can be white or grey through to a reddish brown. If you find a natural source, wash and sieve the clay to remove organic materials.

■ Purchasing

Clay bodies are sold in ready-to-use 12.5kg (25lb) bags. Details of firing temperature, shrinkage, suitability, texture, and colour are given to help you choose the right clay.

■ Combining clays

It is possible to combine different coloured clays in one piece to add colour and pattern. When choosing clays to combine, ensure that they have the same firing temperature.

Clay soil
Clay deposits are usually found near river banks, and or where the soil feels sticky.

Ready-to-use clay
Clay comes pugged (processed) and ready to use. Wire off and wedge only what you need.

Patterned blend
Agateware (see pp.160–61) has different proportions of coloured clay when it's thrown.

■ Storing clay

Clay will last a lifetime. Store bagged clay in a frost-free place out of direct sunlight. Any wet or dry scraps can be kept in a bucket covered with water. Once full, this can be reclaimed and dried on a plaster slab (see p.31).

PLASTICITY

There are several material properties that give clay its unique qualities, of which the most commonly referred to is plasticity. Those looking for a good throwing body will want a clay with high plasticity, which is flexible and easily moulded. You can increase the plasticity of clay by kneading and preparing it before you begin throwing (see pp.28–30).

MAKING CLAY

Making your own clay body is simple on a small scale and allows you to tailor your material to your method of making and firing. When the clay has come together and holds its shape, leave for a week covered in plastic, to give time for all the ingredients to become the same consistency.

You will need	Clay recipe	
■ Weighing scales	■ China clay	55
■ Bowl or plastic container	■ Feldspar	20
■ Wooden board	■ Quartz	25
■ Jug	■ Bentonite	5
■ Water		
❗ Respirator mask		

1 Weigh and mix dry ingredients
Wearing a respirator mask, weigh out all the dry ingredients from the clay recipe and place them in a bowl. Mix the dry ingredients together thoroughly with your hands.

Use your hands to start mixing the water and powder together

2 Tip onto a board
Carefully tip out the mixed dry ingredients onto a large wooden board, forming them into a mound. Make a small dip or well in the centre of the mound, and pour a little water into it from a jug. Work the mix together, adding more water little by little.

3 Mix the clay
Continue to add water, gradually working towards a consistency you could use to make a pot. Avoid adding too much water in one go; if it gets too wet leave on a plaster bat to dry. When it has come together, knead (see pp.28–30), picking up any bits of mix.

Clay preparation

WEDGING, KNEADING, AND RECLAIMING

Well-prepared clay is the key to success. Compressing through wedging and kneading eliminates air pockets and realigns the clay particles, helping to prevent explosions in the kiln. Any leftover, unfired clay can be recycled.

WEDGING

Wedging expels air bubbles from the clay by compressing it, to produce a compact lump that can be stored easily. Wire off what you require when you're ready to throw, then knead it.

You will need
- Lump of clay
- Absorbent surface, such as plaster bat, bare wood, or concrete slab
- Wire

Wedged clay

1 Get into position
The amount of clay depends on how much you need and how much you can work with based on the size of your hands. Stand near the edge of the wedging bench and hold the lump of clay with both hands at chest height. Slam the clay onto the bench.

Keep throwing the lump until all the air bubbles are expelled

Check for air bubbles by slicing the clay in half

2 Wire and stack
From the nearest edge, slide the wire under the clay to the middle then lift the wire to cut the clay in half. Stack one half on top of the other.

3 Turn and repeat
Rotate the whole lump 90 degrees, then slam and wire again. Continue slamming the clay onto the bench, throwing it down from different directions and angles to make a wedge.

Mixing clays

Ram's head kneading is ideal for mixing clays of different consistency to achieve a workable plasticity, or to mix different clays to obtain a new clay body colour or texture. Make sure that the clay that fires at the higher temperature is more than 50 per cent of the mix.

Sandwich different clays
Cut thick slices of each type of clay and sandwich them together in layers. Knead using the ram's head technique (below).

Check your progress
Cut the clay in half using a wire to check progress. If you can still see the different colours or any air bubbles, keep kneading.

RAM'S HEAD KNEADING

Kneading will also get rid of air bubbles but the lump of clay will be more plastic than if you just use wedging, and easier to throw. The key here is the number of rotations, not how hard you push the clay.

You will need
- Lump of clay
- Absorbent surface, such as plaster bat, bare wood, or concrete slab

Kneaded clay

1 Position and push
To minimize the strain on your wrists, only knead the amount of clay you plan to use. Put one foot in front of the other and keep your back as straight as possible. With your hands on each side of the clay, push forward with the heels of your hands.

Use the heels of your hands to push the clay as you knead

The clay is ready when there are no air pockets visible

2 Roll and knead
Lift the further end almost completely off the bench, towards you. Roll it back down, pushing the top down and in to knead it.

3 Retain the shape
Repeat steps 1 and 2, always retaining the "ram's head" shape as you knead. Try not to push down too hard or you will flatten the lump. When ready, roll or tap into a ball.

>>

SPIRAL KNEADING

Suited to the preparation of a large amount of clay for throwing or throwing off the hump, spiral kneading is an alternative way to make your clay homogenous and free of air bubbles.

You will need
- Large lump of clay (at least 1.5kg/3lb 3oz)
- Absorbent surface, such as plaster bat, bare wood, or concrete slab

Spiral-kneaded clay

1 Push down
Take a large, long lump of clay and, with the heel of your right hand, section off a small portion from the lump. Push down on this portion with your right hand only, using your left hand as support rather than adding pressure.

2 Roll up
Using both hands, roll up your clay, picking up the area you have just pushed down and lifting it away from the surface, leaving a small portion still resting on the work bench. This action is repeated as you knead; find a rhythm with the same hand movements.

3 Reposition your hand
Supporting the clay with your left hand, reposition your right hand so you are able to push down again on a new section of clay, slightly overlapping or folding as you push and twist. The number of rotations and repetitions will depend on your clay's consistency.

4 Finish the shape
Keep kneading to achieve a spiral in the clay. Any air bubbles will pop and reveal themselves along the scalloped edge. To bring the shape together and into a cone, press down a little less hard with each rotation and roll on the bench to smooth the sides.

RECLAIMING CLAY

Use a lidded bucket to store any leftover, unfired clay; keep different types of clay separate (label your buckets). Cover the clay with water and when the bucket is almost full, it is time to reclaim.

You will need
- Scraps of unfired clay in a bucket of water
- Wooden spatulas
- Plaster bat

Reclaimed clay

1 Transfer the clay
Using your hands or a wooden spatula, put the clay onto the bat in an even layer. Try to leave as much water in the bucket as possible; the more liquid the clay, the longer it will take for the water to evaporate and the clay to become workable. Depending on the room temperature and moisture in the air, this can take anything from a few hours to a week or more.

Use wooden tools on a plaster bat as metal may cut and mix plaster into the clay

Make an even layer but bear in mind the thicker the layer, the longer it will take to dry

A residue of dry clay on the edge indicates the clay is ready

2 Reclaim the clay
You'll know when the clay is ready as the bottom will start to lift from the bat naturally. Use a wooden spatula to lift the clay off the board in a single piece. Knead it into a ball, using any of the techniques shown on pp.28–30.

"Any bit of **unfired clay**, no matter how dry, **can be recycled**."

Making paper clay

ADDING STRENGTH

Paper clay is simply paper mixed with clay. This mix has many properties that make it popular for handbuilding: paper fibres give the clay body extra strength and as they burn away during firing, they leave a lighter piece, which is ideal for ceramic wall art and larger pots. Use any natural cellulose fibre without synthetic additions or starch.

▥ Joining and reworking with paper clay

Paper clay breaks all the rules; you can join wet clay to dry, re-wet the clay, and even join wet clay to bisque-fired pieces with joining slip. These qualities make it a great choice for repairing and reworking, and a very versatile building material.

Joining bisque-fired pieces
Here, pieces of bisque-fired porcelain paper clay are joined with wet joining slip and re-fired. The joining slip moistens the clay but the shape won't collapse due to the bonds in the paper fibres.

This porcelain clay is mixed with toilet paper to create a paper clay with fine fibres throughout. Wet paper clay will rot over time, so only mix up small batches, and aim to use the clay within a couple of weeks.

You will need
- ½ bag porcelain clay
- Roll of toilet paper
- Two buckets
- Muslin cloth or mesh bag
- Wooden board
- Electric drill and paint mixer
- Plaster bat
- ❗ Respirator mask (optional)

Cut bagged clay into small chunks before slaking

Ensure the buckets are clean when preparing clay

1 Slake clay and soak paper overnight
Place powdered clay or chunks of bagged clay in a bucket and cover with water. Tear up the toilet paper into small pieces and place in a second bucket, adding enough water to cover the paper. Leave both buckets overnight to soak. If using powdered clay, wear a respirator mask when handling the clay and add the water to the bucket slowly to avoid creating dust.

2 Wring out water from the paper
After soaking, use a clean muslin cloth or small mesh bag to wring out the water from handfuls of the paper mush. Place the resulting lumps on a wooden board and discard the paper water.

3 Mix the clay
Use a paint mixer attached to an electric drill to stir the clay, mixing it together to achieve a smooth consistency without any lumps. Work in an open space away from equipment as the mix may splash.

4 Add the paper to the clay
Break apart the wrung-out balls of paper with your hands and drop the pieces into the clay slip. The paper pieces will be mixed in, but adding smaller pieces will make this process easier and quicker.

5 Mix the paper into the clay
When all the paper has been added, mix everything together with the paint mixer. The mixture will start to thicken as the paper absorbs the liquid. Keep mixing until the liquid is smooth without lumps.

6 Dry on a bat
Transfer the paper clay onto a plaster bat. Watch closely as it dries and once firm enough, wedge before use (see p.28). Store in a cool, dark place and not in a clear container. Dry any leftover mix completely on a plaster bat; re-wet to use or mix into a fresh batch.

Slip

UNDERSTANDING SLIP AND ITS USES

Slip is liquid clay, or – more specifically – a suspension of clay particles, and often other ingredients, in water. Slip can be painted on to add decoration, used to join pieces of clay together, and poured into plaster moulds to cast shapes. The ingredients for slip and properties of it differ depending on the intended use. Slip should usually be the thickness of double cream.

Decorating slip

Decorating slip is often made with a mixture of ball clay, china clay, silica (a glass former), and a flux (an ingredient that lowers the melting point of the silica). Colour may also be added in the form of oxides or stains. Decorating slip can be used in a similar way to a glaze or engobe, though, being liquid clay, it is applied before the bisque firing. The resultant piece will be matt and porous unless finished with a glaze.

Joining slip

Slip can also be used to join separate pieces of clay together, for example when adding a handle to a mug or joining two sections of a larger pot. Score the clay first before applying slip. Joining slip can be made from pieces of excess clay, left to slake in water until they have softened, then sieved to remove lumps and mixed to the desired consistency. The same type of clay must be used for the objects being joined and the joining slip.

Casting slip

To turn slip into a liquid suitable for casting in a plaster mould, a deflocculant such as sodium silicate or darvan, which ensures the clay particles are evenly suspended in the liquid, is added, while the water content is kept low. You can buy ready-made casting slip, but making your own is more cost-effective and allows you to tailor the mix, perhaps adding an oxide or stain to colour the clay; ideal for making composite pots of more than one colour.

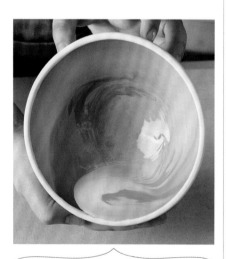

Adding coloured slip
Decorating slip can be applied to wet or dry leather-hard clay by pouring, dipping, or brushing on. Unlike glaze, slip will not melt or run in the kiln.

Sticking clay together
Whenever you need to join one bit of clay to another, have a bowl of joining slip ready. Any two clay forms being joined together must be at the same level of wetness or dryness.

Preparing slip for use in moulds
Different amounts of water and deflocculant are needed depending on the deflocculant and clay used. Check the specific gravity of your mixture first (see above right).

Measuring specific gravity

Specific gravity measures the weight of your clay slip mixture against the equivalent weight of water. Trial and error is the best way to learn, and it depends what you are casting and in what clay. If your specific gravity is too high, add a little water; if it is too low then wait for the bucket to settle and take some water off the top.

Weighing your slip
Weigh 100ml (3½fl oz) of your slip mixture on a set of scales and weigh 100ml (3½fl oz) water. Divide the slip weight by the water weight, to give you the specific gravity. The target is normally around 1.8.

MAKING CASTING SLIP

The following method makes up a small batch of casting slip. You could also use bagged clay that has been slaked. As changes can be made and recipes tailored, it is important to keep accurate notes.

You will need
- Weighing scales
- Bucket
- Electric drill and paint mixer
- Dropper
- Jug
- ❶ Respirator mask
- ❶ Protective gloves

Casting slip recipe
- 10kg (22lb) white earthenware powder
- 4 litres (7 pints) water
- 34g (1oz) sodium silicate

Use a clean bucket for mixing to avoid contamination

1 Leave clay to slake
Wearing a mask, place your powdered clay, or a chopped up bag of clay, into a bucket and cover with 90 per cent of your water. Leave to slake overnight.

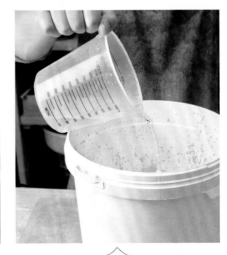

2 Mix together
Use a paint mixer attached to an electric drill to mix the clay and water until they have combined completely, leaving a smooth mix without any lumps. Work in a clear space to avoid splashing other equipment or pots with the slip.

3 Add the deflocculant
Check the specific gravity (see above) and adjust if necessary. Wear gloves to add the sodium silicate to the remaining water with a dropper, then pour into the bucket. Mix again.

Making plaster

MIXING PLASTER POWDER

You will need to mix plaster from powder for model- and mould-making. Plaster types vary, so always read the instructions on different mixing and setting times carefully, as making a "poor" plaster – either too soft, or too brittle – can cause problems at the next stage of use. Wear a mask when working with plaster powder, and never encase body parts in liquid plaster.

PUTTING IT INTO PRACTICE

Here, a flat plaster bat is made in a mould formed from wooden slats. Prepare the walls beforehand on a smooth surface; plaster sets very quickly, so have everything ready, only making as much as you need.

You will need
- Plaster powder
- Water – 1 litre (1¾ pints) will make 1.5–1.75 litres (2¾–3 pints) of liquid plaster
- Flexible container
- Mould made from wooden slats
- Clay to seal the mould
- Metal scraper (optional)
- ❗ Respirator mask

1 Add the powder to the water
Measure the water into a clean container. Wearing a mask, add the powder to the water (never water to powder) by scattering evenly over the surface. Wait for the powder to soak up the water, known as "quenching".

2 Look for a peak of powder
Continue to add the powder to the water. When you see a peak of powder forming above the water, this indicates that you have a good ratio of water and powder. Stop adding the powder.

3 Mix the plaster
When all the powder is soaked by the water, start mixing with your hands. Agitation starts the setting process: keep your hand under the surface (to help eliminate air bubbles), and blend evenly.

> "Plaster **sets very quickly**, so have everything **ready before you start.**"

Ensuring a smooth blend

Sometimes you may find lumps in your plaster blend due to a dirty bucket or from an older or used bag of plaster. It is important to remove these lumps, otherwise you may find them again in parts of your plasterwork, which could affect your work.

Removing lumps

Move your hand through the liquid plaster in the container to feel for solid bits in the smooth blend. Lift them out with your hand and place in a bin. Any unblended dry pockets of plaster can be squashed between your fingers and mixed into the blend.

5 Pour the plaster

The mix should be smooth and lump- and air bubble-free before pouring. It will start to thicken and feel heavier, which indicates it is ready to pour. Pour carefully but quickly into the guides; lightly tap the surface to level it.

Form a mould from wooden slats, sealing them with clay

4 Check the consistency

Remove your hand. If your skin is well-covered with mix then you have a good ratio of plaster and water. If it appears watery, it is too thin: add more powder.

Remove the clay and wooden slats from the set plaster

Moisture released during setting will make it easier to remove the slats

6 Release the set plaster

When the plaster is set and feeling warm, it is ready to release. Take care to avoid damages if using a metal scraper to help remove the plaster.

Leave the plaster bat to dry raised on slats or props, so that air can circulate

Making one-part moulds

FOR SLIP CASTING OR PRESS MOULDING

Simple shapes that taper from top to bottom, such as a bowl, vase, or rimless pot, are ideal for casting in one-part moulds, using either slip casting or press moulding. Also known as "drop-out" moulds, you can use them to create a whole piece in a single cast, rather than producing multiple pieces that need to be joined (see Making two-part moulds, pp.40–41).

■ Checking for undercuts

An undercut is the part of a model that will cause the cast shape to stick or grip in the mould. Check your model for undercuts to enable a straight release. If your model is unsuitable for a one-piece mould then making a two-piece mould may be the solution (see above). Deep or complex texture can also prevent release; fill the indents with clay before making the mould.

Easy release
A model with a smooth, tapered profile will make for easy release.

Undercuts
A handle or lipped edge will create an undercut that will prevent release where it protrudes.

A silicone cupcake case that tapers from top to bottom is the model for this round mould. To make the round shape a cottle is required – this is a flexible wall that holds the plaster while setting.

1 Prepare the model
Mix liquid plaster (see p.36) and pour into the silicone case. Let it set hard before removing. The material you are pouring into must be waterproof, sealed, and have no undercuts (see left).

2 Apply a release agent
Attach the model to a tapered shape, or feed, on a plaster base with a border of at least 2.5cm (1in), to create a mould wall. Brush with soft soap and sponge off. Repeat three times.

3 Attach the cottle
Wrap a piece of stiff plastic around the model and tie tightly with string. You can also push a small coil of clay around the base to prevent the plaster from leaking.

You will need

- Model or form to reproduce
- Plaster base and tapered plaster shape (feed)
- Plaster powder
- Water
- Clean bucket
- Soft soap (if using a plaster model) or other release agent
- Brush
- Sponge
- Cottle (flexible plastic or lino)
- String
- Clay (optional)
- Hammer
- Metal weight
- Wooden slats
- ! Respirator mask

Tea-light holders

4 Pour the plaster

Mix the plaster for the mould, allowing enough to extend at least 2.5cm (1in) above the highest point. Pour the liquid plaster in one continuous action. Avoid splashing, which may create air bubbles.

Hold the mould upside-down against your body, not a hard surface, when tapping

5 Remove the cottle

When the plaster is hard, after about 10–15 minutes, remove the cottle. Take care, as removing the cottle too early will cause the plaster to break away and damage the mould.

6 Remove the model

Lift the mould off the model; it should separate easily. To help the release if it is sticking, place a metal object such as a weight on top, and tap with a hammer to shift the model. Dry fully before use, propped on slats.

Making two-part moulds

REPRODUCING COMPLEX SHAPES

When making a mould from a model that has a curved or complicated profile, you will need to create the mould in two or more parts, joined at seam lines. Start by identifying where the shape can be divided, taking any undercuts into account. If you intend to use the mould for slip casting, add a half-cone of clay at the top of the model to create a feed hole.

■ Finishing a plaster mould

Once the mould is dry, the corners and edges will be sharp. For your safety, you can use a surform to smooth and soften the edges and reduce the chances of chipping the mould. Do not surform the insides of the mould seam lines, as this would alter the shape. Once finished, store two-part moulds held together with elastic bands or string.

Smoothing edges
Remove sharp edges and corners by pushing a surform along the edges of the mould. Wear a mask to prevent inhaling plaster dust.

Storing moulds
Put the clean parts of the mould back together for drying. Align the seam lines and hold in place with elastic bands or string.

The curved shape and neck of this bauble create undercuts, so a two-part mould is used. Adding mould locators will ensure that your mould fits back together in the right place for an exact replica.

1 Find the seam line
Prop the model on its side on soft clay, to keep it level. Using a set square to maintain a level line, mark the seam with small dots at regular intervals on the widest point. Join the dots.

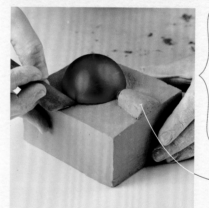

2 Build a clay wall
Model a wall of soft clay to build up to the indicated line, adding more clay until the walls extend 2.5cm (1in) wider than the sides of the model.

Add a half-cone of clay to create a feed hole

3 Secure the box
Prepare a box around the clay using plaster bats or pieces of laminated wood for easy release. Secure the walls with string and tighten; add small rolls of clay to seal any gaps.

You will need

- Model or form to reproduce
- Set square and marker pen
- Modelling tools
- Soft clay
- Plaster bats or laminated wood pieces
- String and/or elastic bands
- Plaster powder

- Water
- Clean bucket
- Sponge
- Coin
- Soft soap
- Surform
- ⚠ Respirator mask (optional)

Cast baubles

4 Mix and pour the plaster
Mix up a smooth blend of plaster (see pp. 36–37). Mark a guideline at least 2.5cm (1in) above the model on the inside wall and evenly pour the plaster up to the line. Lightly tap the liquid plaster to level it.

5 Prepare the second part
When the first half is set, remove the walls and clay. Clean with a damp sponge to prepare the cast plaster mould and model for the second pour. Make mould locators by carving a dimple in the plaster with a coin.

6 Reassemble the mould
Soft soap the cast plaster area. Remember to make the second half of the feed by sticking another half-cone of clay at the top of the model. Repeat steps 3 and 4 to reassemble the mould and pour the plaster.

The gap left by the half-cone enables slip to be poured into the mould when casting

Mould locators help to match the two parts together exactly

7 Release from the mould
When set, remove all walls and release the two parts of the mould, then remove the model and feed. Put the mould back together again to dry, holding the seam lines tightly together with string or elastic bands (see far left).

Slip casting

REPLICATING FORMS WITH LIQUID CLAY

Slip casting is a technique that uses liquid clay and plaster moulds to replicate simple forms made in moulds. You can alter the piece when it is out of the mould if you wish, adding colour, decoration, or texture as with other leather-hard shapes. The absorbent nature of a fully dry plaster mould is key to slip casting, and moulds made from other materials will not work.

PUTTING IT INTO PRACTICE

A one-part mould such as this flower pot is the simplest way to slip cast. Don't leave a cast in the mould for hours as it may crack – the plaster will still be sucking the water from the clay and will dry it too quickly.

You will need
- Plaster mould
- 1 litre (1¾ pints) casting slip
- 80-mesh sieve
- Jug
- Clean bowl or container
- Wooden slats
- Fettling knife or plastic lucy tool
- Banding wheel (optional)
- Sponge

Slip-cast flower pots

"Slip casting **gives a good consistency to** simple forms made in one-part moulds."

1 Prepare the casting slip
Before casting, make sure that the mould is dust-free and fully dried out. Prepare the casting slip by stirring until it has an even fluidity. Sieve into a clean jug.

2 Fill the mould
Ensure that you have enough slip to fully fill your mould. Pour in a continuous stream, into the reservoir above the shape – if you pause, small casting lines will show on the final piece.

3 Check the thickness
Leave for about 10 minutes then check the casting thickness (see above right). Pour out when at the correct consistency.

Checking casting thickness

Knowing when the slip is at the right consistency to cast the shape takes practice; it is something you will come to understand for each clay you use and for your different moulds. Most earthenware slips should be cast at a minimum depth from the edge of 4mm (¼in), whereas porcelain can be thinner as it is stronger.

Testing consistency
Place your fingertip in the slip and pull it away from the edge of the mould – you should be able to feel where the slip has thickened around the edge. If your mould has already been used, your casting time may lengthen.

4 Pour away excess
Achieve an even coverage by rotating the mould as you pour the excess slip into a container. Prop upside-down to let excess slip drip out and the cast harden.

5 Trim the edges
Trim the top edges and reservoir with a fettling knife or plastic lucy tool. Avoid overworking the clay, as marks may re-appear in the final piece.

It may be helpful to use a banding wheel so that you can rotate as you trim

6 Remove the pot
After about 15–30 minutes the edges of the clay start to look dry and shrink away from the mould; the pot is ready for removal. Once the piece has come away from the sides, you can release and lift it out with both hands. If the clay is still soft, you can manipulate it further.

Let the cast become leather hard or dry, then smooth the edges with a damp sponge to neaten

Forming
techniques

Forming **techniques**

The process by which you change clay into a structure or create a shape is known as forming. There are four main methods with which you can craft clay into a vessel – pinching, slabbing, and coiling are described as handbuilding techniques; they require little to no equipment and mostly rely on using your hands. These techniques often overlap, and you may well wish to incorporate more than one way of forming by hand into the same piece. The last technique in this chapter is throwing – using the potter's wheel. This method differs from other forming techniques, not only because of the equipment you require, but also in the need for water: throwing requires constant re-wetting of the clay in order to form it.

Pinching

■ See pp.48–59

In this section you learn to shape clay with your fingers and thumbs to build a form. Pieces made in this way tend to be organic in shape.

Pinching a tall pot (see pp.52–53)

Slabbing

■ See pp.60–75

Smooth, flat clay slabs can be rolled by hand or using a machine, and are either used straight away when still soft, or left to harden first.

Rolling slabs on textures (see pp.72–73)

This chapter will show you how to make a variety of shapes with each forming technique, introducing you to a range of core pottery skills.

Forming by hand

Through handbuilding you will become familiar with your raw material, learning how far you can push the clay, and knowing when a pot is too dry or too soft to work on. Pinching is usually the starting point for a new maker. Coiling a pot is very closely related to pinching, as you are mostly working with your hands. You will learn how to make straighter and larger pieces not possible with pinching alone, and discover how to use coils for decorative effect. Coiling is a relatively straightforward technique that gets progressively more challenging the larger your pieces become.

Working with flattened pieces of clay – slabbing – makes building quicker, as you can work with larger sections of both soft and leather-hard clay. Working with hard slabs allows you to build more angular pieces, making non-organic forms, which is a limitation with pinching and coiling. With the use of rollers, you can add texture to slabs, expanding your decorative possibilities.

Forming on the wheel

Using the potter's wheel is challenging. Throwing is more difficult in comparison to handbuilding, but once mastered it is an easy way to make repeat uniform shapes, as well as a much faster method of forming, especially for larger vessels which can be thrown in sections.

Coiling
■ See pp.76–89
This section teaches you how to build in stages, keeping pots soft enough to add to but sufficiently dry to support themselves.

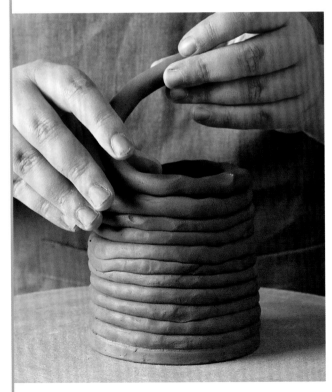

Coiling a simple cylinder (see pp.80–81)

Throwing
■ See pp.90–131
The basics of working on a potter's wheel are all covered in this section, as well as more complex techniques such as forming spouts, handles, and lids.

Throwing a plate (see pp.108–11)

Pinching introduction

FORMING SHAPES WITH JUST YOUR HANDS

This is the most basic and ancient way to form a pot, using just your hands. Through a simple pinching method you can create functional, enclosed, and decorative forms with extensions. This tactile technique is a valuable process to learn: by controlling the clay with repetitive movements, you will really connect with the material.

Controlling the clay

Pinching is the best place for a pottery beginner to start their journey with clay. With a ball of clay and both hands, you will be able to pinch out a bowl shape with relative ease. From this starting point you will connect with your material, learning to control the clay with the way that you pinch and the placement of your fingers and thumbs. An even rhythm and repetitive movements will help to achieve a uniform thickness and even shape.

From this starting point you can progress to forming different shapes and vessels. A tall pinch pot presents more of a challenge, as you work beyond the reach of your fingers. A different hand placement means you can control the shape inwards.

Developing shapes

The limitations of a pinch pot are in making something that is bigger than your hands. However, you needn't be restricted to simple shapes when pinching. It is possible to create taller, larger, and enclosed forms.

You will learn how to join two pieces of clay together using the score-and-slip method. By making two pieces with a similar width at the rim, they can be easily joined to double the size of your piece. Once joined, you can create either an open vessel or an enclosed form, such as a tea-light holder.

Using fingers to form
>> see pp.50–51
Pinching is best done with small repetitive movements, overlapping on sections already covered as you move round the piece. Here, the top of a pinch pot is refined with two hands pinching together.

"With a ball of clay and both hands, you will be able to pinch out a bowl shape with ease."

Narrow pinch pot
>> see pp.52–53
By joining two pinched forms together it is possible to create tall, narrow pieces with walls of an even thickness.

Alternatively, you can use simple kidney tools or ribs to smooth the surface, and perhaps employ decorating techniques as used on other finished pots (see pp.132–81).

For surface decoration you can add extensions by hand as you would with thrown pots. Using paper clay, learn how to make hand-formed flowers and leaves, to create raised decoration to finish your handmade piece.

Finishing pinched pieces
The nature of the pinching process leaves small indents and finger marks across the clay. These can be left, enhancing the organic nature of the handmade pieces, and accentuated with coloured glazes that will pool in the dimples to add more visual interest.

Enclosed forms
>> see pp.56–57
This pointed tea-light holder was created by combining two shapes, with the aperture cut away once joined.

Pinch bowl
>> see pp.50–51
These bowls have been formed using just hands, without tools or a wheel. The pinch marks left by the fingers contribute to the decorative effect, enhanced by all-over coloured glazes.

Pinching a bowl

USING YOUR HANDS TO FORM A BOWL

Your hands are the most basic, and often the best, tools to sculpt and model clay. In pinching, you use one hand to pinch the clay and the other as support: no other tools are required. This simple technique lends itself perfectly to making a bowl. The pinch marks can even become part of the decoration, so choose a glaze that will highlight – not hide – your maker's marks.

▪ Apply even pressure

Though pinching is a straightforward technique, it's harder to create pots with an even thickness by pinching than using a machine, particularly if you work too quickly. To ensure that the walls of your pot are even, make sure that you pinch with the same amount of pressure all the way round.

Uneven pinching
Uneven pressure creates an unbalanced shape. It's tempting to remedy this by pinching more, but it's better to let the pot dry a little. Return and reassess the thickness before pinching again.

Even pinching
To achieve an even thickness and shape, it's best to pinch softly and more often than harder and with fewer pinches. Thick bases can be shaved down with a metal kidney once leather hard.

The potter's pinch marks can be clearly seen in the finished bowl, giving it a handmade, artisanal feel. It has been finished with a layered, two-part glaze to encourage the glaze to pool in the pinch marks.

You will need
- 400g (14oz) clay (all types)
- Wire
- Scales
- Wooden bat
- Banding wheel

Pinch bowl

1 Make a ball
Once you have weighed out your clay, use two cupped hands to pat the clay firmly, getting rid of any sharp edges, until it resembles a ball.

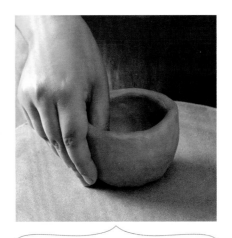

2 Make a hole
Holding the clay in one hand, push the thumb of your other hand into the clay. Your thumb should go in past the base knuckle but leaving enough clay at the bottom to form the base of your pot.

3 Pinch the base
With your thumb inside the clay and your fingers outside, start pinching gently, slowly spinning the clay so the hole opens gradually and you form a base. Control the thickness by making small, gentle pinches that overlap.

4 Create the shape
When you can no longer reach the bottom of the pot with your thumb, put the pot onto a wooden bat on top of a banding wheel and leave it to harden for about an hour, depending on how warm your room is.

5 Refine the shape
Continue pinching into the desired shape on the banding wheel. As your shape develops you can refine the edges.

Pinch along the top rim to level its profile and make sure the walls are even

"Control the **thickness** by making **small, gentle pinches** that overlap with each other."

Pinching a tall pot

ADDING HEIGHT WITHOUT COILING

This technique joins two pinched pots to create a taller vessel, such as a vase, jug, or sculptural form, which cannot be pinched from a single piece. Grogged clay is easier to handle but you can use this technique with any clay. When joining two shapes, the edges to be joined should be the same dimension – working with soft, malleable clay means that you can adjust your shapes to fit.

PUTTING IT INTO PRACTICE

This tactile method of forming a vessel is reflected in the organic nature of the finished piece, with a hand-formed rim. Using a banding wheel means that you can pinch with both hands to create height.

You will need

- 600g (1lb 5oz) white stoneware clay, made into two balls (about 300g/10½oz each)
- Banding wheel
- Piece of paper
- Knife or harp wire
- Toothbrush or stiff brush
- Smooth metal kidney
- Wooden spatula

Tall pinched vase

"For **two halves of a pot to join together smoothly**, they need to be **flat**, **level**, and the **same width**."

1 Pinch
Start pinching with your thumb in the base of a ball of clay, then use the length of your fingers to make a narrow shape, pushing your fingertips against your palm. Turn the clay as you work.

2 Build height
Place the pot on a banding wheel on a piece of paper. With your thumbs inside and fingers outside, move your hands in to squeeze the clay up. Pinch another ball of clay in the same way.

3 Score the rim
Slice both rims to level them, then flatten each rim by pressing down using three fingers. Rough up the rims with a wet toothbrush. The pots should be equal in diameter (see above right).

Adjusting the width

In order for two halves of a pot to join together smoothly, they need to be flat, level, and the same width. If one piece is wider, you can try cutting a notch at the rim to make the opening narrower. Repeat along different sections until the piece has become narrow enough to join up perfectly with the other half.

Cutting out a notch
Cut out a small V-shaped notch from the rim, about 2cm (¾in) long. A knife is good but a harp wire is very useful.

Joining together
Overlap the clay at either side of the notch and squeeze together to bring the shape in. Smooth over the join so it is not visible.

4 Remove the top
Carefully put the two halves together. Use a knife to slice through the clay near the top. Gently pinch the rim to open up the top.

Work up from the bottom to the top with the metal kidney

5 Join and smooth
Make a coil of clay about 1cm (½in) thick. Score gently over the join, apply water, and, supporting the join inside, push the coil into place with your thumb; smooth with your finger.

6 Finish the vase
When the vase is leather hard, use a metal kidney with a small amount of water to smooth the sides, holding your fingers against the inside of the area you are working on. Finally, smooth the overall shape by tapping it with a wooden spatula.

Extensions

ADDING TO A PINCHED POT

As well as the usual handles, spouts, or lids, it is possible to build virtually anything in clay and add it to a piece. The most intricate designs can be achieved by joining any soft or leather-hard pieces of clay together with a little water or joining slip and some scoring. These pieces must be made in the same clay as the main piece, but can be formed in many different ways.

■ Adding a foot

An extension can be functional as well as decorative. For example, feet provide stability to round-based pots and bowls, and can be made in a range of styles. After attaching a base or feet, leave the pot to dry upside-down, to avoid putting pressure on the new joins.

Coiled feet
These feet are made from a coil (see p.78), cut into four parts. Leave one end flat, and shape the other to a point. Score and slip the flat ends to attach them to the base.

Pinched base
Another way of making a foot is by pinching a smaller bowl in the same clay, then attaching it upside-down on the base of the main bowl.

Both this pinched and coiled vase and the small flowers are formed using paper clay (see pp.32–33), a strong material that is ideal for this type of work as the fibres help bind the pieces together.

You will need

- A pinched and coiled leather-hard vase
- 250g (8oz) of the same clay
- Wooden bat
- Banding wheel
- Wooden tool or potter's pin
- Brush
- Joining slip

Vase with flowers

1 Make the centre of a flower
Start with the middle of each flower, rolling a small ball of clay on the palm of your hand, or between your fingertips. Keep this piece small as the petals will be larger.

2 Shape the petals
To make the petals, roll small balls of clay in your hands and squeeze them between your fingertips to flatten them. Then pinch one end to form a teardrop shape.

3 Form a flower
Lay out the petals to form a flower. Squash the ball made for the centre into a flat disc, add a little slip on one side, and press it onto the petals at the central point.

4 Add detail
Use a pointed wooden tool or potter's pin to join the centre to the petals. Add an indent at the base of each petal, pushing down into the clay rather than dragging across it.

Scoring the vase itself will be enough – don't worry about scoring the flowers too

5 Attach the flower to the vase
You can attach the finished flowers to your pot straight away. Cross-hatch a small area on the side of the vase, and brush on a little slip. Press the flower gently into place; put your other hand inside the pot to support the clay.

Enclosed forms

COMBINING SHAPES TO MAKE A HOLLOW PIECE

You can create enclosed or partially enclosed pieces by joining two pinched shapes together at their rims, ensuring the pieces are of the same thickness and width. This versatile technique feeds your creativity, with endless possibilities for combining different shapes, carving apertures, and adding surface decoration to make objects such as bird feeders, tea-light holders, cactus pots, or salt cellars.

PUTTING IT INTO PRACTICE

This tea-light holder is made by combining two pinched shapes, then carving out an aperture. Think about the function of the piece; make sure the base is flat and stable, and, if using a candle inside, add a hole or two at the top of the shape so that heat can escape.

You will need

- 500g (1lb 2oz) clay, made into two balls (about 250g/9oz each)
- Plastic sheet or clingfilm
- Potter's pin or toothbrush
- Joining slip or water
- Sharp knife
- Sponge

Tea-light holder

1 Make two forms
Pinch one ball to form a cup shape and the second to form a cone. Check that both shapes are the same thickness and the rims are the same diameter (see Adjusting the width, p.53).

2 Leave to dry
Dry the shapes a little if they are too soft. It is a good idea to put them upside-down on a plastic sheet or piece of clingfilm, so that the shapes don't warp and the rims don't dry too much.

3 Score and slip
Once your pots are leather hard, score and slip the rims using a potter's pin, toothbrush, or comb-shaped tools. Brush a little water or slip along each rim to glue the two shapes together (see above right).

"**This versatile** technique feeds your creativity, with endless possibilities for combining different shapes."

▪ Making a secure join

Make sure the two pieces are firmly joined to create a single form. Scoring the rims and applying slip softens the clay and helps the two halves make a solid, secure join. It is very important to avoid letting any air become trapped in the grooves you create, or your pot may crack in the kiln.

Applying slip
Score both rims well using a pin or toothbrush. Brush them generously with plenty of slip, then bring them together to join them, twisting the two halves from side to side gently, to help seal the join and work out any trapped air.

Hold the piece gently, without squeezing, as you smooth and blend the join

4 Join the pieces
Roll out a thin coil of soft clay. Dip the coil into water to dampen it, then place it over the join. Smooth into place with your finger or thumb, removing any excess clay, or use a metal kidney.

5 Create an aperture
Leave the pot to dry again. When leather hard, cut an oval opening using a sharp knife, then lever out the clay. You can use a paper template to guide you, drawing around it with a pin, if preferred.

Add holes to the top of the form if it will be used for tea lights

Remove any bits of excess clay from the rim before smoothing

6 Smooth the shape
Run a damp sponge around the rim of the aperture to smooth down the edge, holding the piece gently in your other hand. Continue to smooth the whole shape, removing any pinch marks, and taking care not to distort the form.

Artist **Tina Vlassopulos**
Clay **Earthstone Original Clay**
Finish **Burnished**

Smoothing the texture
« See p.53

To smooth over the naturally dimpled texture of
pinched clay, leather-hard pots are scraped with a
surform, then a metal kidney, then a wooden rib.

Creating fine edges

To achieve perfectly neat edges, first cut
the rim with a knife, then use a surform and
smooth metal kidney to finely shape it until
it is even and relatively sharp.

Pinching in sections
« See pp.52–53

Different parts of a piece can be pinched
separately, then joined together using the
score-and-slip method.

Pinching showcase

Every last bit of a pinched pot is sculpted between the potter's fingers, making the technique ideal for creating delicate, precise forms. Pieces are shaped from bottom to top, appearing out of a lump of clay as if by magic. The walls of these pieces are all of an even thickness.

Combining pinching and coiling

>> See pp.78–79

These simple techniques can be used to make amazing works of art. Each coil that is added is pinched to control the shape of the piece.

Burnishing

>> See pp.152–53

A soft, tactile finish is achieved by burnishing, a process in which unfired pots are polished with hard tools to give them a subtle shiny surface.

Weightless forms

One of the challenges of working with clay is making it appear delicate without letting it become overly fragile. A rounded base creates the illusion that the piece is floating weightlessly.

Slabbing introduction

HANDBUILDING WITH FLAT PIECES OF CLAY

Slabbing is a handbuilding technique where clay is rolled out and can be cut into pieces and constructed to make a variety of forms. Handbuilding from slabs is a simple way to make a variety of different forms without the added cost or space requirement of using a potter's wheel.

The basics of slabbing

Slabs can be used when soft (just after being rolled) or hard (after being left to dry evenly until leather hard). The flexibility of soft slabs allows them to be folded or shaped. You can choose to use soft slabs with hump and slump or press plaster moulds, to create shaped pieces that can be difficult to throw, especially flatware such as plates or dishes, or try manipulating the clay by hand to make a cylinder. Freeform and sculptural pieces, as well as floor and wall tiles, can also be made from slabs; or discover how to join hard slabs to make items such as boxes. Slabs can be left with a smooth finish, but are also the ideal surface for decorating; learn how to impress texture using tools or found objects.

Any type of clay can be used for slabbing, though grogged clay provides greater strength for handbuilding. Before you begin, assemble the basic tools: a rolling pin, guides (such as thin wooden slats), and canvas. Rolling out clay on top of a piece of canvas or other fabric stops it sticking to the table, and makes it easy to pick up and move.

You can also make slabs with a specialist piece of equipment called a slab roller, which works like a pasta maker, pressing and rolling the clay into a flat slab between two pieces of canvas (see p.63). A slab roller is a more

Using canvas
>> see p.64
Large pieces of canvas or other fabric are ideal for rolling out slabs on – clean the canvas in between use to avoid any dry bits of clay being transferred to the new slabs.

"Freeform and sculptural pieces, as well as floor and wall tiles, can all be made with slabs."

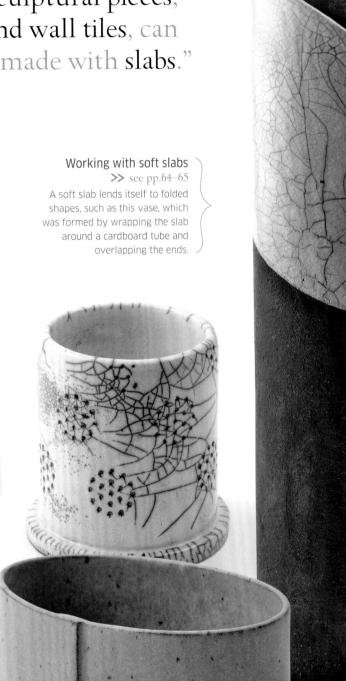

efficient, and less tiring, way to roll slabs than by hand, especially when working on large-scale pieces.

Key tips for slabbing

Keep your work surface clean before and during rolling, to avoid getting debris into the clay. Use clean moulds, so no stray bits of plaster end up in the clay and cause it to crack.

If joining multiple slabs, such as the base and body of a vase, roll them out at the same time so that they dry at the same rate. Slab-built pieces should always dry slowly.

Working with soft slabs
>> see pp.64–65
A soft slab lends itself to folded shapes, such as this vase, which was formed by wrapping the slab around a cardboard tube and overlapping the ends.

Creating textured slabs
>> see pp.72–73
Surface decoration can be applied to slabs while soft, for instance through stamping or impressing texture.

Making clay slabs
>> see pp.62–63
Using a slab roller, or wooden guides when hand-rolling, will help create slabs of uniform thickness. A single slab has been used here for the walls of this bowl.

Making clay slabs

ROLLING OUT CLAY

Slabs can be used for handbuilding ceramics, from functional ware to sculptural pieces that are difficult to make on a potter's wheel. Personal preference and the size and number of slabs required will determine which method – by hand or machine – you use. Correct preparation is key, keeping the thickness consistent with a smooth finish.

HAND ROLLING SLABS

A rolling pin is an easy way to roll out slabs and achieve an even thickness. The resulting slab is perfectly suited to shapes made on a mould.

You will need
- Clay of choice
- Canvas or fabric
- 2 roller guides and rolling pin
- Smooth rubber kidney

Shallow dish

1 Flatten the clay
Use your palm (or rolling pin) to flatten the clay to a manageable thickness for rolling out.

Keep the pressure consistent as you smooth the clay

2 Rolling out with guides
Place the clay on a piece of canvas to prevent it sticking, then position your guides either side of the clay to the width required. Roll out the clay, rotating and flipping occasionally.

3 Compress the clay
Rolling between guides results in a slab with an even thickness. To smooth and compress the rolled-out clay; use a rubber kidney tool, working in different directions, and taking care to maintain a consistent thickness.

Rotating the clay

When rolling out the clay, the slabs should occasionally be rotated 90 degrees and flipped over to ensure the clay particles are spread out evenly. Use a rubber kidney to smooth the clay. These techniques will help to avoid pieces cracking.

Hand rolled
Use two hands to lift, flip, and turn the rolled slab of clay through 90 degrees.

Slab rolled
With the canvas on both sides, flip the piece and turn through 90 degrees.

USING A SLAB ROLLER

Slab rollers provide a fast and easy way to roll out large slabs of uniform thickness that suit handbuilt vessels, such as this folded bowl.

You will need
- Clay of choice
- Slab roller
- 2 pieces of canvas or fabric
- Smooth rubber kidney

Oval bowl

Ensure the canvas pieces are large enough to cover the rolled slab

1 Position the clay
Place the flattened clay between two pieces of canvas or fabric. Select the width on the slab roller by changing the height of the roller, depending on the required thickness of the slab (no less than 5mm/¼in).

Move the roller at a slow rate to prevent stretching

2 Feed clay through the roller
Turn the handle to feed the clay through the roller, holding the canvas in place with your other hand. Flip and rotate the slab between two canvases to feed through again. Smooth with a rubber kidney tool.

Working with soft slabs

MAKING A CYLINDRICAL VASE

A soft slab is freshly rolled clay, which can be used to make various structures, including flowing and freeform designs. Care needs to be taken when handling due to their tendency to distort or stretch. Rolling a slab of malleable clay around a tube is a simple way to create a cylinder. Other shapes can be sculpted freehand, or use a template.

■ Manipulating soft slabs

Various irregular shapes can be made with soft slabs. Instead of rolling the clay around a tube, you can try manipulating it by picking it up then shaping the slab by hand and joining it to create the desired shape.

Shape by hand
With the clay upright, bend the sides around to create a freeform cylinder. A paper template can be used to cut out the initial shape from the rolled-out slab.

Freeform shape
The flared shape at the base of the tube can be shaped by hand or incorporated into a template design. Score and slip the ends before joining, then carefully press the seam to strengthen the join.

PUTTING IT INTO PRACTICE

This freeform cylindrical shape is created by rolling soft clay around a tube, making a feature of the overlapping edges. For more discreet joins, bevel the edges at 45 degrees.

You will need
- Rolled slab of clay, plus extra for base
- Piece of canvas or fabric
- Ruler
- Potter's pin
- Newspaper
- Card tube
- Wooden knife
- Paintbrush (optional)
- Joining slip
- Smooth rubber kidney

Freeform vase

1 Cut the shape
Use a ruler and potter's pin to cut your shape from a rolled slab, creating straight lines along the bottom and two sides. Leave the top edge slightly curved.

Cut slab a little longer than the circumference of the tube

2 Roll a cylinder
Roll the clay tightly around a newspaper-clad tube, aligning the base of the tube with the clay edge. Cut off the excess clay with a potter's pin, leaving a little overlap.

3 Cross-hatch the overlap
Roll the tube back a little and use the needle tool to cross-hatch both edges where they overlap. Apply slip to both edges with a wooden knife or brush.

4 Join the seams
Roll the cylinder over to join the seam, rolling back and forth a few times to apply a little pressure to the cross-hatched edges and help expel any air bubbles.

5 Prepare the base
Roll out a piece of clay for the base to the same thickness as the cylinder (see pp.62–63). Place the tube and clay cylinder on the slab and cut around them with a potter's pin, removing the excess clay.

Remove the newspaper once the tube has been lifted out

6 Join the base seams
Cross-hatch the base and the bottom of the cylinder and apply slip as before. Press the cylinder onto the base and seal the edges together with a wooden knife, pressing the base clay up onto the sides. Smooth with a rubber kidney.

Working with hard slabs

SLAB BUILDING WITH LEATHER-HARD CLAY

Hard slabs are ideal for building objects with straight sides. Unlike soft slabs, they will hold their shape when placed upright, allowing you to build items without using moulds. Assemble your piece right after cutting out your slabs, so that the edges don't become too dry to join together.

▓ Checking the fit

It is very important to accurately measure your slabs to ensure they fit together perfectly. The walls of a box can either be stuck to the sides of the base, so the joins will appear underneath the box, or to the top of the base, so the joins will appear at the sides of the box. You will need different measurements depending on which method you choose – a paper template will help.

Test the fit before joining any slabs

For this box, the length of the two longer sides is equal to the length of the base plus the slab thickness. The length of the two shorter sides is the same as the width of the base plus the slab thickness. Attaching the walls to the top of the base instead is a slightly safer option, if you are inexperienced with joining.

This box is made from hard slabs cut into 10 sections; the sides of the box and lid are joined with simple butt joints. The box and lid should be made at the same time, to ensure they shrink evenly.

You will need

- 5kg (10lb) clay
- Wooden board
- Canvas/cloth
- 2 roller guides and rolling pin
- Paper template
- Sheets of plastic
- Ruler
- Knife
- Toothbrush
- Scoring tool or potter's pin
- Slip
- Surform
- Metal kidney

Rectangular box

1 Roll out clay slabs

Start by rolling out slabs on a piece of canvas or other cloth when the clay is still soft (see p.62). Roll your slabs about 1cm (½in) thick, and use a paper template to check that they are large enough to allow you to cut out all the pieces of your box.

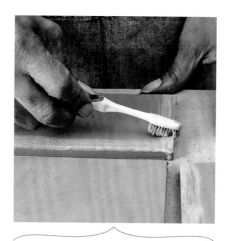

2 Leave to harden
Place each slab on a wooden board and cover with plastic. Leave until leather hard, checking them from time to time. A wooden board absorbs water from the clay; if you use a non-porous board, do not cover the slabs.

3 Cut to size
Once the slabs have dried, start cutting out the components for the box using a ruler and knife. For neatness, the walls will be placed at the outside edges of the base, rather than on top of it (see Checking the fit, left).

4 Score and slip the slabs
Brush and cross-hatch along the edges of two slabs, then apply slip to the scored areas. Don't forget to score and slip a strip along the edge of the longer wall, for the shorter wall to attach to.

5 Join slabs together
Repeating the score and slip process a few times will create strong joins; a special scoring tool is an efficient way of cross-hatching the clay. Lift up the slabs and press them into place at the outside edges of the base.

6 Reinforce the joins
To reinforce the joins, and for neatness, roll out coils and place them over the edges where the slabs meet. Use your finger to press down on the coils, then smooth over with your fingertip or a sponge. Join and reinforce the other two sides of the box.

>>

7 Level the top
Use a surform to neaten the tops of the walls, as well as to even them out if necessary. You can also use a metal kidney to smooth over the joins on the outside of the box.

Smooth over the tops of the walls with a surform for a neat finish

8 Prepare to make the lid
To make the lid, place the box upside-down on top of the other slab and use a knife to mark out the edges of the main section of the lid. The lid is made in the same way as the box, but with a slightly larger base and much shorter walls.

9 Cut out components for the lid
Cut out the main section of the lid. Then, using a wooden slat or ruler as a guide, cut four pieces of equal width for the sides of the lid. Do not worry about cutting these to length yet; it will be easier to do so after joining them.

The overhang can be of any length

Extra width will be needed so that the lid fits around the top of the box

10 Construct the lid
Build the lid in the same way as the main box, cross-hatching along the bottom of the sides and applying slip, then pressing them into place around the main section of the lid.

Excess slab at one end of the lid can be trimmed later

11 Trim sides of lid
Finally, trim off the excess clay from the sides of the lid. Smooth over the joins with your fingers or a sponge. Bisque fire the box and lid together, to 1000°C (1832°F).

Using moulds with slabs

MAKING A DISH

Making batches of the same piece is straightforward when combined with using moulds, which are especially suited to functional pieces such as dishes or plates. Rolled clay slabs make this process even simpler, starting with a smooth piece of clay at an even thickness that can be placed over hump moulds or pressed into slump or press moulds to form pieces. Once the clay is dry enough it can be removed and, if required, shaped further.

PUTTING IT INTO PRACTICE

Hump moulds are ideal for making shallow bowl, dish, and plate shapes. As clay shrinks when drying, ensure that the clay is leather hard but not too dry while on the mould, otherwise it may crack.

You will need
- Clay
- Canvas or fabric
- 2 roller guides and rolling pin (or slab roller)
- Smooth rubber kidney
- Hump mould
- Sponge
- Wooden knife
- Wooden board
- Surform (optional)

Moulded dish

1 Transfer the slab
Roll a slab no less than 5mm (¼in) thick and smooth with a rubber kidney. Transfer to the mould, either by hand or by putting the mould on the slab and using the fabric to flip it over.

2 Press slab onto the mould
Remove the fabric, if used, and then use a damp sponge to gently press the clay onto the mould, working over the whole shape and ensuring that the edges are evenly pressed down.

"Moulds are useful for making batches of the same piece, especially functional ware."

Cleaning the mould

Flatware can crack easily during the making process, and any dried pieces of clay that transfer to the slab will weaken it. Ensure you remove any leftover clay from the mould before applying the slab. This reduces the risk of any ridges, marks, or dents, or the transfer of different clay colours to the next piece.

Use a sponge
Thoroughly clean the mould before use with a damp sponge, wiping off any dried pieces of clay that could transfer to the next piece. Use a clean sponge each time.

3 Trim the clay
Trim the edges and remove the excess clay. Use a wooden knife, to prevent cutting into the plaster and transferring it to the clay, which will cause it to crack when fired.

4 Compress the clay
Use a rubber kidney tool to smooth and compress the clay, working over the whole piece with even pressure. This is a good stage to apply a maker's stamp to the base, if desired.

5 Flip over
Once the clay is leather hard so it can hold its shape, place a wooden bat over the top and flip in one swift movement.

Holding the mould in both hands, lift it straight up

6 Remove the mould
Lift the mould out of the dish. Clean the mould with a damp sponge before reusing. At this stage, the piece can be further shaped with a surform and the edges and inside smoothed.

Creating textured slabs

ADDING INTEREST TO ROLLED SLABS

A rolled-out soft slab provides the ideal smooth, flat surface for impressing and rouletting textures and patterns into the clay, before forming the piece around a mould. Decorative rollers and stamps are available to buy, or almost any found object with a textured surface can be enlisted to great effect. (See also pp.142–43.)

Creating patterns

Patterned roulettes and printing blocks are available to buy, or make your own bisque-fired versions from soft coils rolled over textured surfaces. Embossed rolling pins and textile stamps are also useful.

Patterned roulette
Place the roulette on the slab, apply gentle pressure and move the roller forwards in a single smooth motion, guiding the edge with your other hand.

Wooden stamp
Use decorative stamps singly or in combination to create your own patterns. Practise to get a feel for the optimum pressure and ensure a consistent depth.

PUTTING IT INTO PRACTICE

A stamp is used to create a repeating pattern and bring textural interest to the surface of this cylindrical pot. Raku firing (see pp.232–35) helps the dimpled circles stand out even more on the white glaze.

You will need
- Cardboard tube
- Paper, pencil, and scissors
- 1.5kg (3lb 3oz) smooth clay
- 2 roller guides and rolling pin, or slab roller
- Smooth rubber kidney
- Knife or scalpel
- Stamp or other textured object
- Joining slip
- Wooden knife or brush

Textured pot

1 Roll out the clay
Make a paper template to the circumference of the mould and desired height. Roll out a slab (see pp.62–63), slightly larger than the template and 5mm (¼in) thick; roll another slab for the base.

2 Smooth the surface
Use a kidney to smooth and compress the surface of the slab, removing air bubbles or areas of inconsistency. Take care to maintain a consistent thickness.

3 Cut to size
Place the template on the slab centrally and use a knife or scalpel to cut around it. The wooden roller guides provide a handy cutting edge.

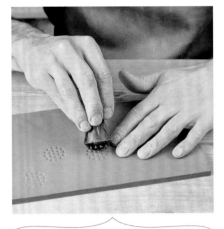

4 Apply texture
Use a stamp, or any found object with a textured surface, such as a button or shell, to impress a repeating pattern on what will be the exterior surface of the pot.

5 Form the cylinder
Wrap the tube with paper to stop the clay sticking, then carefully roll the slab around the tube. Score the edges and wet them with slip before pressing together to join (see also p.65).

6 Add a base
Cut out a base from a slab of the same clay, and attach it to the cylinder (see p.65), securing the join by wrapping round a clay coil and smoothing it in. Remove first the tube, then the paper, and leave to dry.

Artist **Cat Meaney**
Clay **Stoneware**
Finish **Various shiny glazes**

Punched holes
≪ See pp.150–51

Clay can be removed from the middle of a slab as well as from the edges. The punched-out hole in this platter is both elegant and practical.

Exposed joins
≪ See pp.64–65

Leaving a join exposed, rather than smoothing it over with a kidney, makes a design feature of the method of construction.

Unglazed areas

These bowls and plates have had glaze applied on the inside only, with the outsides left unglazed, creating a tactile appeal from the contrast of textures.

Slabbing showcase

Manipulating soft slabs, both with and without the use of moulds, creates work that is easy to engage with. Flat, curved, or tall forms, when made from a single slab, are unfussy and elegant; where multiple slabs are fixed together, the joins can either be smoothed over perfectly or left visible.

Using slabs to make bowls

≪ See pp.70–71

Clay slabs can be draped over moulds to produce bowls and plates of various shapes and sizes. Slabs should be of even thickness.

Glazing flat dishes

≪ See p.201

Glaze can be poured onto a flat dish and swirled around to coat the whole surface, then any excess can be poured away, and the rim sponged clean.

Colour changes at the rim

Pieces made from clays that contain iron can take on lovely burnt orange edges where the glaze meets the natural, unglazed clay. This effect varies depending on the glaze used.

Coiling introduction

HANDBUILDING WITH CLAY COILS

Coils of clay, either made by hand or in a machine, provide the perfect handbuilding material. You can use them in a range of ways, working freehand or with the aid of a mould. Larger shapes are easily achieved once you are familiar with the processes. The outline of the coils can be left as decoration or smoothed over when building.

Building with coils

Coils are easy to make by hand, without the need for specialist tools, and as you progress they will become neater and more uniform. With the aid of an extruder and dies you can make a range of consistently shaped coils relatively quickly. Whether hand rolled or extruded, use the coils to build vessels. Starting with a straight-sided cylinder and progressing to a wider pot, you will learn how to bring the clay out, build upside-down, and bring the coils in to keep a straight shape.

The challenge with any coil pot is to maintain its shape as you build. To help, learn how to correctly cover your work while building in stages, as properly covered pieces can be returned to and built up over a number of days. It is also useful to know how to employ supports as you work.

A banding wheel is a particularly useful piece of equipment when coiling. Long coils can easily be attached while the pot is on a wooden board and spun around. With the aid of a mould, it is possible to make repeat shapes as well as begin to explore the decorative potential of coils.

Decorating with coils

You will find several suggestions for more elaborate combinations or configurations of coils used for

Coiling a wider pot
>> see pp.82–83
Coils are attached on the inside edge to bring the shape inwards. This piece is being built upside-down to create a narrow base that will be attached to a flat disc of clay.

Coiling a simple cylinder
>> see pp.80–81
A straight-sided vessel is relatively easy to achieve by building coils in stages and smoothing the sides.

"Coil shapes can also be attached as pure fancy in an unconventional way."

Using coils decoratively
>> see pp.86–87
Using an extruder with a square die, these coils have been shaped and then attached to create unusual "handles".

decorative effect. Leaving the coil layers unsmoothed is perfectly suited to more organic styles or designs.

Coils can also be attached as pure fancy in an unconventional way. Clay has the magic quality of becoming quite strong once leather hard, and decorative attachments are easy to add once shaped at a softer stage. This process lends itself to being both functional and decorative, with additions such as handles easily achieved in sculptural form.

Coiling into a mould
>> see pp.84–85
Here, coils have been pushed together in a press mould. The interior is smoothed and on the exterior, a glaze highlights the effect.

How to make coils

USING YOUR HANDS OR AN EXTRUDER

A hand-rolled coil is a simple and efficient way to build a pot. Once you are skilled enough in rolling them, you can use coils to create forms that are uniform, even, and straightforward to build. Using an extruder will speed up the process while opening up a range of shapes. Extruded coils can be used to build decorative pieces with more angular shapes.

MAKING COILS BY HAND

Rolling coils by hand requires even pressure as your hands move the clay across the board, gently extending the coil to the desired length and thickness. Work standing up to have more control.

You will need
- 500g (1lb 2oz) clay
- Wooden board

Hand-coiled pot

1 Squeeze the clay
Using gentle, even squeezes, form your clay into a large, round sausage shape with your hands. The firmer the clay, the harder you need to squeeze.

2 Start rolling
Roll the clay gently using the full length of your hands from heel to fingertips, starting with your hands close together. Put the weight of your body into the roll by rocking back and forth.

3 Continue rolling
As you roll, gradually move your hands further apart to spread the clay evenly throughout the coil. Repeat steps 2 and 3 to achieve the desired length and thickness.

Rolling round and even coils

Harder than it may initially look, making an even, hand-rolled coil is a skill in itself. Uneven pressure when rolling can result in thin sections appearing along the length, or a flattened shape. It is possible to fix mistakes in rolled coils by reworking the section by hand.

Thin patch
To fix a thin section, roll the coil and move your hands closer together to push the clay in.

Flat coil
To make a flat, oval-shaped coil round again, push down on the oval edge and gently roll.

MAKING COILS WITH AN EXTRUDER

Using an extruder with a range of die sizes will give you greater flexibility in controlling the length and thickness of the coils. Have a board ready beneath the extruder to catch very long coils.

You will need
- 500g (1lb 2oz) clay
- Wooden board
- Extruder

Extruded-coil pot

1 Attach die
Choose your die depending on the thickness of the coil, and slot it into the die-holder at the base of the extruder, clipping it firmly into place.

2 Fill the chamber with clay
Roughly roll or squeeze a piece of clay into a large sausage shape, just smaller than the chamber of the extruder. Slot it in so it goes all the way to the bottom and put the lever on top.

3 Extrude a coil
Pull the lever down slowly and firmly, using both hands if necessary. The extruded clay will come out from the die at the bottom. Cut it at the desired length.

Coiling a simple cylinder

CREATING A STRAIGHT-SIDED VASE

You can achieve an elegant, narrow, straight-sided vase with just a few tools and hand-rolled coils. With practice and patience it is possible to build uniform pieces by hand, paying careful attention to creating even coils and developing an understanding of your material.

▨ Controlling the drying process

Your pot might distort as you build more height, particularly if it is large or your clay is too soft. Know when to stop and control the drying, to make sure you can continue to add more coils at the right stage.

Add clingfilm
Use a small piece of clingfilm to wrap around the top few coils. This will stop air getting to them and prevent them from drying out. Keeping the top few coils soft will enable you to continue adding coils when ready.

Add plastic
Loosely drape the pot in plastic or clingfilm and leave it to become leather hard. Leaving the pot exposed could mean that it dries too quickly and cracks. By covering and controlling the drying process you can prevent this.

Building layers of even coils on top of each other over a rolled base, then blending them together to achieve a smooth surface, creates a straight-sided cylinder in a short space of time.

You will need
- 1kg (2¼lb) clay
- Wooden board or fabric
- 2 roller guides and rolling pin
- Round cookie cutter
- Wooden bat
- Banding wheel
- Knife
- Smooth metal kidney

Straight-sided vase

1 Roll out the base
Roll out a small piece of clay using guides of approximately 1cm (½in) to ensure an even thickness, using a wooden board or fabric beneath the clay to keep it from sticking.

Flip and rotate the clay occasionally to ensure the clay particles are spread evenly

2 Cut out the base
Push a cookie cutter into the clay to cut out a round base for the pot; the diameter of your cookie cutter will become the diameter of your pot. Transfer to a banding wheel.

3 Attach the first coil
Cut the ends of the coil with a knife so that the edges are straight, then place one end on the base and curve it around the edge. Push the coil firmly into the base to attach it.

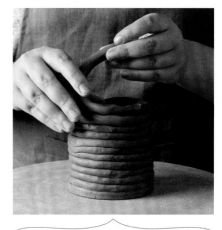

4 Build the coils
Lay a second coil on top of the first, pushing down with your fingers. Repeat to build the pot, placing coils directly on top of each other, or slightly tapering inwards.

5 Smooth the coils
Smooth over the coils using a smooth metal kidney, moving from bottom to top, then across to smooth over the upward strokes visible in the clay. Support the pot with your other hand.

Keep working with the kidney until you have a smooth surface

Coiling a wider pot

HANDBUILDING WITH THIN PIECES OF CLAY

Building with coils needn't be limiting; any shape or size is possible with a few careful considerations when it comes to building the structure, and you can add more interest using handmade coils that are either smoothed or left textured. To form a vessel with a wide circumference, join two lengths of coil together, rather than attempting a circle from a single, oversized length of coil.

PUTTING IT INTO PRACTICE

A wide, open vessel is created initially upside-down. The surface hasn't been smoothed completely, leaving a textured effect that is further enhanced by the coils being left unfinished on the inside.

You will need

- 3kg (6½lb) clay
- Plastic
- Banding wheel
- Round cookie cutter
- Clingfilm
- Smooth metal kidney
- Wooden bats
- Clay supports or stilts

Wide pot

> "Add **more interest** using handmade coils that are either **smoothed** or left **textured**."

1 Join two coils
Roll coils of about 1cm (½in) thickness. Join two coils in a wide circle, placed a short distance in from the edge of the board. Joining two shorter coils is easier than using one long one.

2 Build up curved edge
Add more rings on top, pushing down and squeezing each coil to the upper inside edge of the one below, rather than placing directly on top, to create a curved edge.

3 Attach base
Cut out a circle for the base with a cookie cutter, about 1cm (½in) wider than the hole. Add a little water and press the base on. Cover and dry until leather hard, with the base exposed.

Coil consistency

Rolling all of your coils at the same time is a good way to ensure they are the same thickness. However, you will need to take extra measures to ensure they all remain soft. Put the coils down on a piece of plastic and fold it over so they are covered while you make the rest.

Make coils in batches
The consistency of clay is key: either make all of your coils in a batch and keep them covered, or make them as you go. If made as a batch, place them on a piece of plastic and cover, so that they remain soft.

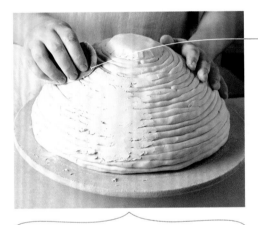

Smoothing before turning the pot over allows you to reach the bottom half easily

4 Smooth the surface
Use a metal kidney to smooth the coils on the outside of the pot, from top to bottom then side to side. You don't need to go right down to the edges; these can be smoothed once the pot is flipped.

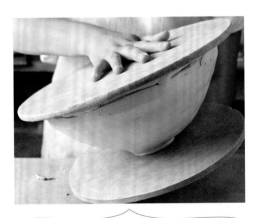

5 Turn the right way up
Place a bat over the base and slide one hand under the lower bat. With your other hand on the upper bat, flip over in one smooth motion. Place the lower bat onto the banding wheel.

Add more coils to bring the top of the pot inwards

6 Build the top edge
Now add more coils to bring the curve of the pot in towards the centre. Once you are happy with the height and shape, use the kidney to smooth over the upper section. Dry slowly, loosely covered in plastic.

Use clay stilts to support the pot while you add more coils (see p.86)

Coiling into a mould

DECORATIVE HANDBUILDING

A plaster mould offers greater support while handbuilding, enabling you to work quicker and on more decorative and challenging shapes. Using a mould also allows you to repeat forms with more accuracy than coiling by hand. You can try this technique with either hand-rolled or extruded coils.

◾ Planning your pot

You can create beautiful effects by incorporating decorative coils into the design of your pot. It can work particularly well to use configurations that can interconnect to form a more intricate design.

Decorative coil ideas

There are many different ways to use coils in a decorative way. Experiment with different patterns and use them to build up the sides of your pot.

Press coils firmly together to help them stay in place

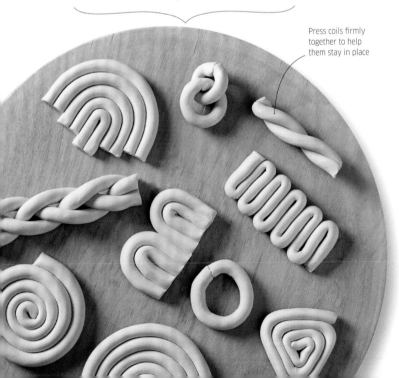

PUTTING IT INTO PRACTICE

This coiled bowl uses the method of making as decoration. Placing the coils vertically across the mould creates an unusual and attractive design, which is highlighted by the white glaze.

1 Fill the foot ring
Push a coil hard into the foot ring mould. Press several times to make sure it has filled the mould fully, then cut off any excess with a plastic kidney and smooth the clay.

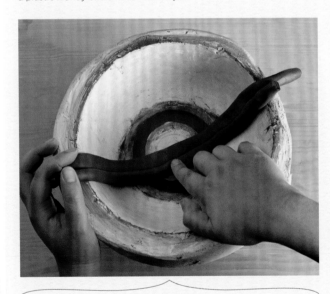

2 Add the coils
Place each coil, pressing it firmly into the mould so that it slightly overlaps the previous coil. Leave any excess clay hanging over the edge of the mould as this helps to keep the coil in place.

You will need

- 500g-1kg (1lb 2oz-2¼lb) clay depending on the size of your coils and mould
- Plaster mould
- Smooth plastic kidney
- Banding wheel
- Sponge
- Lucy tool
- Wooden bat

Coiled bowl

5 Turn out
Place a wooden bat on top of the mould, then gently flip both over and lift the mould. If the bowl doesn't come out easily, it isn't ready: let it dry for a little longer before trying again.

3 Smooth the inside
Use a plastic kidney to smooth the coils in the direction of the overlap, working from the top down. Once the coils are relatively smooth, use the curve of the tool to finish smoothing the inside while turning the banding wheel. Finally, smooth with a damp sponge to get a clean finish.

4 Finish the top
Cut away the excess clay using a lucy tool. Leave the clay in the mould for about 1-2 hours to allow it to dry slightly. When the clay has started to come away from the mould, it is ready to remove.

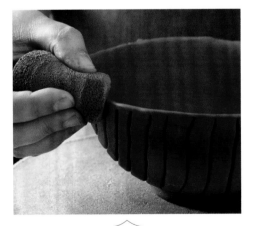

6 Smooth the edges
Use a damp sponge to smooth any rough edges around the top of the bowl, taking care not to smooth out the pattern of the indentations on the main shape, and working in the same direction.

Using coils decoratively

ADDING AN APPENDAGE

Additions can be functional, such as traditional handles or lugs, and they can also make a fun decorative element. Coils provide the perfect way to add some magic and character to a piece with a sculptural quality. It doesn't matter how the main form is made, but ensure both pot and coil are made of the same clay.

◼ Using supports

When you first attach handles or decorative arms to a pot, the joins will be wet, so may slip down with the weight of the clay. It is common practice to support additions or unusual shapes while drying.

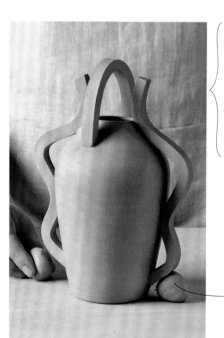

Small balls of clay provide support at the base of the handles

Prevent slippage
As soon as the handles or decorative additions have been placed on the pot, roll a spare piece of clay into a ball and place it beneath the handle to prevent it slipping down.

The "handles" on this narrow vase are decorative rather than functional. Extrude a few lengths of clay and play around with configurations before attaching them.

You will need
- Thrown or coiled vase (leather hard)
- 500g (1lb 2oz) grogged clay, pushed through an extruder to make coils
- Wooden board
- Banding wheel
- Calipers
- Pencil
- Potter's pin
- Joining slip
- Small paintbrush
- Plastic

Sculptural handles

Use calipers to measure and transfer the distances

1 Measure
Measure the distance between the points on the pot where you will attach the coils. Mark the distances on a board with a pencil.

"Coils provide the perfect way to add some **magic and character** to a piece."

2 Shape the coils
Lay the coils on the board, moulding them into shape and using the pencil marks as a guide to get the correct size. Leave them to dry until they are leather hard.

3 Score the joins
Use a potter's pin to cross-hatch the pot at the point where you will attach each coil; creating a rough surface gives the coil something to fix onto.

4 Attach the coils
Position and attach each coil in turn; mark the join, then score and slip. Smooth the joins with a wet brush; a seamless join will prevent cracking. Loosely cover the piece in plastic and dry slowly to avoid shrinking.

Mark the position of each coiled shape with a potter's pin before attaching

Paint a little slip on to strengthen and smooth the join

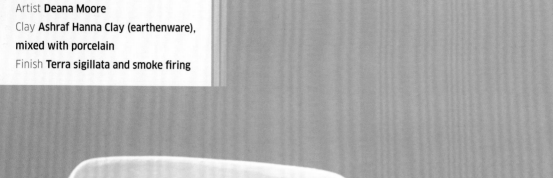

Artist **Deana Moore**
Clay **Ashraf Hanna Clay (earthenware),**
mixed with porcelain
Finish **Terra sigillata and smoke firing**

Combining coils and slabs

<< See pp.62–63

The legs of this pot were made first, by forming slabs into cones. Coils were then added to join the legs together and create the main body.

Pinching coiled pots

<< See pp.50–51

Once all the coils had been joined, this pot was pinched to even out any areas of uneven thickness, and the top edge was trimmed.

Smoke firing

>> See p.236

This decoration was achieved by smoke firing in straw, which burns away leaving carbon deposits on the clay in characteristic patterns.

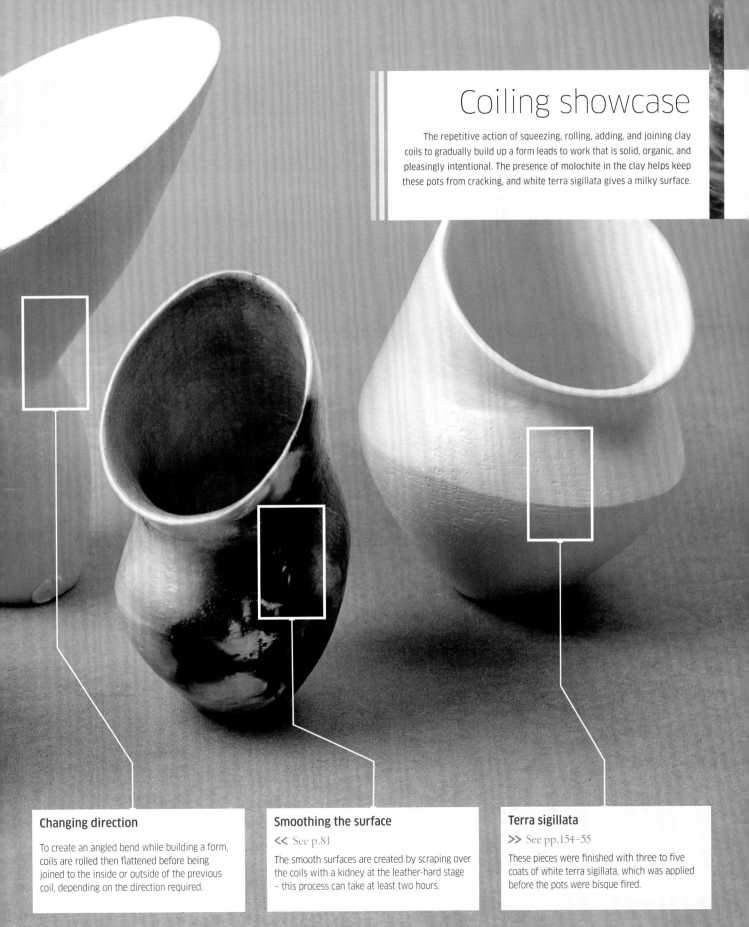

Coiling showcase

The repetitive action of squeezing, rolling, adding, and joining clay coils to gradually build up a form leads to work that is solid, organic, and pleasingly intentional. The presence of molochite in the clay helps keep these pots from cracking, and white terra sigillata gives a milky surface.

Changing direction

To create an angled bend while building a form, coils are rolled then flattened before being joined to the inside or outside of the previous coil, depending on the direction required.

Smoothing the surface

« See p.81

The smooth surfaces are created by scraping over the coils with a kidney at the leather-hard stage – this process can take at least two hours.

Terra sigillata

» See pp.154–55

These pieces were finished with three to five coats of white terra sigillata, which was applied before the pots were bisque fired.

Throwing introduction

FORMING SHAPES ON THE WHEEL

The term "throwing" means to create clay forms on a spinning potter's wheel. Once the basic technique is learnt, and given enough practice, any shape is achievable. As important as mastering the steps is developing a feel for the clay: knowing when it is too soft to continue or if you can make something even larger.

Getting started

It is a good idea to have all of your pottery tools and a towel to hand, having prepared a few pieces of clay. Once you have started to throw a pot, your hands will become wet and being prepared means you can respond to the pot in the moment.

You will start with the very core of making on the wheel by learning how to centre the clay, bringing it into the middle of the wheel. The two most basic shapes are best learnt first – throwing a cylinder and a bowl – which will teach you how to produce pleasing shapes with uniform thickness. Once you have mastered these shapes, continue to practise and build on these skills to refine them and develop your own style.

You can then progress to trimming, the process of removing excess clay to leave a flat base or a foot ring. This skill takes concentration and patience but is ultimately rewarding.

Extending your repertoire

The next stage is to advance to making much larger and flatter work by throwing onto a bat, with instructions for throwing a plate with a rim, and learning to throw in sections so that pieces can be joined together. Key here is careful measuring and mastering the tongue-and-groove technique.

Throwing with precision
>> see p.117
This is the top half of a two-part piece. Once leather hard it is turned over, still on its board, and attached to another thrown pot. You will learn how to accurately measure and ensure a strong join.

"Start with the very core of making on the wheel by learning how to centre the clay."

Throwing in sections
>> see pp.116–19
Larger pieces like this are thrown in two sections. A special tongue-and-groove system is used to join them together.

Thrown pots are often typically finished with an addition, such as a handle on a mug, a spout on a teapot, or a lid on a pot. Follow the instructions given for making lips, spouts, and handles, adapting them to personalize your own pieces.

Finally, throwing off the hump, where you form repeated small shapes from a larger, centred lump of clay, is a great technique to add to your repertoire if you are batch-making pieces, such as teacups, or making a lot of pieces at once. Use these little bowls as test pieces for decorating.

Making handles
>> see pp.120–23
For functional pieces, learn how to make handles and attach them securely to finish your work.

Changing shape
>> see pp.106–07
(far right) Adapting a thrown shape is relatively simple on the wheel using trimming tools.

Throwing principles

GETTING TO GRIPS WITH THE WHEEL

When it comes to learning to throw on the potter's wheel, there are a few tips, tricks, and useful rules that will make the task easier. Having your hands and arms in the correct position, holding tools correctly, and knowing how much water to use will help. Put in a lot of practice and you will be rewarded with the ability to make any number of useful objects.

HAND AND BODY POSITION

It is important to place your arms correctly when sitting down at the wheel. Your arms should remain stationary with your elbows locked, resting on your thighs, and close to your body as much as possible. Your hands should generally stay together, overlapping, interlinking, and supporting each other. This isn't always possible if, for example, you make large-scale work, which may prevent either arm from resting down, and your hands from touching. Holding a tool is also often done with both hands together.

Arm position

Both arms should be an equal distance from your body, resting on your legs. Keeping them close to your body will give you more strength and stability. As you mould the clay, your hands move up and down then out a little, depending on the shape.

Hands together

Your hands always work together on the wheel, with one always supporting the other; they provide stability as the wheel is spinning, and help you keep tools still.

DIRECTION OF THE WHEEL

Depending on which is your dominant hand you can change the direction of the wheel to suit you, but you must also change the way in which you use tools. Right-handed throwers will throw with the wheel spinning anti-clockwise. Imagine the wheel as a clock: once you have opened up to make the base of your piece, you then only work with the clay between 3 and 6 o'clock. In this way, you work with the direction of the wheel while keeping your arms down and close to you.

Wheel direction

If you are right-handed and throwing anti-clockwise, you move tools from the centre of the wheel to 3 o'clock. The same applies when pulling up or pinching the side, and later when trimming a piece.

Left-handed throwing

If you are left-handed and throwing clockwise, you should also change over your hand movements. The placement of your hands should be swapped, tools moved from the centre to 9 o'clock, and sides pulled up with your left hand outside and your right hand inside the pot.

WATER AND SPEED

Two other key factors are the lubrication of the clay and the speed of the wheel. Water is needed so that the clay doesn't create too much friction with your hands. You must also pay attention to the wheel speed, which varies during throwing.

Water or slip

Without enough water on the wheel your hands will pull the clay off. Too much, though, and the clay won't be able to support itself, so your form could collapse. Slip is also used, to minimize the addition of water to the clay.

Speed of the wheel

As a general rule, spin the wheel fastest at the early centring stages and then slower as your pot begins to form. Spin slowest at the end while refining and finishing the shape, but faster again when trimming.

Centring

POSITIONING CLAY FOR THROWING

The key to throwing a uniform and even cylinder, bowl, or plate is to make sure the clay is in the centre of the wheel before you move on to the next stage of throwing: opening up. Although this may sound simple, centring can be a very difficult technique to master and it is often the bugbear of many beginners. As with many elements of pottery, when it comes to centring, practice really does make perfect.

PUTTING IT INTO PRACTICE

Centred clay is the starting point of any thrown pot or vessel, such as this shallow serving dish. When your clay is centred, it will feel still in your hands when the wheel is spinning. A well-centred piece of clay will result in a pot, dish, or bowl that has an even thickness and a level top.

You will need
- 500g–1kg (1lb 2oz–2¼lb) clay
- Potter's wheel
- Bowl of water
- Sponge
- Wooden rib

Thrown bowl

Use cupped hands to form a ball shape

Your right thumb should be crossed over your left

The pressure should only come from the top through your thumbs

1 Make a ball
With cupped hands, pat the clay into a ball shape, removing any sharp edges. Throw the ball of clay fairly hard onto the wheelhead, aiming for the middle. If it's a little off, you can slide it into place.

2 Position your hands
Add some water using a sponge and make sure both hands are wet. Position your hands around the clay so the tips of your left fingers are clasped over the right. Spin the wheel fast, adding more water when the clay dries out.

3 Push down
With your thumbs on top, push down to make sure the clay is well stuck to the wheelhead and you have a firm base to start coning from. Don't push with the side of your palm. This should be a quick movement.

Removing excess clay

Clay can sometimes come loose at the bottom of the cone, making the wheel head uneven. This can force your hands to become unsteady, which will knock your clay off-centre. It is worth taking time to remove the excess clay, and any excess water, which can cause slippage, using a wooden tool to scrape the wheel head clean.

Holding the tool with both hands
Use the short, straight edge of a wooden tool to scrape away any excess clay. Spin the wheel at a medium speed with both hands together and your arms braced on your legs.

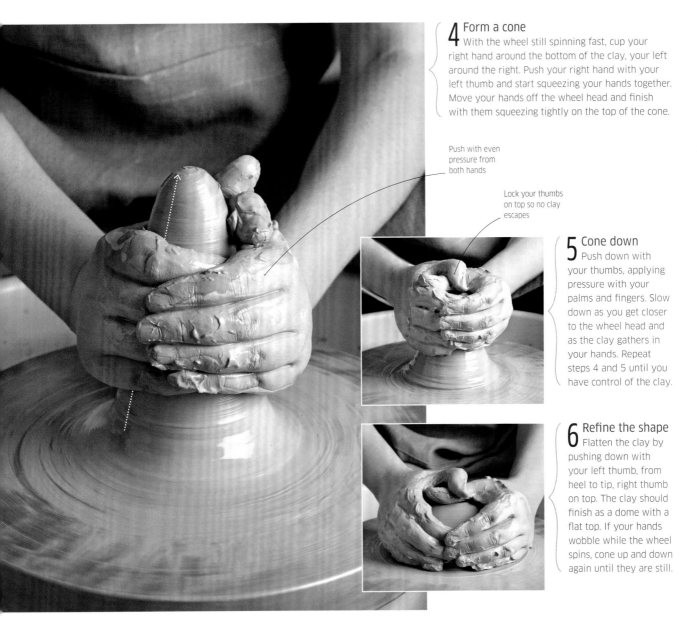

4 Form a cone
With the wheel still spinning fast, cup your right hand around the bottom of the clay, your left around the right. Push your right hand with your left thumb and start squeezing your hands together. Move your hands off the wheel head and finish with them squeezing tightly on the top of the cone.

Push with even pressure from both hands

Lock your thumbs on top so no clay escapes

5 Cone down
Push down with your thumbs, applying pressure with your palms and fingers. Slow down as you get closer to the wheel head and as the clay gathers in your hands. Repeat steps 4 and 5 until you have control of the clay.

6 Refine the shape
Flatten the clay by pushing down with your left thumb, from heel to tip, right thumb on top. The clay should finish as a dome with a flat top. If your hands wobble while the wheel spins, cone up and down again until they are still.

Throwing a cylinder

MAKING A CYLINDRICAL POT

The cylinder is the foundation to learning how to throw on the potter's wheel. Traditionally, a potter would learn how to throw a cylinder by copying an example made with a prescribed weight of clay. Only when they could replicate that shape and size could they move on to the next shape. The key is to work against the force of the wheel to keep the sides straight.

■ Maintaining a narrow shape

A cylinder can easily taper out and become too wide. Collaring in will help bring the shape back in. This must be done before another pull, otherwise it will only exacerbate the problem.

Finger position
To collar in, bend your middle finger and touch it flat against the clay, with the pads of your thumbs and index fingers also touching the clay.

Collaring in
Starting at the bottom of your pot, gently squeeze in, making sure all six points are touching the clay all the way to the top.

This basic cylinder is a crucial pot in any thrower's repertoire. Use a wooden rib to achieve perfectly straight sides and keep practising until you can throw cylinders of a consistent height, width, and thickness.

You will need
- Potter's wheel
- 500g (1lb 2oz) clay
- Wire
- Bowl of water
- Sponge
- Wooden rib

Cylindrical pot

1 Make an opening
Centre your clay (see p.94). Spin the wheel at medium speed, cup the clay with your hands and push your thumbs down to make a shallow hole.

Keep your little fingers flat on the wheel

"The basic straight-sided cylinder is a crucial pot in any thrower's repertoire."

2 Open out
Pull your thumbs out from the hole to open up the clay. Push the tips of your thumbs slightly further to make a bulge on the outside. Aim for a flat base.

3 Compress the base
With a damp sponge in your right hand, supported with your left, apply pressure to the clay from the middle out to the right. Stop at the wall. Repeat back to the centre.

4 Tilt the shape inwards
Grabbing the clay with two cupped hands, spin the wheel at a medium speed and push the clay in on itself. Apply more pressure on the top to create a hollow mountain shape.

Press in harder at the top of the pot

>>

Your index and
middle fingers are
opposite your thumb
on the inside

5 First pull
Slow the speed of the wheel. Place
your left thumb on the outside of the
bottom of the pot, and your left index
and middle fingers inside.

6 Move up
Cup your right hand around your left, and
gently rest your little finger on the rim. Start
pinching and, with the same pressure, move
your left hand from the bottom up, with a
little pressure on the top edge from your
little finger on your right hand. Apply more
pressure with your thumb to keep the shape
tilted in as you move up the sides.

Link your hands by anchoring your left thumb on top of your right hand

7 Second and third pulls

The second and third pulls give your cylinder more height. Place the side of the knuckle of your right index finger at the bottom of the pot, around the 4 o'clock position. Place the pads of your left index and middle fingers opposite, on the inside. Pinch and pull up again, leaning in a little more with your right hand to keep the shape tilted inwards.

8 Straighten

Use the wooden tool to remove any excess clay from the base (see p.95). Then use the straight side of the tool in place of your right hand and butt it up against the pot. Place the middle finger of your left hand inside, at the bottom of the pot, directly opposite the tool and your left thumb on top of the tool. Then, with the wheel spinning, move your left middle finger to the top of the pot, pushing the clay against the tool.

9 Wire off

Remove any excess clay from the inside of the pot with a sponge and add a little water to the wheelhead. With the wheel spinning as slowly as possible, hold the wire straight on the wheelhead and pull it towards you to cut the cylinder away. Touching the cylinder at the base, gently slide and lift it off the wheel, supporting it from underneath.

Throwing a bowl

MAKING A BOWL ON THE POTTER'S WHEEL

Once perfected, the humble bowl is a thing of great beauty; everyone has a favourite breakfast or soup bowl that is just the right size. When throwing a bowl, focus on mastering the inside curve: it should be a continuous, uninterrupted line flowing from one top edge to the opposite side.

▆ Keep the base wide

Practise throwing your bowls with a relatively wide, strong base as this will help keep your bowl firmly on the wheel. This extra clay may mean that your bowl doesn't look like a bowl on the wheel, but don't worry: the most important thing is to make sure it has a clear, defined curve in the base of the bowl. The extra clay on the outside can be trimmed off later.

A wide base
When the clay is still wet and being worked on the wheel, a wide, strong base gives you the stability to create a wide, open bowl.

After trimming
While removing excess clay from the base of the bowl, aim to replicate the curve on the inside onto the outside.

PUTTING IT INTO PRACTICE

This simple bowl is made on the potter's wheel, using two pulls to form a pot, and a final pull for shaping. Its relatively small size makes it a good practice shape and excellent for functional purposes.

You will need
- 500g (1lb 2oz) clay
- Potter's wheel
- Bowl of water
- Potter's pin
- Sponge
- Wooden rib
- Wire

Functional bowl

1 Make an opening
Centre your clay (see pp.94–95). With the wheel spinning at a medium speed, cup your hands around the clay with your little fingers flat on the wheel and thumbs on top. Push down with your thumbs to make a shallow hole.

The hole shouldn't be too deep. Test the thickness of the base with a potter's pin when the wheel is stationary

2 Open out
Keeping your hands in place, pull your thumbs out from the hole to open up the clay, lifting them up and out to create a bowl shape. Don't pull the pot further out than the base.

Cup the clay gently, with your little fingers touching the wheelhead

3 Compress the base
With a sponge in your right hand, apply pressure to the centre of the clay, moving out towards the right and all the way up the sides to create a slightly curved wall. Do the same back to the centre.

Make sure your sponge is damp so it moves over the clay smoothly and doesn't dry it out

4 First pull
With your left hand directly in front, place your thumb on the outside at the base, and your index and middle fingers opposite, inside. Cup your right hand around your left, with your little finger on the top. With the wheel spinning at a medium speed, start pinching while moving your left hand slowly from the bottom to the top.

Maintain the same amount of pressure as you pull the sides up

Apply pressure gently on the top edge with your little finger

"Once perfected, the humble bowl is a thing of beauty."

>>

"Its relatively small size makes this bowl
a good practice shape and excellent
for functional purposes."

5 Second pull

The second pull helps your pot gain more height. Place the side of the knuckle of your right index finger at the bottom of the pot, around 4 o'clock position. Place the pads of your left index and middle fingers opposite, inside. Link your hands by anchoring your left thumb on your right hand. Then, pull up from the bottom, without pausing.

6 Shaping pull

With this pull, you guide your straight-sided, tall pot into a curved bowl shape. Place your hands as in step 5. Pulling again from the bottom up, apply a little more pressure outwards from your left hand to pull the pot out into a bowl shape.

The bowl should be thinner at the top and thicker at the bottom to keep the shape stable

7 Wire off

Remove any excess water from the inside of the bowl, using a sponge, then add a little water to the wheelhead. With the wheel spinning as slowly as possible, hold the wire straight on the wheelhead and pull it towards you to cut the bowl away. Touching the bowl at the base, gently slide and lift it off the wheel onto a wooden board.

When moving the bowl, keep it supported from underneath

Using a bat

MAKING LARGE OR FLAT PIECES

Working on a bat (see p.17) rather than straight onto the wheel allows you to create large pieces and those with wide bases. If your clay is soft or you want to throw very thin pieces, you may find it easier to throw everything on a bat. Production potters may use a studded wheelhead, where a bat with a hole is secured to a wheel, but the method shown here is suitable for most beginners.

PUTTING IT INTO PRACTICE

Here, a terracotta clay has been used but any type of clay is suitable. It is better if you use the same colour or type of clay that you will be using for your finished pot to avoid contamination.

You will need
- Potter's wheel
- 500g (1lb 2oz) clay
- Bowl of water
- Sponge
- Wooden bat

1 Flatten the clay
Centre your clay on the wheel. With your hands keeping hold of the sides of the clay, place your left thumb straight diagonally across the centre, and rest your right thumb on top of it to form a cross. Push down with your thumbs to begin flattening the clay.

2 Widen shape
Use the heel of your right hand to push out and across the clay, from the centre to the 2 o'clock point, to make it wider. As you do this, gently apply pressure with the palm of your left hand against the side of the clay.

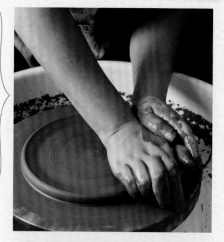

3 Level out
To smooth the surface and level the clay, place your left hand as before, make your right hand into a fist, and drive the bottom of your hand from the centre out to the left side.

The circle of clay may become larger as you work it

▦ Levelling out

The bat should be perfectly level; you can test whether it is even by resting one finger near the edge and spinning the wheel very slowly while holding your hands still. You will be able to feel if the bat is not evenly placed all the way around, as it may only touch your finger at one point. Any unlevelled parts are easily corrected by a quick tap with a fist.

Spin the wheel

Rest your arms on your legs. Hold a finger lightly on top of the bat, supported with your other hand. Slowly spin the wheel.

Adjust levels

Identify which section is higher and give it a tap with the base of your fist. Spin and check again, repeating until corrected.

"Working on a bat allows you to **create large pieces** and those with **a wide base.**"

4 Form rings
Supporting your right hand with your left, use the tip of your right middle finger to push into the clay and form rings. Start near the centre of the clay, and work your way out, keeping the circles evenly spaced.

5 Attach the bat
Hold the bat on opposite sides, place over the clay, and push down evenly. Spin the wheel 90 degrees and push the other sides down. The air in the rings creates suction to hold the bat.

Changing shape

ALTERING A THROWN FORM

The potter's wheel is a great way to start a diverse range of forms. Clay is naturally softened through the process of throwing, making it very malleable. This lends it to further manipulation once the wheel has stopped spinning, using your hands or throwing tools to mould, adjust, sculpt, and refine a thrown form into a new shape. Even the most unusual of sculptural pieces may have started as a simple vessel.

PUTTING IT INTO PRACTICE

A humble cylinder is transformed into a sculptural, twisted vase using different tools to smooth and flatten the sides with fluid strokes. The carved feet elevate the shape further.

You will need

- Thrown cylindrical pot with smooth sides and 2cm (¾in) thick base
- Potter's pin
- Wooden throwing rib
- Double-ended loop tool
- Surform
- Smooth metal kidney

Sculpted vase

> "Clay is softened through the process of throwing, which lends it to further manipulation once the wheel has stopped."

1 Mark out a square
Start with a tall cylindrical pot. Use a potter's pin to mark four evenly spaced points around the outer rim and four corresponding points on the outer base.

2 Draw diagonal lines
Put your middle finger inside at one of the lower points and draw it up in one movement towards the next point along at the top. Repeat to make three more diagonal lines.

3 Flatten the outside
Use a wooden rib to flatten the sides while the clay is still malleable. Make smooth strokes up the centre of each side to square off the pot. Work round until the top is square.

Shaping with a scalpel

Another way of changing the shape of a thrown form is by simply cutting off sections of clay with a scalpel. You can reshape leather-hard plates and other pieces easily with this method. The scalpel will create sharp edges at the sides, and any other areas, such as the corners, can be tidied up afterwards with a surform.

Altering once leather hard

Put the piece on a cutting mat or sheet of graph paper. Mark where you want the cuts to start and end before you start slicing – then cut straight through the clay with your scalpel, holding the piece in place with your other hand to keep it steady.

4 Mark the feet

Once the piece is leather hard, turn it over and draw out guidelines for yourself on the base using a potter's pin. To create four feet at the corners, mark out a large square and section off smaller squares at each corner.

5 Carve the feet

With a loop tool, remove clay from the sides of the base. Twist and scoop out a circle in the centre then remove the sections between the corner squares. Take care not to carve through the base.

6 Use a surform to finish

Finally, use a surform to further shape the sides. Pull the surform across the surface of the clay towards you to even out the sides, making them square at the base, as well as at the top.

Go over the sides with a kidney afterwards to make them perfectly smooth

Throwing a plate

CREATING A FLAT FORM

In principle, a plate appears easy to create, with little pulling up and a simple shape. However, keeping the clay level and even, compressing the base, while all the while getting used to new positions for your hands, can prove a challenge. Once mastered, plates provide a wonderful canvas for potters to express themselves.

■ Thickness of base

You can test the thickness of your plate's base using a potter's pin before compressing, which will remove the hole. Always throw thicker than you need, to allow for some clay to be left on the bat. A thicker base will also mean you can trim a foot ring once leather hard.

Testing with a potter's pin
Push the pin through the plate and onto the wooden bat (shown here in cross-section, for clarity), then slide your finger down the pin until you reach the plate surface. Pull out the pin with your finger in place. The gap from finger tip to pin tip is the thickness of your pot.

PUTTING IT INTO PRACTICE

The refined rim of this porcelain plate is achieved by using a throwing rib to define the shape. This classic shape with a rim is deceptively tricky to throw but leaving enough clay at the edge helps to form the rim.

1 Push the clay down
With the clay on a bat, follow the technique for Using a bat (see p.104). As the clay widens, keep the length of your left thumb as flat as possible; push until your hands separate.

2 Push out wider
With the heel of your right hand, supported by your left, push out from the centre to the edge of the clay, creating the basic plate shape. Leave the ridge that forms around the edge.

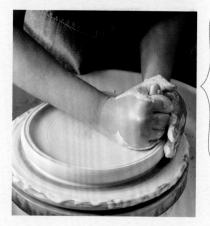

3 Level out
Level out the plate by moving the base of your right fist across from the centre to the left side, using the knuckle of your little finger to create a slight indent at the plate's rim.

Compress the base gently, moving smoothly out from the centre to the side

You will need

- 1½kg (3lb 5oz) clay
- Wooden bat
- Potter's wheel
- Bowl of water
- Sponge
- Wooden throwing rib
- Wire

Rimmed plate

4 Compress the base

Use a sponge to compress the base. This is an important step – if you skip it, or if it isn't done correctly, your plate will crack. Start in the centre and move the sponge smoothly out towards 3 o'clock. Repeat with the flat edge of the rib.

Push the edge of the rib across and into the rim to define it

>>

"Rather than **flattening** the natural **ridge** at the edge of the plate, use it to form the **raised rim**."

5 First pull
Add a small amount of water to the rim, then gently pinch it upwards with the thumb and fingers of your left hand, letting go when you get to the top. Your right hand should rest over your left, with the little finger gently applying pressure on the top edge of the rim, to keep it straight.

For the first pull lift the rim around 2cm (¾in), pulling up relatively straight

6 Second pull
Put a little more water on the rim for the second pull. This time, pinch with the pads of the two first fingers on your left hand inside the rim, and the side of your right index finger outside. Move both hands together and up to pull up the rim.

Let go gently from the sides, rather than lifting your hands from the top

7 Push the rim down
At one side of the plate, hold the sponge against the outside of the rim and the flat edge of the wooden throwing rib against the inside. Gently apply pressure with the throwing rib, moving the sponge down simultaneously to support the clay, until the rim of the plate is almost level.

Push the rim down a little further than you would like – as the clay dries it will shrink up

8 Wire off
Remove the plate and bat together. Hold the wire at the far side of the plate's base and pull it slowly towards you. This will separate the plate from the bat, but leave the plate in place; when it's half-dry, you can lift it off completely. Now wire off the bat from the attaching clay. Leave this clay on the wheel – you can reuse it to attach another bat.

Pull the wire up against the base of the bat and draw it across to remove it from the wheel

Trimming

FINISHING A THROWN SHAPE

Once a thrown piece has dried to soft or leather-hard clay, you can trim the excess clay at the bottom and carve the foot ring. These finishing touches will refine your piece, and require as much care and attention as forming the main vessel. For best results, ensure the thickness of the wall and base are the same, and that the foot ring is wide enough to stabilize the shape.

■ Helpful aids to trimming

When trimming you need to ensure that the cuts are smooth and even, so that you retain the same thickness all round. Keep a steady hand and support the tool as you work to avoid it skipping and creating indents.

Holding the tool
To carve out the base, hold the trimming tool with your index finger on top of the loop to support it, resting your hand on the base of the pot for stability. Keep the tool steady to create a continuous, smooth cut.

Using supports
If your pot is too small or delicate to be placed upside-down on the wheel, you can make a support to hold it while trimming. Supports can be made specifically for individual pots; simply shape a piece of clay, ensuring the surface is smooth.

PUTTING IT INTO PRACTICE

Trimming the base and creating a foot ring take some practice, but bear in mind that it is the speed at which the pot turns that helps you carve, not the pressure of the tool.

You will need
- Leather-hard pot to be trimmed
- Potter's wheel
- Extra clay for supports
- Loop tool or trimming tool

Balanced bowl

1 Position and secure
Place your pot upside-down on the wheel, as centrally as you can, and spin the wheel slowly. Hold your right hand still to feel the pot as it spins, moving the pot where necessary. The pot is centred when it touches your finger for a full rotation.

Add soft clay supports around the edge to keep the pot centred

"Ensure the thickness of **the wall and the base are the same, and** that the foot ring **is wide enough to** stabilize the shape."

2 Mark the base
Use the edge of a loop tool to mark a circular line where the edges of the base of the pot will be. Then mark another circle inside the first, for the inner edge of the foot ring.

3 Carve the outside
Steady the pot, with the tool in contact with the clay. Turn, working up to the edge of the foot. Use the corner of the tool for thin areas, and the flat side for wider sections.

4 Carve the foot ring
Start with the tool in the centre of the foot ring and move it across the clay to 3 o'clock on the inside edge. Support the tool with the index finger of your left hand as you go. Keep the tool flat so that the base is even.

5 Check the profile
When you have finished carving the foot ring, check that the base of the pot is balanced and symmetrical, with an even thickness all round. Adjust as necessary.

Throwing a lid

CREATING A WELL-FITTING COVER FOR YOUR POT

A pot and its lid will both shrink as they dry, so when throwing the pot, measure the diameter of the rim as soon as you have thrown it, while it is still wet. A little ledge, the "gallery", lets the pot and lid fit snugly together, and is either made as part of the lid or part of the pot. Make the lid slightly wider than necessary so that it can be trimmed to fit when leather hard.

PUTTING IT INTO PRACTICE

There is something very satisfying about a ceramic lid that fits well, and a pot and its lid always look best when they match each other. Here, a domed lid complements the simplicity of the plain cylindrical pot.

You will need

- One cylinder previously made, about 8cm (3¼in) in diameter
- 160g (6oz) clay (for 400g/14oz pot), plus extra for securing and optional knob
- Potter's wheel
- Calipers
- Wooden rib with a right angle
- Wire
- Sharp trimming tool

Pot with domed lid

"There is something very satisfying about a ceramic lid that fits well."

1 Throw the lid
Centre the clay on the wheel and flatten it to make a disc, using the side of your other hand to steady the edge.

2 Measure
Use calipers to measure the disc, taking the internal not external diameter. It should be 10 per cent smaller than the final measurement, since it will widen when you make the gallery.

3 Form the gallery
With your left index and middle fingers in the centre, pull out and push down on the outside of the rim to form the gallery. Keep the rim flat with your right little finger on top.

Adding a knob

Any knob must be securely attached to the lid to prevent cracking. When the lid is leather hard, you can add a knob by attaching a small cylinder of clay and throwing it into the shape you want with your fingers; give it a simple, cylindrical shape or flatten the top. When attaching wet clay to a leather-hard or half-dry shape, always "score and slip".

Scoring the clay
Centre the lid on the wheel and hold it in place. Score an area to match the size of the knob and add a little water or slip.

Throwing the knob
Press the rough shape for the knob down on the scored area and wet the knob. Spin the wheel and use your fingertips to shape it.

4 Make the outside edge
Use the corner of a rib to press the outside rim downwards, holding the rib angled towards you slightly so as not to dig into the clay. Slope the gallery inwards slightly so that it will fit easily into the pot.

5 Shape
Pinch with your middle finger and the rib, until the gallery is about 1cm (½in) tall and the outer diameter is slightly greater than the inner diameter of the pot. Wire off.

6 Trim the top
When leather hard, centre the lid and hold in place with clay. Trim the outer edge then smooth from the centre out to 3 o'clock. Trim and smooth the top.

Support the pot in the centre of the wheel with four small pieces of clay pressed into place

7 Trim gallery
Place the lid upside-down in the top and centre it. Trim the gallery with a trimming tool, holding the lid steady with your middle finger. Regularly check the fit; take care not to remove too much. Add a knob, if desired (see above).

Throwing in sections

CREATING A LARGE FORM IN TWO PARTS

To make a large form, instead of battling with a heavy lump of clay, you can make two smaller forms and fit them together. The result is a lighter, thinner shape that dries faster. The bottom part uses more clay, which acts as a support when they are joined. Any vase-like shape can be made using this technique; traditionally, it is used to make the famous Korean "moon jar".

■ Use tongue and groove to join

Adding a tongue in the top and groove on the bottom pieces will ensure a good fit. To check the pieces match, measure the diameter from the middle of the groove and the middle of the tongue. Before joining, let the pieces dry so they are still malleable enough to reshape.

Making a groove

On the bottom form, use the corner of a wooden rib to mark a slight channel in the centre of the rim, all the way around the top, supporting the inner edge.

Making a tongue

On the top form, make a tongue by rolling the edge of one finger over the rim while pinching it together with the fingers of your other hand.

There's no limit to the size of pot you can make if you throw it in sections. However, start small as for this heart-shaped vase, in order to get used to securely joining two round forms precisely.

1 Make a large bowl for the base

Throw the larger amount of clay for the base and give it a flat bottom inside. On the final pull, check that the sides at the very top of the rim are vertical and the rim is perfectly flat, to make it easier to join the two pieces later.

2 Add the groove

Make a shallow groove in the centre of the rim all the way round (see left). Measure the diameter of the base between the bottom of the groove on each side. Wire off the bat with the bowl on it.

You will need

- 5kg (10lb) clay in two pieces: 3kg (6½lb) and 2kg (4½lb)
- Potter's wheel
- Tape measure
- Two wooden bats
- Wooden or plastic rib with a straight edge
- Serrated metal rib or sharp knife
- Small paintbrush
- Water
- Wire

Heart-shaped vase

3 Make the top
On another bat, throw the top section with the smaller lump of clay, but when opening it out, push all the way down to the bat so that it has a hole in the base. This will form the opening in the joined pot. Finish the sides and rim as for step 1, but don't make the piece too tall or thin. Measure the width as you go.

The opening should be wide enough for a hand to go through

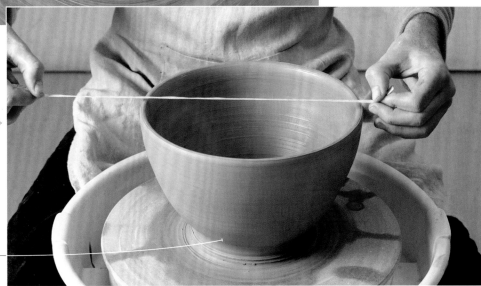

4 Measure the diameter
Form a tongue around the rim of the top (see left). Measure from ridge to ridge on the rim of the top to ensure that it matches the base, measuring in two directions at right angles to avoid an oval shape.

Do not trim: leave as much clay as possible on the bat to support the pot when flipping it later

5 Score the rims
Dry the pots for a few hours; they should still be malleable. Use a serrated rib to score the tongue and groove, rolling it on the tongue and pushing the corner into the groove.

6 Add slip or water
Use a small paintbrush to brush a little water or slip onto the scored rims to help them bind together. Place the first pot back on the wheel.

"There's no limit to the size of pot you can make if you throw it in sections."

7 Flip the top over
In one quick but controlled movement, flip over the bat holding the top piece so that it is upside-down. Lower it carefully into the groove, making sure the pieces are aligned all round.

8 Wire off the top bat
Use a wire to cut off the bat where it is attached to the inverted pot. Keep the wire close to the surface of the bat as you pull it towards you.

Brace the edge of the bat against your chest to steady it

9 Seal the join
Use a wooden throwing rib to smooth over the join and seal the two halves together. Insert one hand inside the pot to support the clay as you push the rib over the surface while turning the wheel (you could also hold a rubber kidney against the inside of the pot to support the clay).

Hold the rib in one position while you turn the wheel

10 Form the neck
Trim excess clay on the neck edge then wet the top and inside. Pull up using your thumb and index finger, supporting the side of the neck with your other hand. When the neck gets taller, use your thumb and middle finger to squeeze it in and up until it is the desired shape. Trim the neck and smooth the top when leather hard.

Apply water with a sponge to the top and inside edge to soften the clay

Pull up the sides to form an elegant neck to finish

Making handles

PULLING AND ATTACHING HANDLES

There are a number of different ways of creating handles from clay; "pulling" handles in your hands and using a sponge to shape a handle on a flat surface are two common methods. A good handle should be smooth, evenly shaped, and, most importantly, securely attached.

■ Pulling a handle for a mug

When making handles it is important to consider the usability of the finished piece. A handle for a mug should have enough space for fingers to fit inside it, and should be positioned high enough to allow the mug to be held easily when full – though keep the top of the handle below or level with the rim, so the mug can be placed upside-down to dry after being washed up.

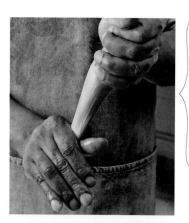

Pull a handle
Roll clay into a cone shape and dip into water. Pull your hand down the clay repeatedly, keeping your hand wet, until the shape extends and tapers. Stick one end to the edge of a board and leave the handle, hanging down, to dry slightly.

Attach to a mug
Cut the handle to size, and score and slip the ends, as well as two points on one side of the mug. Attach the top of the handle first, then the bottom, smoothing both joins. Leave mugs upside-down to dry so the handle doesn't droop.

PUTTING IT INTO PRACTICE

This casserole has handles at the sides as well as on the lid. Keep in mind that handles on a pot intended for use in cooking should be large enough to hold onto with oven gloves on.

You will need
- Leather-hard pot with lid
- 900g (2lb) of the same clay
- Wooden board
- Sponge
- Banding wheel
- Wooden slat or ruler
- Knife or potter's pin
- Joining slip
- Paintbrush

Lidded casserole

1 Roll out a coil
Start with a soft ball of clay, and roll it into a coil (see p.78). You will cut all three handles from this coil, so make it a little longer than you think you'll need, so that there is enough clay for all of them.

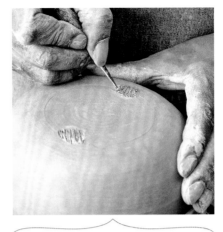

2 Shape the coil with a sponge
Lay the coil on a board. Hold a wet sponge between your fingers and use it to pinch the coil at one end, then swiftly run along the coil. Repeat this action to create a smooth ridge.

3 Mark the top of the lid
With your pot on a banding wheel, hold a knife where you want the edge of the handle to go, then spin the wheel to mark a circle over the centre of the lid. Mark either side.

4 Score and slip the lid
Cross-hatch and apply slip to the areas where the handle will stick. It is worth repeating this step several times to make absolutely sure the handle will not detach.

Blend the joins with a sponge – you can also use a paintbrush dipped in water for narrower areas

5 Put the handle in place
Cut off one-third of the shaped coil and carefully bend it into a semicircle. Press the ends into place on the cross-hatched areas of the lid, and smooth them down with your fingers, neatening the join with a sponge.

>>

"**Handles** on a cooking pot should be large enough to hold onto with **oven gloves on.**"

6 Mark positions for the side handles
Remove the lid to mark out the positions for the side handles. Decide where you want the handles to sit, then poke the clay slightly with a knife and spin the banding wheel to mark out a line all the way round the pot. Then use the wooden slat or ruler again to mark the centre point of each handle.

7 Score and slip the sides

As in step 4, score and slip the areas where the handles will attach to the pot. You can also make side handles that work like ridges, attached to the pot fully along one edge rather than at either end.

Make sure the scored areas are equidistant from the centre line

8 Attach the handles

Trim the two side handles to length from the remaining coil. Stick one handle into place over the scored areas on the side of the pot.

Be careful not to push too hard, or the handle could come off

9 Smooth the join

Once again, use your fingers and then a sponge to smooth the joins. Attach the other side handle. Then leave the pot to dry before bisque firing to 1000°C (1832°F); remember to fire the lid and pot together so that they shrink evenly.

Create a smooth transition from handle to pot

Making spouts

THROWING AND ATTACHING SPOUTS

There are a few things to take into consideration when throwing spouts. Aim to make a spout as thin as you can at the top, with a perfectly smooth surface. The size of the hole is important – do not make it too small, or you will get a bottleneck effect when pouring. Also, consider the water level when designing your spout: when you pour, liquid needs to come out of the spout before it comes out of the top of the pot.

▣ Avoiding drips

To avoid having a spout or lip that is prone to dripping when used, try to make the tip as sharp as possible. You can cut off the end of the spout when it is at the leather-hard stage to create a sharp edge, or sculpt the tip with your fingers. Keep testing out different spout shapes to perfect the one that works best.

Sculpt the tip
If the clay is soft enough, carry on sculpting the tip of the spout or lip until it comes to a sharp point; you can dip it into water to aid shaping as you work.

Use your fingers to push the round end of the spout together to form a pouring tip

PUTTING IT INTO PRACTICE

The spout on this coffee pot is angled almost at 90 degrees, making it easy to pour from. Make the spout longer than you think you'll need – it can easily be trimmed down to size.

You will need
- 300–450g (10½oz–1lb) clay
- Leather-hard pot
- Potter's wheel
- Wooden throwing rib
- Smooth metal kidney
- Potter's pin or other thin pointed tool
- Wire
- Corer
- Paintbrush
- Joining slip

Coffee pot

1 Form a small cylinder
Centre a small ball of clay, then make a hole in the centre using your thumb, and form a small cylinder. Either go all the way through, or stop short and trim the base later.

2 Stretch and shape
Make the cylinder taller and thinner, then collar it in by pushing gently on the sides with your thumb and index finger. Shape with the rounded edge of a rib.

3 Cut to shape
Wire off and leave the spout to dry until leather hard. Trim the base on a diagonal, so the spout will point upwards, and cut a curve to the side that will sit against the pot.

4 Finish the hole
Use a corer to make a hole at the base of the spout, if the base is still closed over, joining up with the hole you created on the wheel. Smooth the base with a metal kidney.

5 Mark attachment position
To mark where the hole will need to go on the pot, hold the spout in place and poke a pin or thin tool down it. Mark the centre of the hole on the side of the pot.

6 Cut a hole in the pot
Position the corer over the mark you just made and pierce the pot. The hole should line up exactly with the hole in the spout, when joined together.

Cross-hatch around the hole on the pot, as well as the area of the spout that will sit against it

7 Attach the spout
Score the side of the pot and base of the spout, and apply slip to both before pressing the spout into place. Blend the edge as desired with a brush or your fingers, and some slip. Make sure to fill in any gaps around the spout. You can reinforce the join with a coil of clay.

Making lips

CREATING A LIP ON A THROWN FORM

The addition of a lip transforms a simple pot into an elegant jug. Making lips is a quick process, but also one that takes practice. The action of your index finger pulling the clay out, down the throat of the jug, creates the final shape of the lip. Be careful to avoid breaking the lip, or causing it to become too thin, when sculpting it.

Creating decorative rims

The same basic technique shown here can also be used to create highly decorative forms. Wider lips can be shaped using your whole hand or even two hands, and the same action can be carried out in the opposite direction to create more complex designs.

Wavy vase
This fluid shape was created by dividing the rim into three sections, then pulling them out with the lip-making action, but on a larger scale. Two smaller sections of clay were then pushed between each of the larger curves.

PUTTING IT INTO PRACTICE

While still on the wheel, a large, sinuous lip is shaped into the rim of this rounded pot to turn it into a jug. The handle is pulled and attached once the jug has reached the leather-hard stage (see p.120).

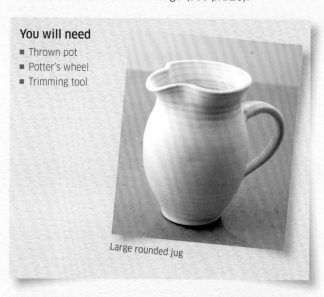

You will need
- Thrown pot
- Potter's wheel
- Trimming tool

Large rounded jug

1 Throw the form
For a rounded jug, throw the main form as usual on the wheel. When you are happy with the shape, trim excess clay from the base, then wash and dry your hands, getting rid of any clay on them.

2 Create the lip
Place your left thumb and index finger against the rim, either side of where the lip will be, and your right index finger between them, against the inside of the pot. Draw your left thumb and finger together, while tilting back your other index finger.

Pull in the sides of the lip at the same time as you draw out the curve

"The action of your **index finger pulling the clay out**, down the **throat** of the jug, creates the final **shape of the lip**."

Hold the side of your finger against the clay

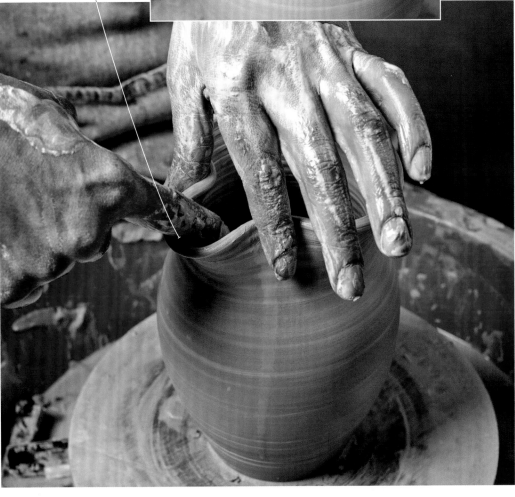

3 Shape the lip
Wiggle your right index finger from side to side to shape the lip. You want to stretch the clay, rather than pull it – this is important to avoid forming a lip that droops (see also Avoiding drips, p.124). When you are happy with the shape, wire off the jug and leave to dry before firing.

Throwing off the hump

PRODUCING SMALL PIECES IN QUICK SUCCESSION

If you have a series of small vessels to produce, throwing off the hump can be the solution. You start from a large lump of clay, but only centre the amount of clay at the top that you need. You can then continue to throw pieces from the remaining hump. This is also a great exercise in speed throwing; free yourself from over-thinking and let your fingers produce each pot in seconds.

PUTTING IT INTO PRACTICE

There is no rule about the shapes you produce off the hump, but tea bowls, beakers, and small vases are particularly suited to this technique. You can also throw various lid shapes quickly this way.

You will need

- Large lump of well-wedged clay, about 4kg (8½lb)
- Throwing tools
- Length of thin fishing line or strong thread (not wire), knotted at one end to a toggle or curtain ring

Tea bowl

2 Make an indent
Once you've centred the small hump, make a visible indent with your nail or the corner of a throwing rib at the base of the hump to indicate where you will wire off the piece.

Hold the rib in place, supported by your other hand

3 Throw the piece
Throw your piece as usual. As there is no hard surface at the base to press against, you will need to compress the base more gently than against a wheel.

Don't bring the inner base of your piece lower than the indent

1 Form the "hump"
Slam a large lump of clay onto the wheel head as centrally as possible by eye; don't worry if it is slightly off centre. With the wheel spinning, centre only the amount of clay you need for your vessel.

Making a series

Throwing off the hump is a very time-efficient method, especially if you are producing a run of similar pieces, all from the same clay. You only need to centre a small amount of clay and don't have to clean the wheel head between vessels, leaving more time for throwing.

Vary the designs
Each vessel or piece thrown off the hump can be a different design and size, allowing you to experiment with small pieces and develop your ideas fluidly across a series.

"This is a **great exercise in** speed throwing; **free yourself** from overthinking and **let your fingers** produce each pot in seconds."

Wiring off the hump requires a thread or a length of fishing line with only one toggle

4 Position the thread
When the piece is finished, dry your hands. Stop the wheel and position the wire around the base of the pot in the indent, holding the toggle all the time. With the wheel turning slowly, and in one quick movement with steady hands, pull the toggle towards you to remove the finished piece. This will feel easier with a bit of practice.

5 Lift the piece
As soon as the thread has gone through the clay, drop the thread and, using both hands, quickly lift your piece onto a board so that it doesn't stick back to the lump of clay.

Artist **Norman Yap**
Clay **Stoneware**
Finish **Matt feldspathic glaze,
reduction fired**

Finessing the shape
« See p.96

To make a thin neck, collar in the form once tall enough with a pincer-like motion. Keep long necks supported, if they start to flop.

Wider shapes

Start with a flat, wide base, then carefully raise the walls, paying attention to the strength of the rim; this is the part that gives the vessel its integrity and strength.

Adding colour to clay
>> See p.163

An oxide or stain can be added to clay, which should be wedged repeatedly until the colour has been blended in, before being thrown.

Throwing showcase

Throwing is probably the first thing most people picture when they think about pottery. This core technique can be used to create an infinite range of shapes. These pieces are thrown, left to dry until leather hard, then turned on the wheel, before being glazed and reduction fired in a gas kiln.

Creating balanced forms

As long as you have centred your clay correctly, pieces thrown on the wheel will be symmetrical. Follow what appeals to your eye when creating the shape.

Making taller forms

« See pp.96–99

Using dryer clay, and lubricating it with slip rather than water, often makes throwing tall forms easier; they may collapse if too wet.

Extending the base

This bowl was thrown with a thick base, then put upside-down on the wheel so the extra clay could be thrown into a long foot, as though it were another differently shaped bowl.

Decorating

techniques

Decorating **techniques**

The ways in which you can treat the surface of clay are many and varied, and decoration is a key part of any clay artist's repertoire. Either use the material itself or carving techniques to create texture, or apply colour to decorate pieces in whatever style you choose. With the right tools you can alter the surface of clay in diverse ways, creating facets of texture, or removing clay to mark patterns that can be filled with glaze or slip.

On the following pages you will learn techniques to alter clay at different stages, mixing colour into the clay itself or adding a colourant to a liquid clay mixture, called decorating slip. It is a versatile medium, capable of adding texture as well as colour.

Texture
■ See pp.136–57

Through a variety of carving techniques you will discover how to bring a different dimension and depth to the surface of your work, by removing or building up clay to create shapes and patterns, and experimenting with rough and smooth textures.

Sgrafitto (see pp.140–41)

Inlaying (see pp.144–45)

Through carving, sgraffito, and impressing you will learn how to add textured decoration by altering the surface of the clay in relatively easy processes. Inlaying, where the introduction of colour is combined with carving, is slightly trickier. With sprigging, the texture is built up using a plaster mould to create additions of clay. Kurinuki is the stand-out technique here, taking carving to the extreme to form a pot from a lump of clay. Smooth surface textures are achieved with burnishing, a relatively simple technique, and terra sigillata, which is more complex; both create amazingly tactile finishes.

Adding colour

The benefit of using decorating slip to finish your pots is that your design won't move or melt in the kiln. Decorating slip is liquid coloured clay and lends itself to a relatively thick application. It is very versatile, suited to painting and printing. Potters often apply slip using a slip trailer, drawing with it in a similar way to a pen or brush. Decorating slip can also be moved and blended with tools such as combs, for patterned and gestural effects. Feathering, marbling, and mocha diffusion are traditional techniques where slip is manipulated to create colourful patterns.

Colour can be added onto a piece and also mixed in with it prior to the forming itself. Thrown agate is a simple process, with different clays mixed together on the wheel. A little more complex is nerikome, a lengthy technique with stunning results, which is an art form in itself.

Colour
■ See pp.158–81

Decorating slips and engobes open up a range of options for adding colour to your work. This section guides you through various ways of applying slip and incorporating colour into the clay itself, as well as introducing some more artistic techniques for painting and printing.

Engobes (see pp.178–79)

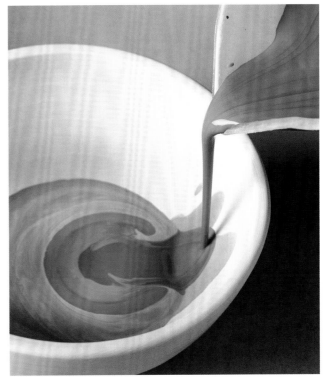

Marbling (see pp.170–71)

Adding texture introduction

CHANGING THE SURFACE FINISH

One of the many wonderful qualities of ceramics is their unique range of surface qualities. As well as working on a pot at a soft stage it is also possible to create decoration while at the leather-hard stage. By carving, cutting, and adding to the clay you can build a broad range of textures.

Raised or carved effects

Shaping the clay with a sharp tool is a popular way to create a textured surface, typically working with a leather-hard pot. In this section, you will learn to do this with sgraffito and carving techniques, making controlled marks to add decoration or pattern. Ensuring your pot is made from a smooth clay and is evenly dry will help.

An unusual textural method is to carve a pot from a whole block of clay, known as kurinuki. This Japanese technique creates a textural surface through the process of making, and is particularly suited to beginners as you familiarize yourself with how clay responds to different tools and effects.

Sprigging is the application of thin raised clay decoration to a foundation piece, creating a patterned texture. These raised elements are easily repeated using a small plaster mould.

Impressed effects

You can use many tools and found objects to impress a shape or pattern into clay to add surface decoration, using coloured glazes or inlaying slip to enhance the effect of these impressions.

For all of these texture-making methods, practise making marks on a test slab of clay to get a sense of how much pressure you should use with the tool or how deep to make your marks.

Using tools
>> see pp.148–49
There is a wide variety of tools to employ for different effects. Sections of increasing and decreasing size have been removed from this leather-hard vase in a repeating pattern to create a distinct faceted texture.

"In contrast to impressed or carved texture, you can also add a polished finish to your pieces."

Sgraffito
>> see pp.140–41
Combining colour and texture, the slip applied over this vase was carved with a fine tool to reveal the clay.

Smooth surfaces

In contrast to impressed or carved texture, you can add a polished, smooth finish to your pieces. Burnishing is a traditional finish – creating a polished sheen with simple stones and no glaze is as minimal as it gets.

Another way to smooth a piece is with the addition of terra sigillata, a very refined clay slip. Once you have learnt how to make and apply this you will have the perfect surface for naked raku, a firing technique without glaze.

Carving
>> see pp.148–49
The fluted lines on this carved teacup add a textured finish to a simple shape.

Burnishing
>> see pp.152–53
(far right) The smooth surface is achieved through burnishing, perfect for saggar firing.

Kurinuki

CARVING FROM A SOLID BLOCK

Originating in Japan, kurinuki is a hand-forming technique in which loop tools are used to hollow out a solid block of clay. It is a subtractive technique more akin to sculptural work and is suitable for any ability. The only rule with kurinuki is that you hollow out the interior space. You can add texture or carve the outside, but do not stretch or pinch the clay.

PUTTING IT INTO PRACTICE

This small teacup was carved from a squared piece of buff clay. Kurinuki is suitable for all types of clay, from heavily grogged to porcelain, but ensure it is not too wet.

You will need

- About 600g (1lb 5oz) block of clay
- Banding wheel
- Carving tools
- Loop tools
- Craft knife (optional)
- Chamois leather or soft, damp sponge

Carved teacup

1 Form the clay
The shape of your finished piece will be largely determined by the shape of the clay that you start with. After your clay has been prepared (see pp.28–31) form it into the shape you want by patting and rolling; it should be fairly firm.

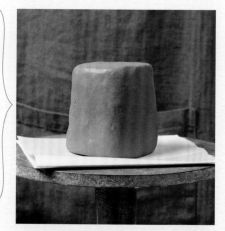

2 Texture the exterior
Start by using any sharp tool to give the exterior of the block of clay its overall shape. You can add texture at this stage, but as you will continue to handle the pot, it's best to refine the exterior at the end.

"Kurinuki is a subtractive technique more akin to sculptural work and is suitable for any ability."

3 Make the outside of the foot
While the clay is still solid, invert the block and use a sharp-edged tool to scrape clay off the edges to define the outside of the foot. The square shape of the vessel is reflected in the foot, with equal sides.

Planning different shapes

Kurinuki is an adaptable technique and you can experiment by using different shapes of clay and varying textures. Bear in mind that the height and width of the block you start with won't change as you work (unlike most other forming techniques). Make sure you prepare blocks of clay that reflect the size of your finished piece. If your clay is quite wet, let it stand for a few hours first.

Tall faceted cylinder
This vessel was carved from a tall cylindrical block and the exterior faceted with a harp wire before hollowing the inside.

4 Carve inside the foot
Hollow out the inside of the foot using a loop-edged tool. The inside is still solid so you can work confidently. Turn the pot over and put the block back on its foot.

5 Hollow out
Define the lip roughly, then use loop tools to hollow out. Go slowly and consider the space you're creating before carving deeper. Start in the middle then refine the walls, keeping an even thickness.

6 Make a lip
When you're happy with the interior, refine the lip by using a smaller loop tool or even a craft knife, to cut a bevel along the inside edge. Refine the outside, then smooth the edge with chamois leather.

Sgraffito

ADDING DECORATION WITH SCRATCHED EFFECTS

The sgraffito technique is a great way to add decoration at an early stage. Scratched lines and textures are applied to a smooth clay with fine loop tools, usually in conjunction with decorating slips of a contrasting colour to your clay. You can also use layers of coloured slip and scratch back to reveal other colours underneath.

■ Alternative design ideas

Plan your design in a sketchbook and then test out your favourite ideas on tiles. Once you are happy and have found a motif or pattern to match your form, you can proceed with your finished piece.

Sample designs
Simple lines drawn with a serrated kidney can be just as effective as more intricately carved designs. Loose, freehand designs may suit some pieces whereas a more rigid repeating pattern might better complement a different form.

PUTTING IT INTO PRACTICE

A striking black and contrasting white bottle has been created using porcelain clay and a decorating slip, with repeated patterns scratched away with loop tools.

You will need
- Leather-hard pot
- Banding wheel
- Decorating slip
- Paintbrush
- Smooth metal kidney
- Fine double-ended loop tools
- Stiff brush

Patterned bottle

1 Paint with slip
Apply one thick, even coat of slip. If your slip is thin, apply two coats, allowing it to dry in between. Leave until dry to the touch.

Apply the slip with a relatively wide, well-loaded brush

"Scratched lines and textures are applied with fine **loop tools**, in conjunction with **decorating slips** of a contrasting colour."

2 Tidy up the base
With a smooth metal kidney, wipe excess slip away from the bottom of the pot in a clean line. On this pot, you can follow the bevelled edge along the bottom.

3 Mark out the design
Mark out the elements of your design using a loop tool. Make sure the pattern is even all the way round, repeating the marks in exactly the same place on each side.

4 Fill in detail
Use a fine loop tool to mark the finer details of your design. Start with any larger patterns and repeat across the whole pot before filling in with the finest detail. It's best to leave plenty of slip and remove it gradually, rather than remove too much all at once.

Use a clean, stiff brush to sweep out any excess bits of clay

The neat edge of the porcelain border along the base frames the design

Impressing

CREATING TEXTURED SURFACES AND PATTERNS

There are many ways to add interest to the surface of your pot, such as pressing shapes and patterns into the clay, which can be as figurative or abstract as you wish. Impressing techniques are suitable for all types of firing, using any clay colour, although the clay needs to be plastic and smooth to obtain well-defined marks. It is easier to impress on a flat surface, but as long as you support the clay, you can impress on any form.

PUTTING IT INTO PRACTICE

To evoke a wall overrun by vegetation, this raku-fired pot uses impressed real leaves combined with a gecko stamp and vine leaf roulette pattern. Wrapping leaves around the pot adds interest to all sides.

You will need
- Leather-hard thrown or handbuilt tall form
- Leaves
- Smooth wooden roller
- Wooden stamp
- Patterned roulette

Figurative design

1 Impress the leaf pattern
Press the leaf into the clay with a wooden roller, supporting the clay on the inside. The harder you press, the more defined the impression, but take care not to misshape the pot. Peel the leaf away.

"Almost **anything can be pressed** into clay to create **patterns**, and any number of techniques combined."

■ Experiment with texture

Almost anything can be pressed into plastic clay to create patterns, a motif, or textures, and any number of techniques can be combined on the same pot. Test textures on scraps of rolled out clay before applying to your piece. This will give you a sense of how much pressure you need to apply to create the desired effect.

Lace
You can use any fabric to make texture on clay. This lace was impressed into a slab of clay using a rolling pin (see pp.74-75).

Roller and stamp
Wooden rollers (left) and carved wooden textile stamps (right) work well on clay and are available in different patterns.

2 Apply the stamp
Hold your shape or stamp against the clay and, supporting it from the inside, press the stamp firmly into the clay. You can push the stamp in with a flat roller to get a deeper impression.

A simple shape will add a clear impression with a defined outline

Move the roulette in a continuous line with even pressure

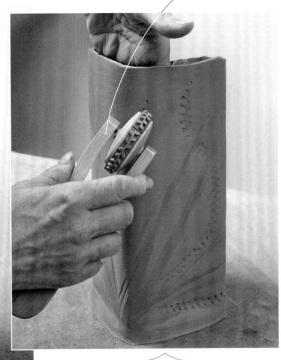

3 Add the roulette pattern
Supporting the clay inside, push the roller into the clay and apply pressure while moving the roller forward in one smooth motion for a fluid effect. Brush away any burrs when the clay is dry.

Inlaying

EMBEDDING COLOURED CLAY

Adding plain or coloured slip to an inlaid design before firing is one of the oldest methods of decoration. To achieve fine lines or patterns, make sure that the clay is smooth, without grog. To embed the design you can make stamps from wood, plaster, or bisque-fired clay, impressing them into soft leather-hard clay to leave a defined shape ready to fill.

Getting the timing right

Knowing when is the best time, and how much slip to apply to the embedded area, is key to achieving a beautiful surface finish. Slip often shrinks as it dries and you may need to apply a few layers. You can try preparing a slightly thinner slip for the first layer so that it fills the fine details, then use thicker slip to finish.

Building layers
The number of layers you need depends on the depth of your stamped-out shapes and the thickness of the slip. Let each layer of slip dry before adding the next one. Keep adding layers until there is a slight dome of slip over each stamp.

Here, the slip has not quite filled the areas stamped out in the design

A final layer of slip fills the shape above the surface level

PUTTING IT INTO PRACTICE

Using different coloured slips on a repeated design gives a varied surface pattern to this plate. Use a clay for the decorating slip that has the same shrinkage rate as the body clay.

You will need
- Soft leather-hard plate, ideally thrown with smooth clay
- Potter's pin (optional)
- Decorating slip
- Slip ingredients, such as stains or oxides
- Brush or slip trailer
- 100-mesh sieve
- Metal kidney
- Sponge
- ⚠ Respirator mask

Inlaid plate

1 Stamp the design
Stamp into the surface when the clay is still soft, but not wet. The indentations shouldn't be too shallow, or too deep – aim for a depth of about 2mm (⅛in). It may be helpful to mark where you want to stamp first with a potter's pin.

Push the stamp down into the clay and lift it straight back up

2 Mix the slip
Prepare decorating slip in two colours, using the body clay if the clay colour is light and won't affect the shade. Make a thick slip to minimize shrinkage, then pass it through a 100-mesh sieve to ensure it is smooth, with a consistency a little thicker than double cream.

Mix two different colours of slip using oxides, if preferred

"The number of layers depends on the depth of your stamped-out shapes and the thickness of the slip."

Ensure the brush is fully loaded with slip before applying

Scrapings will create dust; wear a respirator mask

3 Apply the slip
With a brush or slip trailer, apply slip into the incised patterns, dabbing it onto the surface of the clay to cover and fill the stamped shapes. Repeat to build up to the surface level; leave to dry for at least 10 minutes between coats.

4 Reveal the pattern
When the clay is leather hard, carefully scrape the excess slip with a metal kidney to reveal the inlaid pattern and level the surface. Remove the scrapings with a damp sponge.

Sprigging

EMBELLISHING AND RAISED DECORATION

Making shallow moulds from either carved or impressed motifs is a creative way to produce sprigs – decorative, raised features. Sprigging enables you to produce consistent motifs with ease, as moulds can be used and reused quickly due to their small size. You can either carve a design into plaster, or impress an object into clay, making a more permanent mould if multiples are required.

PUTTING IT INTO PRACTICE

This shallow pattern was hand carved directly into plaster, which is a good way to make neat, sharp-lined textures. Remember to reverse the pattern in the mould as it will come out as a mirror image.

You will need
- Plaster block
- Carving tools
- Jug
- Casting slip or clay
- Metal scraper or smooth metal kidney
- Palette knife (optional)
- Small paintbrush
- Water or joining slip

Sprigged bauble

> "Sprigging enables you to produce consistent motifs with ease."

1 Hand carve the design
Use carving tools to create your sprig mould in a flat block of plaster. Press a small amount of soft clay into the carved pattern to check the depth of the design and the clarity of the pattern.

2 Pour the slip
Pour casting slip from a jug until the sprig mould is filled. You may need slightly thicker slip as it can be more brittle to work with while it dries. Alternatively, press clay into the sprig.

3 Scrape off excess clay
When your design is fully covered with slip or clay, level the surface with a metal kidney, taking care not to chip the plaster. The sprig will dry quickly, shrinking away from the plaster when ready.

Taking impressions

You can use clay to take impressions from existing textures in found objects. Pressing objects such as leaves into clay can pick up lovely small details, or try tree bark to capture texture. Bisque-fire the impressed clay to produce a porous sprig mould for using. Remember, clay will shrink when fired, so check the final size you require and adjust accordingly.

Shredded cardboard
Impressing shredded cardboard into a mould will create a varied texture of irregular shapes, perfect for more abstract effects.

Shells
Making sprigs from found objects, such as shells, means you can reproduce the intricate patterns of beautiful natural forms with ease.

4 Release the sprig
Use a tool such as a palette knife, or a small piece of soft clay, to lift very delicate sprigs out of their moulds without tearing. Avoid leaving the sprig in its mould for too long as it may crack.

Lightly press a small ball of clay onto the sprig so they stick slightly, then gently lift the sprig from its mould

Press firmly to make sure the sprig is fully joined, but take care not to squash the design

5 Apply the sprig
The sprig texture will be ready to apply to your surface very soon after removal from the mould. Score and slip both the sprig and the surface and carefully attach the sprig.

6 Smooth the join
You can work the edges of your sprig or relief texture to blend it into the background. Use a brush dipped in a little water to smooth fine joins. You can reuse the mould to prepare more sprigs.

Carving

MAKING NEGATIVE MARKS

Creating fluted or faceted patterns takes patience and practice but the results are beautiful. Getting to know the ideal tools and how they respond to the clay surface is key to mastering carving. Try different tools, noting how much clay they remove and the shapes they create; you may need to throw a thicker pot if the tools remove a lot of clay or you want to carve large facets.

▧ Choosing tools

The choice of tool depends on your design and how fine or smooth the details are. Make sure you dry the clay to the consistency that works with your chosen tool. With smooth clay the marks will be fine and clear; on textured clay, the marks might break.

Carved design
These controlled patterns were made with a sculpture carving tool like a rhino cutter, on hard leather-hard clay.

Faceted stripes
To achieve these faceted vertical stripes, a harp wire was used when the clay was still soft.

Fluted lines
This regular fluted pattern was made with a loop tool on soft leather-hard clay.

PUTTING IT INTO PRACTICE

The simple repeated pattern on this round shape was created with different-sized tools, maintaining the same number of strokes on each level but changing their size to match the increase or decrease in the curved shape.

You will need

- Stoneware clay
- Potter's wheel
- Plastic sheet (optional)
- Loop or carving tools in different sizes

Faceted pot

Make the walls thicker where you plan to carve

1 Make the basic shape
Throw your pot, making sure you throw the wall evenly as it is difficult to keep control when carving on inconsistent clay.

"Getting to know **the ideal tools and how they respond to** the clay surface **is key to mastering carving.**"

2 Dry upside-down

It is important the piece dries evenly, otherwise your tool will get different levels of resistance and the effect may be inconsistent. Place the pot upside-down to dry to ensure the top, where there is less clay, does not dry out faster than the lower, thicker parts. Alternatively, cover with a sheet of plastic. Trim before carving (see pp.112–13).

Once the top of the pot is dry enough to support itself, turn upside-down to dry overnight

3 Carve the design

Starting at the base, carve a row in your desired pattern. Change tool size for the next row, working between the facets but keeping the number of scoops the same. Repeat until you reach the largest tool size for the widest part, then decrease on each row to the top.

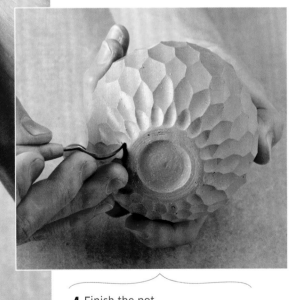

4 Finish the pot

When the pot is dry, use a tool or your fingers to brush off any little burrs of clay that are still stuck on the surface at the edges of the carved design.

Piercing

CREATING CUT-OUT DESIGNS

Piercing decorative sections of a pot can have many uses, not only to create a beautiful design but also for practical considerations. Pierced pots can make excellent tea-light holders, oil burners, colanders, or lattice baskets. Although clay is fragile when dry, it can easily be carved before the first firing when it is leather hard. Once glaze fired, it will become relatively strong.

PUTTING IT INTO PRACTICE

Porcelain has a translucent effect when made thin enough. This lampshade was created from a thrown bowl that was turned to create a narrow top with a small hole, then paired with a pierced decoration.

You will need

- Thrown and turned tall bowl in porcelain or white clay (at leather-hard stage, 4mm/¼in thick)
- Banding wheel
- Paper
- Pen or pencil
- Masking tape
- Potter's pin
- Hole cutters or corers of different sizes
- Tapered sponge on stick
- Bowl of water

Pierced lampshade

"**Porcelain is** particularly **suited to piercing**; it has a translucent effect, which works well when illuminated."

1 Draw your design
Measure a piece of paper to the same size as the area of the pot you'd like to pierce, then draw your design. Leave at least 5mm (¼in) between the holes, or you risk weakening the pot.

2 Transfer your design
With the pot on a banding wheel, tape the paper to the outside, with the design facing out. Trace over the outline of your pattern using a potter's pin to imprint the design.

Creating a strong pattern

When designing your image or pattern, remember to leave a sufficient amount of space in between each section that will be removed. Your piece will become weak if the areas of clay left in place are too thin. Keep the piece leather hard and covered in plastic until you are ready to begin piercing.

Sketched design
Block petals are abstracted from a rose and repeated. The small elements of the design will require careful piercing.

3 Use a hole cutter
Starting with the larger holes, cut circles out of the pot by pushing the hole cutter into the centre of the drawn circles, twisting as you push further in and supporting the pot with your hand to keep it steady. Brush away pieces or burrs of clay.

Support the pot with your other hand as you push the hole cutter through the clay

Cut your sponge to fit the size of the holes, if necessary

4 Smooth the edges
Push a damp sponge into each hole, twisting gently against the sides of the hole as you push in and pull out to smooth the edges. Use your other hand to support the pot.

Burnishing

HAND POLISHING CLAY TO CREATE SHINE

Burnishing is a way of creating a smooth, shiny finish without using a glaze or terra sigillata (see pp.154–55). The technique is practised on greenware and works by compressing the clay surface, allowing the particles to reflect light. It's hard work, but the resulting piece will be glossy and wonderfully tactile. Only attempt to burnish smooth clay, not grogged.

■ Burnishing tools

It is important to use materials of the correct hardness as burnishing tools. Agate, rose quartz, and aventurine, at 7 on the Mohs mineral hardness scale, are all ideal. A curved plastic tool can also be used, and some potters employ the back of a metal spoon, but this should be avoided as it may make marks that remain visible after firing. All tools should be perfectly smooth, without any sharp edges that could cause nicks in the clay.

Agate
A microcrystalline form of quartz with bands of colour, agate is commonly available made into various types of burnishing tools.

Rose quartz
The pink colour of this inexpensive gem makes it a popular choice for face rollers and palm stones, which can be used on clay.

Aventurine
Slightly less hard at 6.5 to 7 on the Mohs scale, aventurine is a type of quartz often made into paper weights, which could be used on clay.

PUTTING IT INTO PRACTICE

A piece with a rounded shape, like an egg, is the perfect choice for burnishing. Make sure your hands are clean, and, if desired, wear cotton gloves to avoid leaving fingerprints on the clay.

You will need
- Clay piece
- Smooth metal or rubber kidney
- Small bowl, for water
- Burnishing stone or other tool
- Cotton gloves (optional)

Saggar-fired egg ornament

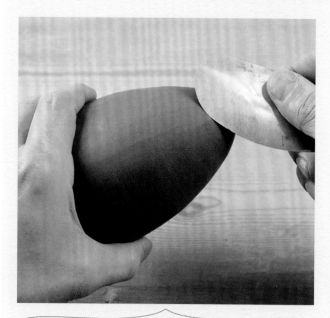

1 Smooth and leave to dry
To prepare your piece for burnishing, first smooth over the surface of the still-soft clay with a metal or rubber kidney. Let the piece dry until it is leather hard, and in the meantime fill a small bowl with a little water.

"The process of burnishing is **hard work,** but the resulting piece will be **wonderfully** tactile and have a **glossy appearance.**"

2 Wet the surface
Dip your finger in water and lightly rub it on a section of the clay. Wetting the clay creates enough moisture for the stone to glide smoothly, although may be unnecessary depending on the clay's condition.

The water acts as a lubricant to help achieve a smooth burnishing action

This plastic tool is easy to hold and has a large surface area

3 Rub with the stone
Use a stone or other burnishing tool to rub the damp area in small, circular motions. Remember that the clay is unfired, so do not apply too much pressure.

4 Continue burnishing and fire
Work your way around the piece, wetting and rubbing until you have burnished the entire surface of the clay. You may wish to wear a pair of clean cotton gloves to help keep the surface free of fingerprints. Carefully place into the kiln for firing.

Terra sigillata

CREATING A SHINY FINISH WITHOUT USING GLAZE

Terra sigillata, an Italian term that translates as "sealed earth", is a liquid similar to slip, which leather-hard clay can be coated in to achieve a shiny finish without using a glaze. Different colours can be achieved, depending on the type of clay used to make the terra sigillata. Bear in mind that mixing terra sigillata is a lengthy process that will take at least three days to complete.

PUTTING IT INTO PRACTICE

The first layer of terra sigillata is made with the same clay as the piece and turns black when raku fired (see pp.232–35). The white layer is made from earthenware clay, and the orange from iron-rich clay.

You will need

- 2 jugs and lid covering
- Stirring utensil
- Plastic tube (clean)
- Leather-hard piece
- Banding wheel
- Spray gun and booth or soft brush
- Microfibre or cotton cloth
- Plastic bowl
- ! Respirator mask

- 225g (8oz) dry clay for each mix: ball clay (base layer); earthenware (white layer); iron-rich clay (orange layer)

For each terra sigillata layer

- 1 litre (1¾ pints) distilled water
- 25g (1oz) sodium hexametaphosphate (deflocculant)

Tea-light holder

"**Different colours** can be achieved, depending on the **type of clay** used in the terra sigillata."

1 Mix up
Pour the water into a jug; distilled water stops the mixture turning mouldy. Add the sodium deflocculant first, followed by the dry clay. Mix together thoroughly and cover.

2 Allow to settle
Leave in a dry place for 24 hours, undisturbed, until the mixture has separated into three layers: water at the top, sediment on the bottom, with terra sigillata in between.

3 Siphon off
Use a plastic tube to siphon off the terra sigillata into a second jug, leaving behind the bottom layer and excess water. Repeat the settling and siphoning process twice more.

■ Methods of application

Terra sigillata can be applied in layers, but do not use more than three layers of the same type, or else it may split off. For the first three layers your pot must be leather hard. A spray gun ensures even coverage, but the mix can also be applied with a brush.

Applying with a brush
Use a soft brush to apply the terra sigillata, in order to avoid leaving lines on the finished piece. Place the piece on a banding wheel and turn the wheel as you brush on the mix, for a smooth, even action.

4 Apply the first layer
Use a spray gun or soft brush (see above) to apply the first layer of terra sigillata. Leave the piece to dry completely, until it no longer feels cold to the touch.

5 Polish the surface
Once dry, polish with a cloth until shiny. You may wish to wear cotton gloves to avoid leaving fingerprints. Do not press too hard. Repeat steps 4 and 5 twice more.

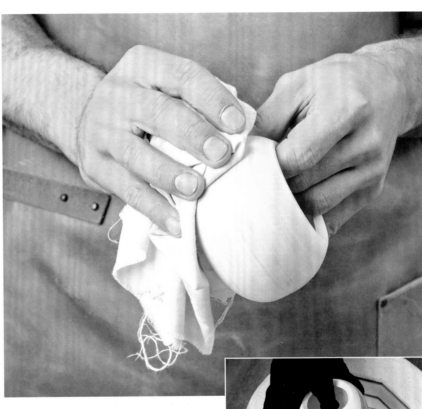

6 Apply other colours
To apply further layers of coloured terra sigillata, pour the terra sigillata into a bowl and dip the piece into it. Dip each side twice for a good coverage. Coloured terra sigillata should not be polished. Each layer of terra sigillata must be completely dry before you apply another coat.

7 Fire the piece
Bisque fire the piece in an electric kiln. If you intend to raku fire, bisque fire to 940°C (1724°F) to keep the surface porous.

Artist **Mizuyo Yamashita**
Clay **White stoneware, and mixtures
of stoneware and terracotta**
Finish **Various glazes**

Combining contrasting textures

>> See pp.190–91

The intricately carved lower section of this
pot contrasts with the smooth, satin texture
of the pine ash glaze at the top.

Highlighting texture with a glaze

The clay and glaze used can work together to
enhance or subdue carved patterns. Similar
pattern effects can be achieved with rollers
or stamps (see Impressing, pp.142-43).

Carving symmetrical designs

When carving, shorter strokes are easier to
control. A tape measure and potter's pin can
be used to draw guidelines around a pot first,
making it easier to repeat the pattern exactly.

Texture showcase

A pared-back, natural palette of creams and greys allows the surface texture on these pieces to come to the fore. Having some grog in the clay body helps contribute to rough textures. Glazes will pool in indentations and thin out over ridges, highlighting the patterns underneath.

Rough textures

The rough, natural-looking texture on this jug was created by drawing a serrated metal kidney across the surface of the clay in random strokes.

Fluting

« See p.148

A repeated pattern such as fluting looks neat and stylish. It also compels the viewer to run their fingers over it, making it ideal for functional ware.

Working with the shape

Decoration can be used to accentuate the shape of a thrown form. The horizontal lines on the interior of this mug also contrast with the vertical fluting on the outside.

Adding colour introduction

CREATING INTEREST WITH COLOUR AND PATTERN

There are many ways to add colour to a piece of ceramic with the use of stains and oxides (see pp.196–97). These can be blended into the clay body, mixed into a decorating slip, or even applied once fired. You can marble, print, paint, or pour to achieve colourful, patterned, and rich surfaces.

Changing the clay

The first opportunity you have to add some colour is before you start building, by mixing an oxide or stain into your clay body. Combining coloured clays in different proportions then throwing, for agateware, or layering colours to create patterns for nerikomi, will encourage you to experiment with mixing colour and pattern making. The possibilities are endless when your material is part of the decoration.

Liquid colour

Decorating slips are liquid coloured clay and typically used on leather-hard clay. The key to a successful application with any of these slip techniques is to prepare your slip well. Sieve before use and ensure you have the right thickness for the task at hand. Pouring and dipping slips are the simplest ways to use this medium, while ensuring an even application. You can learn to use tools, such as a comb or potter's pin, to draw through layers of slip and create patterns. Marbling combines colours and mixes them in the piece, with fluid, random effects that look stunning.

For more controlled applications with a brush, you can paint with slips or engobes. An engobe is similar to a slip but can be painted onto bisque. With both methods, you can build layers of colour to create visually rich surfaces.

Feathered effects
>> see p.170
Using simple tools, such as a potter's pin, you can create patterns in coloured slip, drawing the tool in alternate directions for a traditional feathered effect. This technique is ideal for flatware.

Engobes
>> see pp.178–79
Engobes can be painted directly onto bisqueware. Here, expressive brush marks of overlaid colour add artistic flair.

Discover how to transfer a painted design from paper onto your work using the monoprinting technique. This straightforward method is suited to motifs and limited colour palettes.

Tips for success
To ensure success with colour, make sure that you test colours first. Try out the strengths of colours or different combinations on test tiles. Once you are ready to begin, make sure your piece is at the right stage. If a little too soft or not quite leather hard, your work could crack or break once decorated.

"With engobes or slip you can build layers of colour to create visually rich surfaces."

Dipping slip
>> see pp.164–65
You can dip an entire piece in slip, or partially dip rims and edges, to leave solid bands of colour on the outside.

Marbling
>> see p.171
The beautiful effects of the partially mixed colours of this bowl are highlighted by the white porcelain exterior and a clear glaze.

Thrown agate

MIXING COLOURED CLAYS

Agateware refers to any work made by mixing different coloured clays, either based on the natural colour of the clay or by using stains and oxides to colour a white clay body. Regardless of the method you choose to form your piece, plan ahead of the make, double wrapping the coloured clay in clingfilm and labelling it. This way you can be a lot more spontaneous when throwing agateware, without stopping to add colouring oxides or stains.

■ Checking the mix

Make sure that you check the progress of the mix when cutting the combined ball with a wire, to ensure that it still retains the separate colours. Over-mixing will reduce the stripes in the thrown piece. This is also a good opportunity to check for any air bubbles.

Eliminating air bubbles
Stacking separate pieces of clay can introduce trapped air into the rolled ball. When cutting the ball with a wire to mix the clays, check for air bubbles and knead again to remove them.

Air bubbles are revealed where coloured clays have been mixed together

This pot is thrown from a mixture of buff, black, and porcelain clays to create natural and fluid stripes of colour. Don't worry if you can't see a pattern when throwing the pot, as it may be blurred by the slip.

You will need
- Three clays of contrasting colours, but of the same consistency (about 650g/1lb 8oz in total)
- Wire
- Potter's wheel
- Smooth metal kidney

Agateware pot

1 Prepare the clay
Wedge or knead each clay colour separately. Choose one clay to be the dominant colour; it should represent at least 50–60 per cent of the total mass.

Use a wire to cut the clay into pieces – the larger portion will be the dominant colour

2 Stack the coloured clay

Experiment with how you stack the colours in your ball. The smaller the bits of coloured clay added into the main colour, the thinner the stripes on the finished pot.

3 Mix the clay

Use a wire to cut the stacked clay ball into pieces, then stick them together in a random pattern to create one large ball. Briefly wedge or knead the clay again to remove any air.

4 Throw the shape

Transfer the ball of clay to the wheel and throw the shape as directly as possible: the amount of time you spend centring and pulling will affect how the pattern develops.

5 Reveal the pattern

When you've thrown your pot, gently scrape over the form with a metal kidney with the wheel turning slowly, wiping the slurry away. A crisp pattern should be revealed. If you're throwing clay that you have coloured with oxides or stains, the process is exactly the same.

Adjust the shape as you turn the pot, if desired, and sharpen the pattern further

Nerikomi

CREATING DECORATIVE PATTERNS

Originating in Japan, nerikomi involves creating decorative patterns by stacking, rolling, and slicing coloured clays. The technique lends itself to many forms but a plate or shallow dish is a good place to start. The pattern will widen each time you press the rolling pin into it, so finding a balance between the thickness of the resulting slab and the overall pattern takes practice.

PUTTING IT INTO PRACTICE

This dish with a large, recurring pattern was created from different coloured clays, rolled together, sliced, and assembled in a square mould. Nerikomi is very versatile – try different combinations for other effects.

You will need

- About 500g (1lb 2oz) clay (ideally a white, smooth clay), divided into four: the base clay and three prepared colours
- Clean cloths
- Knife
- Rolling pin
- Square dish mould
- Oil and talcum powder (optional)
- Paintbrush
- Banding wheel
- Wire (optional)
- Metal rib (optional)
- ❗ Protective gloves

Nerikomi dish

"Nerikomi lends itself to many forms but a plate or shallow dish is a good place to start."

1 Stack each colour
Roll a slab of each colour. Stack one slab directly on top of the other on a cloth. Place a coil of black clay across the slabs, brushing it lightly with water. Trim the edges of the stack to make it easier to roll.

2 Roll the slabs
Starting with the end nearest to you, roll the layered slabs tightly around the coil so that it resembles a long Swiss roll. Take care not to trap any air between the layers.

3 Cut slices
Use a very sharp, clean knife to cut the roll into slices of equal thickness. Ensure that you keep the clay wet to prevent the knife dragging the pattern.

Mixing coloured clay

You can mix coloured clays from oxides for use in nerikomi. Cut your ball of clay into several slices, paint the oxide mixture on the top of each slice, then knead the ball until the colour is uniform. Keep the clays from contaminating each other before you assemble to ensure crisp results. Leave for a few hours to firm up or knead on a plaster bat.

Adding oxide
Always wear protective gloves when handling oxides, especially as you will have to knead the oxide in for a while. Before preparing the next colour, wash the wedging bench and wire, and replace your gloves.

Use a clean cloth for each stage, to prevent the transfer of unwanted colours

Smooth the edges to remove any burrs after trimming

4 Assemble the slices
If necessary, prepare the dish mould with oil and talcum powder. Use a small brush to paint water on the short sides of each slice and stick them together to form a rough slab on a clean cloth.

5 Roll the slices into a slab
Put a clean cloth on top of the nerikomi slab, making sure there are no folds. Roll a rolling pin gently in one direction, then rotate 90 degrees and roll again. Repeat to the desired thickness.

6 Place in the mould
Remove the cloth and place the nerikomi slab into the mould, trimming the excess with a wire or sharp knife. When the slab is leather hard, you can further sharpen the pattern by gently scraping the surface with a metal rib.

Use a banding wheel to support the mould, turning it as you trim

Pouring and dipping slip

APPLYING LIQUID DECORATING SLIP

Many makers use decorating slip as a way to add colour to a piece, often in conjunction with a transparent glaze. Take into consideration the colour of your clay and use that to accentuate the slip. Apply to leather-hard clay to allow the slip to dry with the piece. Take care when handling once slip has been applied, as the piece will become wetter again and may warp.

▓ Glazing over a bucket

If the design of your piece does not allow you to hold it while applying slip, or if you do not have enough slip to dip into, you can place the piece in a bucket or large bowl and pour the slip over, while turning the wheel.

This terracotta cup is partially decorated with a striking blue-green slip, which is highlighted by the red clay. The rounded and curved shape makes it easy to decorate the interior and exterior.

1 Pour slip on the inside
Transfer your slip into a jug. Hold the cup you are decorating over a clean bowl; twist your wrist inwards, holding the cup upright with your fingers around the base. Fill to the brim with slip.

Pouring slip
Place two slats on a banding wheel in a bucket or bowl, and rest the pot over them upside-down. Pour the slip over, turning steadily as you go. Aim for the lowest point on the piece that you want to colour. If you miss any patches, go back over them for an even coverage.

2 Tip out while twisting
In a single movement, rotate your wrist and turn the cup upside down, allowing the slip to pour around the insides of the cup and out into the bowl beneath.

Dipped cup

3 Dip top down

Holding the cup in the same way, dip it into a bowl of slip to coat the top section of the outside. Watch the angle – for an even divide, go straight down, and angle the cup if necessary to cover any missed areas.

Clay softens when coated in wet slip, so handle your cup with care

Hold with a firm grip, spreading your fingers wide over the base

4 Wipe off excess

Immediately after you take the cup out of the bowl, run the side of your index finger around the rim to quickly catch the drips. This means that when you turn it the right way up, the slip won't run down the sides.

Wipe away any excess slip with your finger so that none remains in or on the cup

"Rounded vessels are ideally suited to coating with slip both on the inside and outside."

Slip trailing

CREATING RAISED DECORATION WITH SLIP

Slip trailing (sometimes known as tube lining) is a very traditional way of decorating pots; commemorative and celebratory plates, in shades of yellow and brown, are typical of this technique. The benefit of using slip is that it doesn't melt or move in the kiln. It also means that your decoration is raised, adding texture as well as colour.

PUTTING IT INTO PRACTICE

This vase has been decorated with a light blue slip in a simple pattern. The more you practise, the more intricate your designs can become – you can stack up the slip and apply more once the first layer is dry.

You will need

- Leather-hard pot
- Banding wheel
- Potter's pin
- Decorating slip
- Sieve
- Slip trailer
- Wooden board (optional)

Slipware vase

> "A benefit of using **slip** is that your decoration is raised, adding texture as well as colour."

1 Mark out lines
Use a potter's pin first to mark the upper and lower boundaries of your design, and then to score vertical lines around the pot. To ensure evenly spaced lines, start with a line on either side of the pot, then two more halfway between those, then four more.

2 Fill slip trailer
Sieve your slip and ensure your slip trailer is clean and dry. Squeeze the air out of the slip trailer before inserting the end into the slip. Then gently release the pressure on the bulb to draw slip in to fill the slip trailer.

Filling in detail

A slip trailer can also be used to great effect to accent a design. Paint a base layer of coloured slip onto a leather-hard pot and let it dry, then use a slip trailer to outline the design or add detail in a contrasting colour. A slip trailer, or pipette, gives you freedom to "draw" in slip, adding patterns or figurative designs to create colour interest.

Adding fine detail
It is possible to add fine, precise detail using a slip trailer with a smaller opening or, if you have one, a pipette. Draw lines onto your design, following the shape on the base slip or drawing freehand.

Try not to let the slip splurge out at the end

Position the dots in the centre of the gaps between the lines

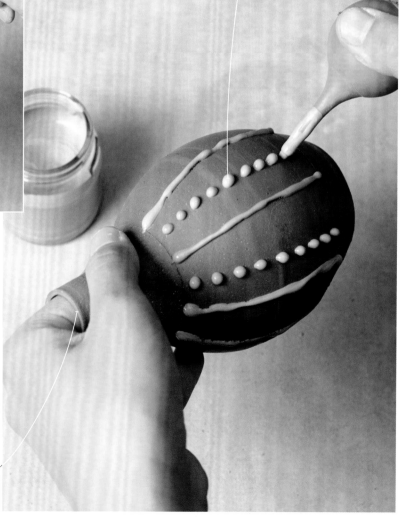

3 Draw lines
Practise squeezing out slip on a board or your work surface before applying it to your pot, in order to get a sense of the flow. When ready, follow the scored lines on the pot with the slip trailer, moving your hand quickly for a smooth, even application.

4 Draw dots
For columns of dots in between the lines, squeeze out small blobs of slip at even intervals down the side of the vase. If you make a mistake, scrape it off carefully.

Hold the vase inside the neck, so you can work all the way around; alternatively, let one half dry before decorating the other half

Painting with slip

ADDING COLOUR WITH LIQUID CLAY

Using slip as a decorating technique allows you to be expressive and build up layers of colour, using paintbrushes or your fingers. Although the colours will brighten during firing they won't melt, move, or change a great deal. Slip gives you more scope than glazing to use painterly effects such as mixing, layering, and adding texture.

Incorporating pot colour in the design

To get the best effects, think about the colour of the pot alongside that of the slip. Using contrasts, harmonious colours, and textural techniques such as sgraffito (see p.140) creates interest and variety.

White background
Using a white clay, such as porcelain, as a background colour provides a blank canvas for adding contrasts of colour.

Harmonious effect
A thin application of red slip over a red clay gives a subtle effect and keeps the piece harmonious.

Textural contrast
Scratching through the white slip with a potter's pin reveals the black coloured clay beneath.

PUTTING IT INTO PRACTICE

This slab-built vase uses only three colours of decorating slip: red, white, and black. A variety of brushes were used as well as fingers to blend areas together. After firing, a clear glaze was added.

You will need
- Leather-hard tall vase
- Banding wheel
- Potter's pin
- Decorating slips in three colours
- Paintbrushes

Abstract design

1 Mark the design
Mark out your design on a leather-hard pot using a potter's pin so you know where to apply your slip.

For abstract shapes, keep your marks free and fluid

"Expressive, painterly effects are easy to achieve **when applying slip with a brush or your fingers.**"

2 Paint blocks of colour
Block out large areas of your design using a wide brush to apply thick coloured slip with expressive brushstrokes. Use a clean brush to apply each area of colour.

3 Finger smudging
Add abstract expression by using your fingers to smudge the white slip into the red. It's best to do this while the slip is wet, then leave it to dry before adding the finer detail.

4 Add detail
Use a smaller brush to add the finer detail following the outline marked in step 1. Darker colours tend to be better for finer work as they stand out more sharply.

Loose marks showing the direction of the strokes add to the decorative effect

Feathering and marbling

CREATING DECORATIVE PATTERNS USING SLIP

These slip patterns are applied while a piece is leather hard, allowing the slip to dry with the piece. As slip is liquid coloured clay it won't melt or move in the kiln, so you can employ thickness as decoration, adding ridges of colour.

FEATHERING

The decoration on this plate is created from paired stripes of slip, dragged in alternate directions to feather them. Slip won't produce a glossy finish, so a transparent glaze was added after bisque firing.

You will need
- Leather-hard plate
- Decorating slip in two colours
- Sponge
- Slip trailer
- Potter's pin
- Jug

Feathered plate

1 Pour on slip
Prepare the decorating slip, thinning with more water, if necessary. Pour the base slip in the main colour onto the middle of the plate, pick up the plate and tilt it to spread the slip evenly over the base. Pour out the excess and clean the rim with a sponge or metal scraper.

2 Trail the slip
Fill a slip trailer with the second slip colour and draw lines across the plate. Here, two pairs of lines have been drawn with a gap in between.

3 Feather the slip
Drag a potter's pin through the lines of slip from top to bottom. Clean the pin, then draw another line, working across the plate. Repeat in the opposite direction, from bottom to top.

Leave enough space between the lines to drag the pin the opposite way

Slip consistency

You may need to adjust the thickness of your slips depending on your chosen technique and to make sure they are the same consistency. A thinner consistency is better for marbling, so that it can spread easily around the pot. For feathering, the slip should be thicker to hold its shape.

Thinning slip

You can make slip thinner by adding a little water, but you can't make it thicker. For this reason, if there is any water sitting on top of the slip when you open it, it's best to pour it off.

MARBLING

Marbling is suited to the rounded shape of a bowl and is most effective when worked with similar colours or shades, as here, where the shades of blue also contrast with the unglazed porcelain exterior.

You will need

- Leather-hard porcelain bowl
- Decorating slip in three shades
- Jug

Marbled bowl

1 Pour the slip

Pour a little of each coloured slip into the bowl. Ideally, you'll need enough slip to cover the inside of the bowl without needing to pour any out again. It may take some practice to get the right amount.

Add just enough slip to cover the piece – don't mix too much

Swirl the coloured slips in a circular motion to marble the colours together

2 Tilt the bowl

Slowly tilt the bowl, moving it around so that the slip covers the inside of the bowl and the three colours swirl into each other, creating a marbled effect. Tip out any excess slip once the interior has been covered.

Combing

MAKING PATTERNS IN SLIP

This is a very direct way of making surface decoration. By pouring slip onto a leather-hard piece, you can make all sorts of patterns by combing your fingers or almost any other tool through the slip while it is still fresh. The slip consistency is key here: too wet and the pattern will disappear, too thick and you will have crisp, hard lines instead of a fluid mark.

▇ Experiment with different tools

Even though the concept is simple, good results depend on experimenting with a range of tools to discover their particular characteristics. Test different tools for different marks, from actual combs to handmade tools.

Using a straw brush
Here, a simple hakeme brush made from a bundle of straw is used in a circular motion over fresh, wet slip.

Fired design
The circle design made with the brush has revealed the white clay beneath. The texture left by the slip is highlighted further with a transparent glaze.

PUTTING IT INTO PRACTICE

The green slip of this sushi dish contrasts with the bold yellow slipped lines. A traditional wooden comb has unified the two elements of the dish with two bold strokes, worked in opposite directions.

You will need
- Leather-hard dish
- Decorating slip (sieved) in two colours
- Jug
- Bowl or container
- Sponge
- Wooden board and/or banding wheel
- Slip trailer
- Wooden comb

Combed dish

1 Pour the slip
Stir the base slip in a jug; it should be roughly the thickness of double cream. Pour the slip over half the dish positioned above a container. Flip the dish in your hand to glaze the remaining half. Use your finger to remove excess slip from the rim (see pp.164–65) and a sponge to tidy the base.

"You can make all sorts of patterns by **combing your fingers** or almost any other tool **through the slip** while it is still fresh."

2 Trail two lines of slip

Once coated, the piece will become soft as it absorbs water from the slip, so keep it on a wooden board or banding wheel, to avoid distorting the shape. Fill a slip trailer with the contrasting coloured slip and draw two lines across the dish. Keep each line steady and consistent, completing it in one pass.

Do not lift the combing tool until you have finished the pattern

3 Comb through the slip

As soon as the yellow slip is added, make your marks by dragging a comb through the slip. If the slip is on the thin side, you might need to wait for it to start drying before combing. Don't be shy when dragging the tool (or your fingers): you only have one shot at this and a bold move will work best.

A banding wheel can be used so that you can easily rotate the dish to work on the other side

Monoprinting

TRANSFERRING COLOUR

Monoprinting is a simple but effective way of making marks and adding colour to leather-hard work. This printing technique allows you to create a flat repeat pattern with decorating slip or underglazes (see p.168 and p.194). Paint the slip onto thin paper or acetate and layer up your design, working in reverse, before transferring it to your leather-hard pot.

■ Removing paper

This simple technique can still throw up a number of challenges. Removing the paper at the right moment is one of them. Once the paper and design are added to the vessel, the leather-hard pot will quickly start to absorb water and dry the slip and paper. You can add a little water to soften the paper to make it easier to peel off, without affecting the design.

Softening the paper
Lightly press a damp sponge over the paper, gently dabbing over the whole piece. You can then peel the moistened paper away to transfer the design.

PUTTING IT INTO PRACTICE

Here, a simple black-and-white design reminiscent of a photograph has been paired with a terracotta vase. Explore painterly effects with a brush, using a limited palette to make the design or motif stand out.

1 Paint the design
Cut a rectangle of thin paper or newsprint and draw the outline of your design. Use a small brush to fill in the shape using coloured slip; you are working in reverse, painting the detail first. Wait for the painted shape to dry but not completely – it should have lost its sheen but not be so dry as to begin to flake off.

2 Paint the paper with slip
Paint a thick layer of white slip over the coloured shape. The slip will make the paper wet so it is best to paint on a porous surface such as a wooden board, to aid drying. Wait for the slip to dry enough to touch but still remain damp so it will stick to the vase.

You will need

- Leather-hard piece
- Thin paper or newsprint
- Decorating slip in two colours
- Pencil
- Paintbrushes
- Wooden board
- Small rolling pin
- Banding wheel

Monoprinted design

"Explore painterly effects with a brush, using a limited palette to make the design stand out."

3 Apply to the pot
Take the painted piece of paper and apply it to the pot, smoothing it in place from base to top in one movement.

Support the pot with one hand on a banding wheel as you transfer the design and peel away the paper

4 Transfer to the pot
Rub over the pattern to transfer the design. You can use a rolling pin to further secure the paper onto the vase. Roll back and forth over the paper with even pressure to cover the whole surface.

5 Remove the paper
Remove the strip of paper before it starts to dry, softening it with water if you need to (see far left). Gently peel the paper away starting with a corner. Take care not to smudge the marks and let them dry naturally.

Mocha diffusion

ADDING MOSS-LIKE PATTERNS

This is an old English method of adding diffused patterns to earthenware plates and vessels. Traditionally, a red clay vessel is used with white slip, but any clay will work as long as you have a contrasting slip colour. Some of the best decorative effects are achieved by using cobalt oxide (dark blue) or manganese dioxide (dark brown to black) to add the pattern into the white slip.

PUTTING IT INTO PRACTICE

Mocha diffusion works well on shallow forms as you can easily control where the mocha goes and in which direction. Here, just three mocha drops were used; more would have made for a crowded design.

You will need

- Leather-hard press-moulded plate
- Small pot
- Cobalt oxide, 5g (⅛oz)
- Apple cider vinegar, 30ml (1fl oz)
- Dropper
- White decorating slip, sieved (not too thin)
- Jug
- Sponge
- ❗ Protective gloves
- ❗ Respirator mask

Diffused pattern

1 Prepare the oxide

Wearing a respirator mask, pour the cobalt oxide into the apple cider vinegar in a small pot and mix it well. The mixture should be very liquid, or it won't diffuse enough. Stir again just before transferring the mixture into a dropper.

" Successful mocha diffusion relies on the consistency of your slip and the timing."

2 Prepare the dish

First, you need to coat the dish with a good coating of white slip. Stir the slip, then pour it into the dish and swirl it around the inside to cover the whole surface.

Timing and slip consistency

Successful mocha diffusion relies on the consistency of your slip and the timing. Have everything you will need prepared and near you before pouring the slip, as you will need to work fairly quickly so the slip doesn't dry too much before applying the mocha. The slip needs to be the right consistency, or the effect won't work.

Too thick
With slip that is too thick, diffusion can't go deep enough to make a mark and the texture will also affect how it spreads.

Too thin
If the slip is too watery, the mocha pattern will be much less defined and the colour diluted. The result is very blurry marks.

3 Pour off excess slip
When the slip has covered the inside, pour out the excess back into the jug, making sure that you leave a fairly thick layer so the mocha has a base to spread on.

4 Wipe the rim
Use a sponge to wipe off excess slip, such as that left on the rim when pouring. Do this when the slip is very wet and just before you add the oxide.

5 Drop the oxide onto the slip
Working quickly, shake the dropper and squeeze a drop of oxide onto the plate. Be very decisive and let the oxide drop in quick succession. Incline the plate to control the diffusion.

Vary the height from which you release the drop of oxide to change the pattern

Engobes

ADDING COLOUR AND TEXTURE WITH ENGOBES

The application of engobes provides an effective way to add colour to the surface of clay. Engobes are liquid decorating colours that contain less clay than slip, and less silica than glazes, putting them halfway between the two. They can be added to clay at any stage, both before and after the first firing, and are particularly useful for layering to add texture.

PUTTING IT INTO PRACTICE

This pot was made and fired in two separate pieces, which were then further contrasted with different decoration. Here, a thin coating of engobe allows the colour of the clay to show through.

You will need
- Bisque-fired pot
- Banding wheel
- Engobes
- Brushes
- Sponge

Painted pot

"Any brush marks will remain after firing, so take this into consideration when decorating."

1 Apply the base colour
Prepare and mix your base colour engobe, then apply with a wide brush. Any brush marks will not melt away when the pot is fired, so take this into consideration when decorating.

Engobes should, in general, be the consistency of double cream

2 Sponge on engobe
Apply more engobe; use a sponge for getting into hard-to-reach areas, and achieving an even coverage. If painting multiple layers, wait until the lower layer is slightly tacky before adding more.

Think about the texture the sponge will leave

Adding texture

Engobes can also be added directly to the surface of raw clay that's freshly rolled, leather hard, or bone dry. This is a great way to introduce more textural interest to your work. Apply a thick layer of engobe then run combs or other tools through it to create texture.

Brush on
Use a wide natural fibre brush to apply swathes of engobe.

Add texture with comb
Use combs of varying sizes to add texture – see Combing, pp.172–73.

3 Introduce colours
You can add colour in the form of oxides or stains to white engobe, make up a coloured engobe from scratch, or buy pre-made coloured engobes. Use brushes of various sizes to apply different coloured engobes.

4 Add more layers of colour
Build up colour and add texture as desired. When you are happy with your pot, fire according to instructions. If you intend to apply glaze on top of the engobe, you may wish to bisque fire the pot a second time before adding the glaze; this prevents the engobe from peeling off.

Artist **Sophie MacCarthy**
Clay **Earthenware**
Finish **Shiny transparent glaze**

Handles

≪ See pp.120–23

Handles, pulled and attached to thrown forms, can carry an extension of the design on the main section of the piece.

Colouring the inside of pieces

≪ See pp.164–65

Colour added to the insides of jugs, bowls, cups, and pots by pouring in slip really brings the whole design together.

Brushing-on slip

≪ See pp.168–69

Here, multiple colours of slip have been applied with a soft brush, allowing for precise placement of the different colours.

Colour showcase

One of the challenges of working with coloured slips, engobes, and glazes is learning to translate the dull colours of these liquids in their raw state into the vibrant end results. Liberal use of a bold, saturated colour palette and creative painting techniques can produce brilliant effects.

Stencils and paper cut-outs

Handmade stencils and paper cut-out shapes were used to achieve the perfect edges on these slip-painted leaves. The resultant sharp colour contrasts have great impact.

Inspiration from nature

≪ See pp.10–11

The natural world is a particularly rich resource for colour inspiration. Observing the world around you will always present you with ideas.

Wax resist

≫ See pp.198–99

Using wax resist is a great technique to employ when layering colours, as the wax emulsion can be applied with a paintbrush, ideal for fine detail.

Finishing

techniques

Finishing **techniques**

A piece of pottery is never finished until it has been through a glazing and firing process. Ceramic is glazed for decorative purposes, not only to add colour but also to give you a smooth surface that you can clean easily, especially in the case of tableware.

Once glazed, a piece is finished during the final firing, at a temperature where the glaze will melt, fusing to the ceramic. In this chapter you will learn how to achieve different glaze colours and textures, from following glaze recipes to different methods of application. The firing process itself offers yet more options for creativity - learn how to use an electric or gas kiln, and discover some alternative firing methods.

Glazing

■ See pp.186-221

This section covers mixing glazes as well as how to apply them, plus three different methods of decoration on top of a glaze. Expand your range of colours and finishes with different glaze recipes, gain an understanding of the materials, and learn what to do when things go wrong.

Making glazes (see pp.190-91)

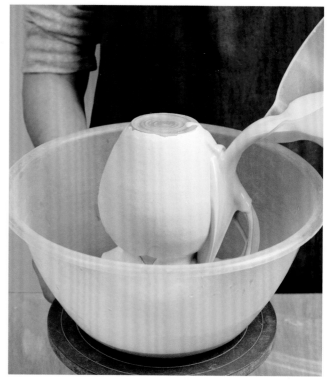

Applying glazes (see pp.200-01)

Glazes exist to suit every purpose, from simple shiny or matt base glazes to eye-catching colours and textures. With some background information about the raw material, a few recipes to get you started, and instructions on mixing a glaze, you will be ready to experiment with your own glazes to achieve the effect you want.

Applying glazes

There are several ways to apply glazes to pieces after they have been once- or bisque-fired. Starting with dipping, the simplest method, you can move on to brushing techniques. This can be time-consuming – investing in a spray gun and booth will open up a range of decorative effects and help you achieve a very even finish.

Transfers, lustre, and onglaze colours are all techniques where you decorate on top of the glaze after it has been fired. The benefit of this is that you are not working with a glaze, so it won't melt and you can be more precise. The downside is that you need an extra firing to seal on the design.

Firing methods

The two main firing methods, electric and gas, are explained in detail, alongside suggested firing cycles. Achieving a successful firing takes practice and experience; test firings are essential and it is important to always keep notes of successes and failures. Modern kilns can fire themselves with controllers but still need programming. Older kilns and handbuilt ones, fired with wood or gas, will need careful tending, with expert knowledge of how to control the fuel and flames.

Firing

■ See pp.222–41

Learn how to fire and finish your pieces in both gas and electric kilns, or achieve one-of-a-kind crackle effects with a raku firing. This section also introduces you to using a wood-fired kiln, and to ways of introducing other materials into the kiln for decorative effects.

Using an electric kiln (see pp.224–27)

Using a gas kiln (see pp.228–29)

Glazing introduction

ADDING A SURFACE FINISH

Making glazes is no more difficult than cooking. The raw materials are supplied in powdered form and mixed with water, then sieved before using. Many potters find out how their glazes perform from the experience of working with them over a long period of time. Experiment and keep notes as you expand your glazing repertoire.

Although glazing happens at the end of the making process, it can be the defining moment in the character of your work. A glaze can be as simple as a transparent finish to seal your piece, making it strong and resistant enough to hold water or be used as tableware. Altering the finish can give shiny or matt surfaces, and you can experiment by adding minerals and oxides for colour and texture effects.

A scientific approach

In order to gain an understanding of how glazes work, it is important to learn about the underlying science and the properties of the raw materials. Mixing a glaze involves careful measurement of oxides, carbonates, and minerals to create a balanced recipe that, when mixed with water (see pp.190–91), will create a glaze that adheres to the clay surface and reacts in the kiln to give the desired effect. The availability of oxygen during firing will affect whether the glaze colours remain bright or become more muted.

With a greater understanding of your raw materials and what you are asking them to do in the kiln, you can develop your own recipes, experimenting with textures and crystallization.

Not all kiln openings are happy ones and sometimes things go wrong, so troubleshooting (see pp.212–13) is another important skill to develop.

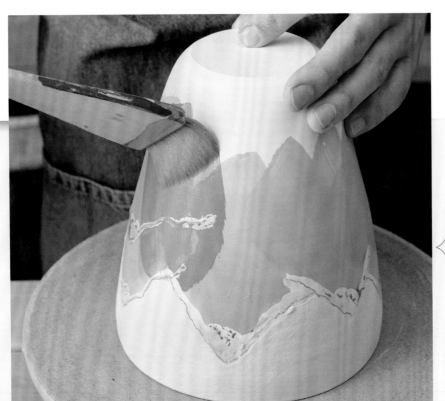

Using brushes
>> see pp.198–99
Colour, in the form of a glaze or oxide, is easily applied with a brush, giving you the freedom to use figurative or more abstract marks to create individual effects.

"Although **glazing** is a stage that comes at the end of the making process, it can be **the defining moment** in the **character of your work.**"

Using resist

>> see pp.198–99
There are several ways to add texture to a glazed piece. Here, resist is used to repel the glaze from the bisque-fired clay to "read" as mountain peaks.

Experimenting with glazes

Through an understanding of glaze properties and how to combine them, you can achieve varied effects in both texture and colour. There are many methods, from spraying and hand painting to textured and crystalline glazes, that result in either controlled or random effects that you can exploit to personalize your own pottery style (see pp.200–11).

Pouring glaze
>> see pp.200–01
An all-over glaze, both on the inside and outside of a vessel, is easily achieved by either dipping or pouring the glaze.

Spraying on glaze
>> see pp.202–03
Using a spray gun gives a fine, controlled mist of glaze that is ideal for use with unusual shapes.

Glazing raw materials

COMPONENTS OF GLAZES

Glazes are composed of three types of material: silica, flux, and stiffener, which are combined to produce the desired effect after firing. The addition of other materials can alter the glaze – to colour it, create a shiny or matt finish, or add texture.

The three main components of a glaze work together to create a stable mix. Silica is derived from pure forms of silicon dioxide, such as flint and quartz. The melting point of pure silica is very high, so fluxes are added to enable the silica to melt at the temperatures in a kiln. In stoneware glazes, the main flux is feldspar, containing alkali metal oxides, which react with the acidic silica, helping it to melt. However, alkali metal fluxes and silica do not make a stable, durable glaze, so a secondary flux is added, such as whiting (calcium carbonate). This would make a very

runny glaze, so clay, which contains alumina, is added to stiffen the melt and make it more viscous. Clay helps to suspend the other ingredients in water, strengthens the dry glaze, and makes it less powdery once applied to the pot.

Glaze properties

When two materials are mixed together and the resulting combination has a lower melting point than either of the pure materials, this is known as a eutectic. To make a shiny glaze, the glaze materials are combined in a eutectic mixture. For silica and alumina,

Cobalt carbonate (blue)

Oxides and minerals

In general, small amounts of colouring oxide will dissolve in the glaze, resulting in a transparent coloured glaze. Larger amounts will remain undissolved to produce an opaque effect.

Chromium oxide (green)

Copper carbonate (turquoise or green)

Vanadium pentoxide (yellow)

Yellow iron oxide (yellow or brown)

Rutile (tan yellow)

Cobalt oxide (blue)

Copper oxide (turquoise or green)

Iron chromate (grey or brown)

Manganese dioxide (brown)

Manganese carbonate (brown)

Bentonite

Clay
China clay, ball clay, or bentonite can be added to a glaze in powdered form as a stiffener.

Potash feldspar

Feldspar
Used as a flux. Contains either sodium or potassium oxides and will make a glaze shinier.

Quartz

Silica
Supplied to potters as flint or quartz; either material can be used in glazes.

Calcium borate frit

Frit
A manufactured mix of fluxes. The more frit that is added to a glaze, the lower the firing temperature.

the eutectic combination is 9 molecules silica to 1 molecule alumina. If you want a glaze recipe that gives a certain finish, use an online calculation program (such as glazy.org) to find the required ratio of alumina to silica.

Altering a glaze
You can adjust the property of a glaze with different additions. To make a matt glaze, reduce the silica or add more clay until the molecular ratio of alumina to silica is 1:5. To make a soft, satin matt glaze with subdued colour, add more calcium or magnesium in the form of dolomite.

To make brightly coloured matt glazes, add barium or strontium carbonate. These fluxes will produce bright colours when mixed with oxides.

Adding colour
Colouring oxides and stains can be added to a base glaze to make coloured glazes. While stains are commercially produced pigments that will not change during firing, colouring oxides will change colour on firing as they react with the materials in the glaze and dissolve to give transparency and depth. Fluxes in the base glaze will also have an effect on colour.

Dolomite Tin oxide

Altering the finish
Dolomite is magnesium calcium carbonate and is added to make a satin matt glaze. White glazes are made by adding tin oxide or zirconium silicate to a clear glaze.

Stains and underglaze colours
Stains are made by heating colouring oxides with silica and opacifiers. Use stains for red, yellow, or orange glazes, as these colours are not easy to make from oxides.

Blythe red underglaze

Daff yellow underglaze

Turquoise underglaze

Zinc oxide

Ilmenite

Adding interest
Zinc oxide is a flux used to make crystalline glazes that grow crystals as the piece cools (see p.210). Use granular ilmenite in glazes for a speckled effect.

Making glazes

MIXING YOUR OWN GLAZE

Mixing a glaze is a perfect way to personalize your pottery. To get started, try the recipes on pp.192–93, or ask other potters for their recipes, choosing whether you want a glossy, matt, or satin texture. The most useful stoneware glaze materials are potash feldspar, whiting, quartz, and china clay. Matt glazes usually also include dolomite or talc, and mid-range and earthenware glazes also include a frit.

▪ Keep accurate notes

When making your own glazes it is important to keep notes. Keep a record of firing temperatures and time cycles, and record what clay you have tested the recipe on. Make test tiles for whatever glazes and clays you will be working with; for instance, have a test tile with texture on if you work with texture.

Marking a test tile
Use an underglaze pencil, or red iron oxide mixed with water, to number your glaze tests, writing each number on the back of your test tile, along with any firing notes.

The recipe given here makes a clear glaze. To scale it up to 1kg (2¼lb) glaze, multiply each ingredient (given as a percentage) by 10. After firing at 1250°C (2282°F), a glossy finish is revealed.

1 Weigh out the glaze ingredients
Weigh the china clay or ball clay first, then the other dry materials, ticking each one off your glaze recipe as you go. You should wear a respirator mask while weighing out powdered materials, to avoid inhaling any dust.

2 Slake in water
Add the dry ingredients to a bucket half-full of water (750ml to 1kg/1¼ pints to 2¼lb dry glaze powder), sliding them in to avoid creating dust. Slake for at least half an hour; ideally several hours.

You will need

- Weighing scales
- Rubber gloves (optional)
- Stick blender (optional)
- 80-mesh sieve
- Rubber spatula or stiff brush
- Two wooden slats (optional)
- Two buckets (one lidded)
- ! Respirator mask

Glaze recipe (see pp.192-93)
- China clay 5
- Soda feldspar 45
- Borax frit 15
- Whiting 14
- Quartz 17

Glossy glaze

3 Mix together

Using your hand, or a stick blender, mix the ingredients together thoroughly. You can wear rubber gloves if you prefer, though you may find that it is easier to feel for lumps without gloves on.

Mix the dry ingredients into the water until well combined without lumps

> "Mixing a glaze is a perfect way to personalize your pottery."

4 Sieve

If your sieve does not fit over your bucket, place two slats across the rim to hold the sieve. Push half the glaze through the sieve using a rubber spatula or a stiff brush, then sieve the remaining half. Flush through with water, if necessary. Sieve a second time.

5 Check the consistency

The glaze should be the consistency of single cream, or slightly thinner. To check it, dip your hand in; it should be slightly translucent. If too thick, add more water; if too thin, leave to settle overnight then carefully pour off any water.

Glaze recipes

GETTING STARTED WITH GLAZE MIXES

A glaze recipe is a list of raw materials that add up to 100, showing the percentage of each material in the glaze by weight. You can scale up by multiplying each amount by 10 to make 1kg (2¼lb) of dry glaze. Add approximately 750ml (1¼ pints) water, to obtain a mix with the consistency of single cream, and a specific gravity of around 1.4 (see p.35).

BASIC GLAZE RECIPE

Most basic stoneware glazes are made using feldspar as the main flux. The most common secondary flux is whiting, another name for calcium carbonate, chalk, or limestone. Silica is silicon dioxide, supplied to potters as flint or quartz. Clay is added to the glaze in its powdered form; either china clay or ball clay can be used.

Basic recipe

Cone 9 1280°C (2336°F)
- Potash feldspar 27
- Whiting 21
- Quartz 32
- China clay 20

TRANSPARENT GLAZES

The differences between stoneware and earthenware glaze recipes can clearly be seen. Earthenware glazes contain less clay, and more frit is added to decrease the firing temperature. Soda feldspar gives a more fluid melt than potash feldspar, but the glaze will be slightly softer and scratch more easily. In general, the higher the firing temperature, the harder and more scratch resistant the glaze and the harder and stronger the fired clay body becomes.

Stoneware glaze

Transparent glossy
1260°C (2300°F)
- Potash feldspar 34
- Standard borax frit 14
- Whiting 16
- Quartz 23
- China clay 13

Earthenware glaze

Transparent glossy
1060–1100°C (1940–2012°F)
- Soda feldspar 27
- Calcium borate frit 39
- Whiting 5
- Quartz 23
- China clay 6

COLOURED GLAZES

These recipes give you a range of colours, from red to blue, and finishes, from glossy to matt. Colouring oxides such as chromium, manganese, iron, copper, and ilmenite are added to a base glaze recipe as an additional percentage. For example, if a recipe has 1% copper oxide, you will need to add 1g to 100g dry weight of base glaze.

Iron red stoneware
Cone 6 1220-1240°C (2228-2264°F)

- Potash feldspar 47
- Bone ash 15
- Lithium carbonate 4
- Talc 17
- Quartz 11.5
- China clay 6
- + Red iron oxide 11.5

Green glossy earthenware
Cone 04 1060-1100°C (1940-2012°F)

- Borax frit 50
- Soda feldspar 35
- Whiting 5
- Flint 6
- China clay 4
- + Copper oxide 1
- + Ilmenite 5

Satin matt pale green
Cone 8 1240-1260°C (2264-2300°F)

- Potash feldspar 33
- Talc 21
- Whiting 12
- Quartz 16
- China clay 15
- Zinc oxide 3
- + Nickel oxide 2
- + Titanium dioxide 5

Strontium matt turquoise
Cone 8 1240-1260°C (2264-2300°F)

- Nepheline syenite 60
- Strontium carbonate 21
- Lithium carbonate 2
- Flint 9
- China clay 6
- Calcium borate frit 2
- + Copper oxide 2

SPECIAL GLAZE EFFECTS

Volcanic glazes are made by adding silicon carbide to a matt glaze. During firing, the silicon carbide breaks down to form bubbles of carbon dioxide gas that bubble up through the stiff, matt glaze to form craters. Jun glazes are runny, opaque pale-blue glazes. The blue is an optical effect caused by tiny particles of phosphorus-rich glass suspended in the surrounding silica glass.

Volcanic glaze
Cone 9 1280°C (2336°F)

- Nepheline syenite 60
- Barium carbonate 18
- China clay 11
- Quartz 10
- + Rutile 2
- + Silicon carbide 2

Jun glaze
Cone 10 1300°C (2372°F)

- Soda feldspar 30
- China clay 12
- Silica 36
- Whiting 10
- Dolomite 10
- Bone ash 2
- + Bentonite 5
- + Black iron oxide 0.6

Underglazes

PAINTING UNDERGLAZE

Underglaze colour is brushed directly onto a bisque-fired surface and then coated with a clear glaze before a second firing. You can use colouring oxides (see p.188–89), commercial stains, or ready-made colours (stains mixed with china clay, frit, and a brushing medium such as gum arabic). Colouring oxides change colour on firing; manufactured underglazes and stains don't change.

PUTTING IT INTO PRACTICE

A simple stripe pattern was created on this bowl using two different colouring oxides: cobalt carbonate, which changes from pink to blue, and iron oxide, which turns from rust red to dark brown.

You will need
- Bisque-fired pot ready for glazing
- 1 teaspoon red iron oxide
- 1 teaspoon cobalt carbonate
- Small containers
- Water
- Jug
- Natural paintbrushes
- Transparent glaze
- Scraping tool
- ❗ Respirator mask

Striped bowl

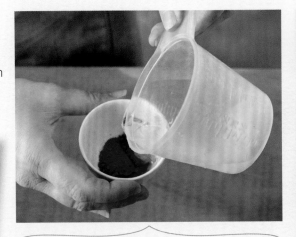

1 Mix with water
Wearing a mask, mix a teaspoon of oxide with a little water in a small container. Add more water if you want a lighter tone. Here, red iron oxide is being mixed with water.

2 Brush on decoration
Mix frequently while using, as the oxides settle quickly. Use a small, natural paintbrush to apply stripes of oxide to your bisque-fired pot.

> "Colouring oxides change colour on firing, while commercial stains will not change."

■ How to vary the tone

Some colouring oxides, particularly cobalt, are stronger than others and will need to be mixed with more water before applying to a bisque-fired piece as an underglaze. You can try lightening the colour by diluting the oxide with water, increasing the amount to produce a range of tones. Always wear a mask when mixing colouring oxides.

Diluting oxides
Here, cobalt carbonate is being mixed with water to lighten the tone. Add small amounts of water until you reach the desired level of colour. After firing, the pink cobalt carbonate turns a rich cobalt blue.

3 Brush on the second colour
Mix then apply stripes of the diluted cobalt carbonate. You can use as many colours as you like but always use a clean brush for different colours.

4 Cover with clear glaze
Dip your pot into a transparent glaze. If your pot is small or thin-walled, pour glaze into the inside, leave to dry, then dip the outside to avoid the pot becoming saturated.

5 Wipe off base
Use a scraping tool, followed by a sponge, to remove excess glaze from the base or foot ring of the pot, wiping back to the bevel. Leave to dry before placing in the kiln.

Brush glaze onto any gaps left by your fingers

Using oxides and stains

MIXING COLOUR INTO A GLAZE

Colouring oxides include cobalt, copper, chromium, iron, and manganese. They change colour on firing to produce blues, greens, and browns. For yellow, orange, and red, use commercial stains, which do not change colour on firing.

■ Testing colouring oxides

As oxides change colour on firing, it is a good idea to test before use. Either brush them onto a tile and cover with a transparent glaze or mix into a glaze. Compare a single and a double dip of glaze on two halves of a tile.

0.1% copper oxide
Mixing 0.1% copper oxide into a clear glaze produces a pale tint.

1% copper oxide
The darker tones here are created with a double layer of glaze.

1% cadmium yellow stain
For pale yellow tints, such as cadmium yellow, use a low percentage of stain.

4% cadmium yellow stain
For a deeper colour, mix a higher percentage of stain into a clear glaze.

PUTTING IT INTO PRACTICE

Mixed into a glaze, or used as an underglaze, you can add a layer of colour in one simple step. Here, a glossy turquoise glaze made from copper oxide is used on the inside, with a white matt glaze on the outside.

You will need

- A bisque-fired pot ready for glazing
- Copper oxide or carbonate
- Transparent glaze, see recipe on p.192
- Weighing scales
- Large bowl or bucket
- 80-mesh sieve
- Jug
- Sponge
- Matt white glaze
- Two buckets (one lidded)
- ⚠ Respirator mask

Jug with coloured interior

1 Mix the glaze
Weigh the copper oxide onto a folded piece of paper – it will make up 1 per cent of the total glaze. Add to the transparent glaze ingredients. Leave to slake and then mix (see p.190). Sieve the glaze a few times, adding water until it resembles thin cream.

Sprinkle the copper oxide into the glaze mix

> ## "Mixed into a glaze, or used as an underglaze, you can add a **layer of colour** in one simple step."

Pour all the glaze into the pot and coat the inside

Place your hands into the pot and press gently outwards to hold

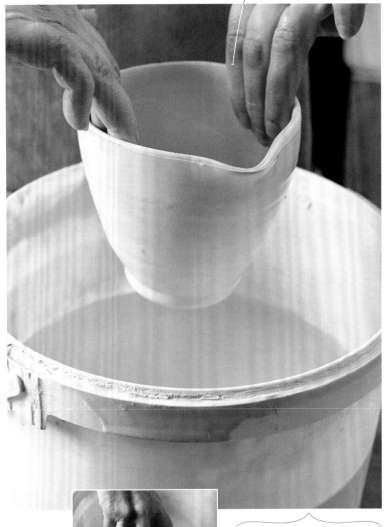

2 Apply the glaze
Pour the mixed glaze into the pot and swirl around to coat the inside, then pour out. Make sure you apply a single, even layer; a thicker application may produce a stronger colour.

3 Wipe excess
Wipe away any drips or excess glaze from the top edge and the outside of the pot with a sponge. Leave to dry for around half an hour; if you glaze the pot again too soon it will still be wet, so the second coat of glaze will not be absorbed.

Turn upside-down and dip the rim by 2–3mm (⅛in)

4 Dip outside
Holding the pot on the inside, dip the outside into the glaze up to the rim. Then, after leaving it for a minute or two to dry, turn the pot upside-down, and dip it again to coat the rim. Shake lightly to get rid of any drips. Clean the base before firing.

Using resist

USING WAX AND STICKERS TO REPEL GLAZE

Wax resist is used when glazing, either on the bottom of pieces, between a lid and pot, or simply as decoration. The wax repels the glaze while glazing and burns off during firing, leaving an unglazed area. Some resists can be peeled off and the shapes filled to build layers of surface decoration. These methods produce fumes during firing, so kilns should be well ventilated.

PUTTING IT INTO PRACTICE

A simple mountain landscape is illustrated on this bowl using just two glaze colours and cobalt oxide. The mountain peaks were picked out with a wax resist, which reveals the clay colour.

You will need
- Biscuit-fired bowl
- Pencil
- Paintbrushes
- Wax
- Wooden bat
- Banding wheel
- Glaze in two colours (white and blue)
- Cobalt oxide mixed with water

Wax-resist bowl

"Shapes such as **circles, rings, or stars** can be used to make satisfyingly neat, **repeated designs.**"

1 Draw the design
Outline your design on the bisque-fired pot in pencil, as a guide for where to apply wax. Don't worry about the pencil marks – the graphite will burn away in the kiln.

2 Paint with wax
Dip a thin brush into wax resist and brush it carefully onto your pot, following the pencil lines. Fill in any other details, such as snow on the mountain peaks.

3 Brush on white glaze
Paint the sky above the mountains in white glaze. Note that when you brush over the wax, it repels the glaze without affecting the clay underneath.

Make use of any sticker

You can use any adhesive label, sticker, or even masking tape as a resist. Shapes such as circles, rings, or stars can be used to make satisfyingly neat, repeated designs. More complex stickers also work well when painted over to create a silhouette in the glaze. These can be peeled off and the blank area filled in with glaze, or left unglazed.

Repeated star design
A regular repeat pattern has been created here with small star stickers and then painted over with a yellow glaze before firing.

Bird silhouette
Here, a paper sticker of a bird resting on a branch is glazed over. When the paper is removed, glaze can be added to the space.

4 Paint the blue glaze
Once the white has dried, turn the pot upside-down and place it on a bat on a banding wheel. Paint the lower section with blue glaze, going right up to the wax. Do not paint the base. Wipe excess glaze from your brush to avoid drips.

Hold the pot steady with one hand while you paint the glaze

Use a clean brush to apply the wash of cobalt oxide

5 Add more detail
Use a wash of cobalt oxide mixed with plenty of water to add a shadow to one side of each mountain. Take care not to wash off the glaze with the watery oxide; just paint on a light coat. When finished, leave the pot to dry before firing.

Applying glazes

DIPPING AND POURING

These two methods are probably the most common ways of glazing a pot. Whether you can just dip the pot in the glaze or pour it over will depend on the size of your piece and the size of the glaze bucket.

DIPPING

Make sure that the glaze has been well stirred and always give it a stir again just before dipping. Check that the bucket is wide and deep enough for your pot; you need to be able to move the pot in the glaze bucket either with your hand or with tongs.

You will need
- Bisque-fired pots
- Glaze tongs
- Your chosen glaze in a bucket
- Sticks or brushes (to stir the glaze)
- Soft paintbrush
- Sponge
- ⚠ Respirator mask

Dipped mug

Hold the pot with one tong on the outside and one on the inside

Ensure the glaze bucket is wide enough to easily move the pot around

1 Immerse in the glaze
Pick up the bisque-fired pot with your hand or glaze tongs. Dip the pot into the glaze. The longer you leave it in, the thicker the glaze will be. Always let it drip over the bucket before putting it down the right way around.

2 Touch up
Your piece will have small, unglazed spots where your fingers or the tongs were holding it. Use a small, soft brush to cover them over with a drop of glaze and use a clean, damp sponge to remove glaze from the base of the pot so it doesn't fuse to the kiln shelf during firing.

Removing air bubbles

No matter how you apply your glaze, it is possible that you'll end up with a few small holes from air bubbles, especially if your pot is textured. Touch these up before firing, particularly if using matt glazes which don't run together, so any unglazed areas won't remain once fired.

Finger rubbing
When the glaze is touch-dry it will have a powdery texture. Wear a mask and use your finger to push the powdery glaze into any unglazed spots.

POURING

For round forms that are too big to be dipped, it is best to pour glaze over them, using a bowl to catch the excess. Always glaze the inside first: that way you don't risk adding unwanted drips on the outside.

Glazed jug

You will need

- Funnel
- Large bowl
- Bisque-fired pot
- Banding wheel
- Your chosen glaze in a jug
- Sticks or brushes (to stir the glaze)
- Soft paintbrush
- Sponge
- ⚠ Respirator mask

1 Position the pot
Put an upturned funnel in the bottom of the bowl and place the pot on top. The inside of the pot has already been coated.

Position the bowl on a banding wheel

2 Pour the glaze
Use a jug to pour the glaze over the pot while slowly spinning the banding wheel to get a smooth and even coat. Dab drops of glaze onto any thin or unglazed areas using a brush. Use a sponge to remove glaze from the base of the pot so it doesn't fuse to the kiln during firing.

Spraying glazes

USING A SPRAY GUN

Spraying glazes offers the perfect solution to the difficult task of glazing an unusual or large shape, and is also a great way to blend colours. You can achieve a very even finish provided the piece is being turned and the spray gun is moving continuously. Since a fine mist of glaze is produced, take care while using a spray gun and booth: always wear a respirator mask to ensure that no glaze particles are inhaled.

■ Creating different effects

Learning how to control the spray gun is key to creating different effects. The angle at which you hold the gun, and the distance from the piece, will affect the coverage of the glaze. It is important not to stay in one area with the gun for too long – aim for a fine powdery coating.

Intense colour
To achieve a more intense colour on a small area, hold the spray nozzle a short distance away from the shape, and spray a quick burst of glaze.

Shadow effect
Angle the spray gun so the glaze only hits one side of the shape to create the illusion of shadow.

The spray gun has been used to its full potential on this sculptural form. The spiky design has been highlighted using three different glazes, with a darker glaze creating shadow effects on the underside of the spikes.

You will need
- Bisque-fired shape
- Wax
- Paintbrush
- Banding wheel
- Spray booth
- Base glaze with two colour additions
- Jug
- Spray gun with decompressor
- Sponge
- ❗ Respirator mask

Sprayed piece

1 Prepare your piece
Paint wax resist onto the points that the piece stands on, so the glaze doesn't cover those parts. This prevents the glaze from melting where it rests in the kiln. Place into the spray booth.

2 Fill up the spray gun and test

Put your base glaze into a jug to aid pouring. The consistency of the glaze is important: it must be thin enough that it won't clog the nozzle of the spray gun. Water it down if necessary. Fill up the spray gun, put on your protective mask, and test the glaze in the booth.

3 Apply the base glaze

Begin spraying a fine, continuous mist of glaze over your shape, turning the wheel to rotate the shape while moving the spray gun up and down. Aim for a powdery coating of glaze that doesn't glisten – too much, and it will drip. Once evenly coated, remove, then clean the booth.

4 Spray coloured glazes

Run water through the spray gun to clean it, then refill with your first coloured glaze. This time, spray half of the shape, holding the gun in different positions. Use the second glaze for a shadow effect. Clean the gun and booth between colours.

Shake the spray gun every so often, to ensure the glaze does not settle

"The angle at which you hold the gun, and the distance from the piece, will affect the coverage of the glaze."

Hand-painting decoration

APPLYING GLAZES WITH BRUSHES

Painting onto pottery using brush-on glazes or in-glaze decorating techniques, such as maiolica, is an excellent way for the beginner potter to personalize their wares. You only need a small pot of glaze and a brush to get started.

BRUSH-ON GLAZES

Brush-on glazes contain a "glue suspender", which ensures the glazes form an even coverage. They also dry quickly and layer well; here, strokes of orange overlay pale yellow for a bold contrast.

You will need
- Bisque-fired pot
- Banding wheel
- Hake brush
- Paintbrushes, various sizes
- Brush-on glazes in white, yellow, brown, and orange

Painted plate

1 Paint the background
Apply the base layer of shiny white glaze with a hake brush to maximize the coverage of each stroke. Leave for a minute or two to dry, then paint the yellow petals using a medium brush; brush from the rim towards the centre.

Use a darker colour on top where you overlap layers of a glaze

2 Paint the flower centre
Once the yellow glaze has dried, paint the flower centre in brown glaze using short strokes. Here, two layers ensure that the glaze colour is strong; check your glaze pot as this may vary.

3 Add detail
Using a finer brush, highlight one edge of each petal with a stroke of orange glaze. Brush-on glazes are great for layering up so you can experiment with different combinations of colours or patterns from light to dark.

Achieving an even application of glaze

When painting a large area in a single colour, watch out for an uneven coverage or brush marks where the strokes overlap. For an even application, brush in different directions, working with a flat hake brush to cover a wide area.

Brush in one direction
Paint thick lines from one side to the other, keeping the overlap to a minimum and using the same amount of glaze for each stroke.

Add a second layer
Brush-on glazes can be layered, so paint a second layer from top to bottom over the first, keeping the strokes even.

MAIOLICA

For maiolica, also known as faience or delftware, oxides or stains are mixed with frit to produce colours that melt into the glaze; they are traditionally painted over earthenware coated in a white opaque glaze.

Painted cup

You will need
- Glazed earthenware pot (1 day old)
- Pencil
- Oxides and stains
- Brushes
- Scalpel (optional)

Glaze recipes
Blue:
- 1 part cobalt oxide
- 1 part rutile
- 0.5 part borax frit

Yellow:
- 1 part yellow stain
- 1 part borax frit

Black:
- 1 part manganese
- 0.5 part copper oxide
- 1 part china clay

1 Apply the first colour
You can either paint freehand or draw your design onto the pot in pencil first. Start with the first colour, here the blue, applying it onto the dry, glazed pot with a clean paintbrush and gentle strokes.

2 Add another colour
Use a clean brush for each subsequent colour. Lightly paint the bird's head in yellow, taking care not to overlap colours, as they might mix.

3 Outline the design
Use a fine brush to outline the design in black, adding fine details. Work carefully to avoid making mistakes; you can use a scalpel to scrape away errors, but it may leave an indent.

Incorporate the white base glaze in the design; a limited palette has more impact

Raw glazing

GLAZING UNFIRED PIECES

Applying glaze onto unfired clay requires confidence and a good understanding of the state, thickness, and delicacy of your clay. Raw clay dipped into glaze quickly absorbs water, so ensure the pot is completely dry, and work quickly to avoid letting it soften and collapse. Further decoration, such as flecks of oxide, can then be added. Raw glazed pots need a long pre-heat in the kiln.

▧ Brushing glazes on leather-hard clay

Brushing glaze onto clay that has not been fired can be tricky, especially on flat, smooth surfaces, as the clay will absorb water, causing the brush to stick or the clay to disintegrate if too much water is present. To control this, make sure you add raw glaze at the leather-hard stage, using a large brush. You should see the water in the glaze drying as it is sucked into the clay body.

Brushing on raw glaze
Apply the glaze with a soft, heavily loaded brush, using swift and even strokes. Brush once and move on to the next area. Reload the brush regularly.

When dipping a fully dry pot, ensure you have enough glaze in a container to dip the piece. Before you begin, consider how you will hold and move the piece through the glaze to gain an even application.

1 Check the glaze consistency
Stir and sieve your glaze before using, pouring it into a clean bowl or bucket, and testing the consistency with your hand. If you are dipping a simple or plain unfired shape, then the consistency of single cream is a good rule of thumb to follow.

2 Dip the first half
You will need to work quite quickly: if left in the liquid for too long, the water may disintegrate your work (and contaminate your glaze). With dry hands, dip the pot into the glaze for a few seconds.

Glazed, flecked pot

You will need

- Dry clay vessel for glazing
- Clear glaze
- Stirrers
- 80-mesh sieve
- Bowl or bucket
- Sponge
- ⚠ Respirator mask

Minimize the cross-over of the glaze applications

3 Dip the second half
Wait for the first dip to dry fully before dipping the second half – you should be able to touch the glaze without affecting the application, and the glaze should appear matt. Dip the other half with an even coverage. Shake lightly to remove drips.

Fingertips act as a very fine sanding surface, helping blend any ridges in the glaze

4 Check the glaze
Using either a dry sponge or your finger, smooth any unevenness, taking care not to use too much pressure, which can remove the glaze. Wear a mask, and work over a bowl of water to catch the powder.

Always wipe bases or areas that will come into contact with the kiln shelf, or they will stick during firing

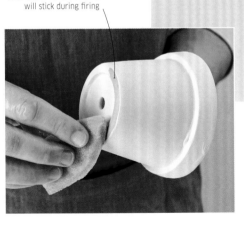

"**Raw glazing** is a technique that requires confidence and a good understanding of your clay."

Textured glazes

USING LICHEN GLAZES

There are several glaze materials that can be used to make lichen glazes: clay, zinc oxide, or light magnesium carbonate. When applied thickly in a glaze, these materials cause the glaze layer to shrink and crack, taking on the appearance of a dry riverbed. During firing, the material shrinks further, causing a textured shrink-and-crawl effect.

▪ Take care when handling

Try to keep handling to a minimum to reduce the risk of damaging the glaze. When applied thickly, the dry lichen glaze becomes cracked and fragmented. Take care when handling the dry pot, as sections of glaze can be easily knocked off; even if you cannot see many cracks in the glaze, it is still liable to chip.

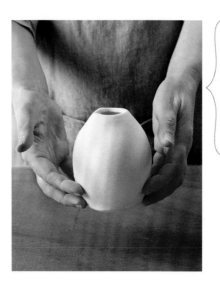

Lifting a fragile glaze
Lift pots with fragile glazes from the base, rather than grabbing hold of the main body of the pot. Use the fingertips of both hands to lightly cradle the pot as you move it.

The all-over textured surface on this pot is created using a magnesium carbonate-based glaze. The entire pot was dipped twice in glaze before firing, to ensure a thick coverage.

You will need
- Bisque-fired pot ready for glazing
- Bucket or bowl
- 80-mesh sieve
- Sponge
- Paintbrush

Glaze recipe (see pp.192–93)
- Light magnesium carbonate 40
- Nepheline syenite 50
- Borax frit 10

Lichen-glazed pot

1 Mix and sieve
Add the dry materials to a bucket or bowl containing 180ml (6fl oz) water. Scale up quantities for a larger pot. Leave to slake, mix well, then push twice through an 80-mesh sieve, adding more water to achieve the consistency of thin cream, if necessary.

"During firing, the glaze material shrinks further, causing a textured shrink-and-crawl effect."

2 Apply thickly

Dip the pot into the glaze – depending on the size of your pot, and how much glaze you have, you may need to dip half at a time. As soon as the first coat has dried, apply a second coat. The glaze needs to be thick enough that it cracks on drying. Wipe off any glaze from the base of the pot.

Any missed areas can be filled in with a brush

3 Leave to dry

Allow your pot to dry for around half an hour. At this stage, keep handling to a minimum (see left). If you knock off any glaze, you will have to reapply.

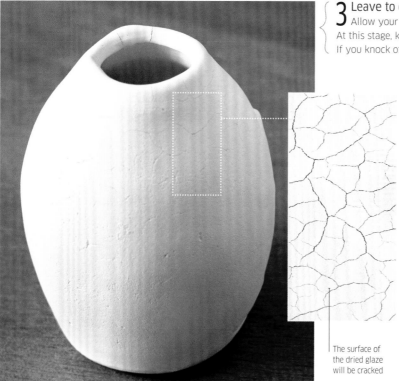

The surface of the dried glaze will be cracked

4 Place in the kiln

Holding the pot at the base, put it in the kiln, making sure not to knock off any glaze. Fire to 1250°C (2282°F). The glaze will continue to shrink and crawl, leaving small islands of glaze.

Crystalline glazes

GROW CRYSTALS IN YOUR GLAZES

Crystalline glazes usually contain zinc oxide, which reacts with the silica in the glaze to form zinc silicate crystals. You can grow the crystals by holding the temperature at 1050–1100°C (1922–2012°F) for several hours at the end of firing, known as a slow cool. The crystals take up certain colouring oxides; cobalt and nickel give blue crystals, while copper colours the background green.

PUTTING IT INTO PRACTICE

The zinc silicate crystals in this glaze pick up blue from the cobalt. Don't worry if the glaze cracks and shrinks before firing – it will melt back together in the kiln. This glaze does not need a slow cool.

You will need

- Bisque-fired dish ready for glazing
- 80-mesh sieve
- Rubber spatula
- Bucket or bowl
- Jug
- Paintbrush
- Sponge

Glaze recipe (see pp.192–93)
- Potash feldspar 63
- Zinc oxide 17
- Dolomite 16
- Rutile 3
- Cobalt carbonate 1.6

Crystalline-glazed dish

1 Mix and sieve
Prepare the glaze (see Making glazes, pp.190–91). Make sure that no glaze material has settled on the bottom of the glaze bucket when you mix and sieve the glaze. The glaze has no clay content, so it may settle quickly; keep mixing it from time to time with a rubber spatula while you are glazing.

> "Don't worry if the glaze cracks and shrinks before firing – it will melt back together in the kiln."

2 Apply the glaze
Pour glaze into the inside of the dish from a jug, swill around and pour off. If you intend to glaze the outside of tall pots by dipping or brushing, apply glaze thinly at the bottom, and more thickly at the top, as this glaze is very runny when it melts.

Very runny glazes

These glazes are often very runny. You can make a specially shaped dish to catch the glaze and prevent it from ruining your kiln shelves. Glaze catchers must be made to fit each piece; measure the base of your pot and make a small dish for it to sit in.

Catching the glaze
Match the diameter of the central foot ring to the base of your pot, with a wide rim to catch drips.

Separating the pot
Use a knife or chisel and hammer to separate the pot and glaze catcher after firing (wear goggles).

Finishing the base
You will need to grind down the base of the pot with sandpaper after removing the glaze catcher.

3 Brush the rim
Brush glaze around the rim of the dish – take care not to let it drip down the sides though.

4 Clean the base
Sponge off any drips or runs of glaze that trickle onto the base of the dish. If you glaze the outside of the pot, you may need to use a glaze catcher (see above). Fire to 1250°C (2282°F).

Troubleshooting glazes

GLAZE FAULTS

Opening the glaze kiln can sometimes reveal unexpected, and unwanted, results. Faults in the glaze present themselves as crawling, crazing, blisters, and pinholes – and sometimes cracks through the piece. Understanding what has caused each problem, and adjusting your glaze or kiln accordingly, is part of your pottery journey so that each batch you fire will add to your knowledge of the craft.

CRAZING

Crazing occurs when the glaze contracts more than the clay body during cooling. A network of cracks forms in the glaze when the pot is removed from the kiln or some time later, accompanied by pinging sounds. Crazed glazes are not recommended for functional ware but some potters like the decorative "crackle" effect. To correct, add a small amount of a low-expansion material, such as talc, to the glaze.

To correct crazing:
- add 5% silica, talc, or calcium borate frit

Crazed surface
Fine cracks form when the glaze is under tension during cooling, resulting in a spider's web pattern across the surface.

SHIVERING, SHELLING, AND DUNTING

The opposite of crazing is called shivering, when the glaze contracts less than the clay body during cooling. A similar problem, called shelling, occurs in slipware. Chips of glaze may flake off rims and edges, or it can even cause the pot to crack, known as dunting. To correct this serious fault, add high-expansion materials containing sodium, including feldspar and high-alkaline frit. Reducing the silica in the glaze will also help.

To correct shivering, shelling, and dunting:
- add 5% feldspar
- or reduce silica by 5%

Shelling
Similar to shivering, flakes of slip or glaze break away from the surface along edges.

Dunting
This problem occurs during cooling, and results in a crack through the pot.

"Understanding what has caused each problem, and adjusting your glaze or kiln accordingly, is part of your pottery journey."

CRAWLING

Resembling beads or islands on top of the bare clay surface, crawling is a glaze defect that can occur when the glaze is applied too thickly and does not properly adhere to the surface, resulting in cracks on drying. It can be corrected by applying the glaze more thinly or reducing materials with high drying shrinkage, such as clay and zinc oxide. Crawling is sometimes caused by greasy or dusty bisqueware: sponge before glazing.

To prevent crawling:
- apply glaze more thinly
- reduce clay content
- and/or sponge bisqueware

Islands of glaze
Caused by problems with application and adhesion, crawling results in pools or beads of glaze that reveal the clay beneath.

PINHOLES AND BLISTERS

Other problems are caused by underfiring or overfiring the glaze. Underfiring, when the kiln doesn't reach the correct temperature for the glaze, can cause pinholes, while overfiring, when the kiln is too hot, can cause the glaze to run, resulting in blisters in the glaze. Pinholes can be healed by holding the peak temperature at the end of firing, known as soaking. Blisters can be ground down and re-fired.

To smooth pinholes:
- soak for 15–30 minutes (hold peak temperature) at the end of firing

To avoid blisters:
- fire to a lower temperature
- or apply glaze more thinly

Pinholes
Tiny holes appear in the glaze surface when the glaze is underfired.

Blisters
Burst bubbles appear on the surface when the kiln temperature is too hot.

Onglazes

ADDING COLOUR IN THE FORM OF ONGLAZE

Onglaze is colour applied to an already-fired pot, which is then fired again at 780–850°C (1436–1562°F) to seal the colours. Onglazes are available in powder and liquid form as well as in small blocks. Onglazes allow you to see the colours as they really are and, unlike underglazes and inglazes, which can change dramatically in the kiln, onglazes remain more or less the same after firing.

◼ Mixing colours

Just like ordinary paints, onglazes can be mixed to create a rainbow of shades. Understanding the colour wheel (below) is the gateway to endless design possibilities. Experiment with colour-mixing to create the colours you want.

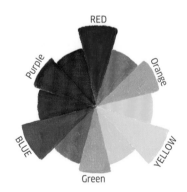

RED

Purple

Orange

BLUE

YELLOW

Green

The colour wheel
The primary colours – red, yellow, and blue – can be mixed to create the secondary colours – orange, green, and purple.

Using a palette
An artist's palette is a useful thing to have around if you work with onglazes, as colours can be arranged side by side and mixed as needed.

A large white vase like this one is the perfect blank canvas on which to experiment with colour. If your piece already has surface decoration, consider using onglaze colours to accent the design.

1 Prepare your colours
Mix powdered onglazes with a couple of drops of water or gum arabic in a palette. Use a brush to mix to the right consistency; it should be a thin gel, but not drip off the brush.

2 Plan your design
Before applying any onglaze to your pot, plan your design on paper. Consider how it will look on the curved surface of your finished piece.

3 Draw design in pencil
Use an ordinary pencil to outline your design on the pot. Do not worry about the pencil marks – they will burn off in the kiln. If working on a shiny glazed piece, you will have to draw with a felt-tip or marker pen.

You will need

- Glazed, fired pot
- Onglaze colours
- Water (if your glaze is matt) or gum arabic (if it is shiny)
- Slip trailer/dropper for water
- Palette
- Paintbrushes
- Pencil
- Paper
- Banding wheel or stand
- Sponges

Colourful vase

4 Sponge on onglaze
Start with the main pattern. Apply onglaze to a dry sponge using a brush, then sponge the onglaze onto your pot. You can layer colours, but remember to use a clean sponge if you don't want them to mix.

5 Add finer detail
Use a thin brush to add more detail to your design. If you make a mistake, take a clean paintbrush, dip it into water (you may need to use a solvent to remove oil-based onglaze), and carefully brush over the mistake to neaten it. Wipe any smudges off the base of the pot.

Transfer printing

ADDING PRINTED PATTERNS

Transfers, also known as decals, are readily available and easy to use. You can either buy patterns or print your own custom designs or photographs onto coated gummed or waxed paper. For successful application, you need a clean working environment and clean hands. Once applied, the transfer is fired at 800°C (1472°F), which melts the print on but isn't hot enough to melt the glaze.

PUTTING IT INTO PRACTICE

A scattered butterfly design adds interest to this simple pastel plate. The intricate detail in the butterfly transfer would not be possible with any other ceramic decorating technique.

You will need

- Ceramic transfers
- Scissors or scalpel and cutting mat
- Bowl
- Kettle
- Banding wheel
- Smooth rubber kidney or sponge

Transfer design

> "Either **buy commercially** available patterns or **print your own custom designs** or photographs."

1 Cut out the designs
Remove your chosen transfers from the sheet, cutting around the edge of the designs using a pair of scissors or a scalpel on a cutting mat.

2 Soak in water
Put the transfers in a bowl of hot water and leave for about one minute. The hotter the water, the less time you need to wait, but take care as the transfers will crinkle if it is too hot.

3 Test the transfer
When the image slides off the base it is ready to apply. Push the transfer gently to slide it partially off the backing paper; take extra care if it is a delicate design.

Cutting darts

To allow the pattern to sit flat against a curved surface, you can try cutting darts to avoid creases or folds in your design. Use very warm, not hot, water to manipulate the transfer.

Cut darts
On a cutting mat, use a scalpel to cut out a narrow dart from the middle to the edge of the design.

Apply transfer
Gently separate the dart then apply to the pot, smoothing it out from the middle without ripping.

Sponge overlaps
If you do get an overlap in your transfer, you can use a hot sponge to smooth it down.

4 Apply the transfer
With the plate on a banding wheel, place the part of the transfer that has been pushed away from the backing paper onto the plate, then press it lightly with your finger as you slide the paper away from the rest of the transfer.

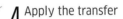

Choose where you want the transfer to go before sticking it down as it can't be picked up again

5 Smooth out air bubbles
Use a rubber kidney to smooth over the transfer, releasing any air bubbles. Do this gently to avoid tearing or moving the transfer. You can also smooth over any bubbles or creases in the transfer with a hot, wet sponge to prevent ripping.

Lustres

APPLYING LIQUID GOLD

Adding lustres to a glazed piece produces something extra special. Metallic lustres are expensive, so are often used as an accent on a piece, a line along a rim, or as dots or stripes. Lustre is painted onto glazed pieces and then fired again to 720–790°C (1328–1454°F), which sets the lustre onto the surface without melting the glaze. Lustre has toxic fumes in liquid form, so always wear a respirator mask when using it and apply it in a well-ventilated room.

■ Creating contrast

Accents of metallic lustre can be further highlighted when combined with a matt glaze or bare clay surface. While glazing you can use resist techniques to mark out the areas you will later decorate. A little goes a long way with lustre. Mix the right amount: too thick a coat and it will burn away, too thin, and it won't work.

Bold contrasts
Lustre pairs well with matt or bare clay, creating an interesting contrast between the gilded stripes and the natural base material. Plan your pattern or design to accent these differences.

The warm colour of the glazed pot, and its elongated design, are enhanced by the elegant stripes of the brilliant gold lustre. The faceted gold lid brings the whole piece together.

You will need
- Glazed pot with lid (ensure it is clean as grease will repel lustre)
- Banding wheel
- Gold lustre
- Natural paintbrushes
- ❶ Respirator mask

Pot with gold lustre stripes

1 Load brush
Work in a well-ventilated room and wear a respirator mask. Dip the brush into your chosen lustre, ensuring the bristles are completely coated and glistening. Wipe off the excess on the edge of the bottle, to avoid drips or wastage.

"A little goes a long way with lustre.
Mix the right amount: too thick a coat and
it will burn away, too thin, and it won't work."

2 Paint the lid
Apply an even coverage of lustre to the lid,
holding it by the unglazed base as you paint.
Try not to overlap or repaint any areas, and
wipe away any runs. Allow to dry completely
before handling and loading into the kiln.

Steady your hand on
the wheel as you start
to paint the next line

3 Paint the stripes
To decorate the pot with painted stripes, either
hold it or place on a stand. Try not to handle your
pot too much, to avoid getting it greasy. A banding
wheel will help and means you can get all the way
around the piece without the risk of smudging lines.

Hold the pot lightly
if not using a
stand or wheel

Artist **Jose Carvalho**
Clay **Stoneware, porcelain, and raku**
Finish **Various**

Pouring glaze

<< See p.201

Multiple blue, white, and transparent glazes have been poured onto this bowl, with wax resist used to keep them separate.

Altering glaze texture

This vessel was coated in a white then a turquoise glaze. Small scratches were made in the glaze to let the white bleed through before it was sprayed in turquoise.

Using resists

<< See pp.198–99

Tape, cut into triangles, was used as a resist while this bowl was dipped in glazes. Manganese oxide was then applied to the areas under the tape.

Glazing showcase

This collection of pieces uses glaze decoratively to striking effect. The richness of the base blues and aquas is achieved by dipping, pouring, and spraying the glazes, while the details are added using a wide range of techniques, from fine brushwork to wax and tape resists.

Glaze accelerators

A white glaze was applied around the rim of the bowl using a slip trailer, then an accelerator was added to make it run further and create the speckled texture.

Textured glazes

« See pp.208–09

This vessel has a coat of white slip on the inside, and is dipped in a matt, indigo-blue glaze, which highlights the coarse texture of the groggy clay.

Spraying on glazes

« See pp.202–03

This deep, smooth blue was achieved by spraying the glaze after bisque firing. A wax resist was used to protect the slip decoration.

Firing introduction

TURNING CLAY INTO CERAMICS

Using a kiln to fire your pots is an essential part of the making process. Kilns can be powered by electricity, gas, or wood to heat them up to a temperature where the clay and glazes can mature. Usually, pots are fired twice, the first bisque firing at a low temperature, then at a higher temperature to set the glaze.

Using a kiln

Your pots need to be fired to transform the raw clay into ceramic, known as bisqueware. A second firing is then carried out to set the glaze. Preparing your pots for the kiln, including making sure they are dry and don't have any glaze on their bases, is an important part of the making process. In the first firing, you will use a firing cycle to control the rise in temperature. For the second firing, you pack the pots into the kiln in a different way and fire a little faster. Oxidation, with oxygen present, is the most common way to fire in an electric kiln.There are clear inherent risks when firing ceramic pieces using a kiln. Modern kilns are extremely easy to use and safe to run, but if your pots aren't loaded correctly or are badly made, they could break during firing.

Other types of firing

Gas and wood firings are a little different, but the kilns are loaded in a similar way. Usually, you will either bisque in an electric kiln before glaze firing in a gas or wood kiln, or raw glaze and only fire once. The magic of firing with a gas kiln is the ability to fire in a reduction atmosphere, where oxygen is removed, creating a particular palette of copper reds, celadon greens, and blues

Kiln packing
>> see p.224
Here, stacked bisque pieces are loaded into an electric kiln prior to firing. At the bisque stage you can layer pieces inside each other to make the most effectve use of your kiln space.

"Preparing your pots for the kiln is an important part of the making process."

Gas firing
>> see pp.228–29
This unique celadon glaze colour is achieved only by firing with gas in a reduction atmosphere. The firing cycle is an important part of any firing and can have an effect on the finish of your glaze.

not achieved in oxidation. Introducing salt or soda ash into a gas or wood kiln when the glaze is melting produces a distinctive orange peel effect. Alternative firing methods such as raku, saggar, and smoke firing present health and safety concerns. Wear appropriate safety gear, and be prepared with all drums, tongs, and other tools before you begin; some firing processes, such as raku, happen fast, as you remove the pots when glowing hot. Raku produces unique crackle glaze effects, ensuring every pot is one of a kind.

Raku firing
>> see pp.232–35
Raku is fast and hands-on. You are directly in charge of heating and cooling, and through post-firing techniques can have some control over the outcomes of each piece.

Saggar firing
>> see p.239
(top right) Items such as leaves, feathers, and horse hair can be packed alongside pots in containers called saggars to create stunning decorative effects during firing.

Using an electric kiln

LOADING, FIRING, AND UNLOADING

An electric kiln is an efficient, safe, and popular way to fire clay. Always follow the manufacturer's instructions for proper installation. Kilns come in two designs: top-loading or front-loading. We have used a top-loader but you would use a front-loader in the same way. Handle pots fired in the first and second firing in different ways.

▨ Making the most of your kiln space

For your first firing, use your kiln space effectively by layering, ensuring pieces are not too tightly packed as too much tension during firing can lead to cracking.

Pieces inside each other
Vessels can be fired inside each other as long as the pieces have wiggle room to shrink.

Pieces up-ended rim to rim
Stacking is also a great method to make good use of space. Pots can be stacked rim to rim and even have other pieces inside them.

STAGE 1: PACKING A KILN FOR FIRST FIRING

The purpose of the first firing is to slightly under-fire your pot by taking it to a temperature that is under the firing range of your clay. The pot will be strong enough to handle but still porous; ideal for glazing.

You will need
- Electric kiln
- Kiln shelves
- Brush
- Props of identical height
- Dry, raw pots
- ❗ Kiln gloves

1 Put the shelf into the kiln
Brush the shelf clean before placing in the kiln and resting on the supports below. The bottom kiln shelf should not be placed directly onto the kiln floor but raised a little so the kiln will fire more evenly.

2 Add props
Place three props evenly spaced at the edges of the shelf and aligned exactly over the props on the shelf below, all the way down the kiln. The upper shelf should sit 5mm (¼in) higher than the pots.

"After the first firing, the pot is strong enough to handle but remains porous, which is excellent for glazing in the next stage."

3 **Add the pots**
Carefully place your pots into the kiln – at this stage the clay is fragile, and will break easily if you apply too much pressure. Pack them in tightly, so they are almost touching.

4 **Close the lid**
Gently close the kiln lid and attach clips as per the manufacturer's instructions. Use the kiln programmer to control the temperature, timings, and cycle of the kiln.

5 **Unload**
Only unload once your kiln has cooled to below 100°C (212°F) and wear protective gloves. The fired pieces will have changed colour and shrunk slightly.

The clay has shrunk to leave larger spaces in between

Wear kiln gloves to protect your hands when lifting the kiln lid and removing fired pieces

STAGE 2: PACKING A KILN FOR GLAZING

The bisque-fired pots are covered inside and out with a powdery glaze that is transformed during the second firing. As glazes can bubble on the surface during firings, allow extra space between the pots.

You will need

- Electric kiln
- Glazed bisque-fired pots
- Props
- Kiln shelves
- Silica sand
- ❗ Kiln gloves

Glazed pot

1 Load the kiln
Place pots of a similar height within the diameter of the kiln shelf, spaced at least 5mm (¼in) apart. Add three props, checking that the pots are below the height of the prop before adding the top shelf.

"Opening a glaze kiln brings joy to even the most seasoned of makers."

Silica sand on the shelf will prevent the pot from dragging when firing

2 Put down silica sand
When firing large items, or those with a wide base, put a thin layer of silica sand down on the shelf before placing the item on top. The sand acts as a roller system, allowing the pot to shrink without its base dragging along the surface of the shelf.

3 Program the kiln
Use the kiln programmer to control the temperature, timings, and cycle of the kiln. Modern kilns are fitted with an electric controller as standard. You can use this to pre-program firing schedules.

4 Open the kiln

Do not open the lid of the kiln before the temperature is under 60°C (140°F). Always wear thick gloves when working with a hot kiln: open the lid and lift out the top shelf.

Once fired, the glaze won't be affected if the pots make contact

5 Unload

Now that the pots have been fired they are much more robust. Take them out carefully, still wearing your gloves as the pots and kiln will be hot. Remember that the finished pots will take some time to cool down.

Using a gas kiln

REDUCTION FIRING WITH GAS

Firing with gas allows you to control and limit oxygen at critical periods, known as reduction firing, which results in a distinctive range of colours or flecks of texture. Four factors are critical: how the kiln performs; glaze and clay types; the firing programme; and the use of kiln furniture. Test firings are the best way to understand your kiln.

■ Creating a "flashing" effect

Flashing is a surface embellishment created by the flames in a gas kiln leaving scorch marks on the sides of vessels. To capture flashing, use a glaze that is relatively high in clay and oxide and low in silica. Dark oxides work better than light ones, though some are considered toxic and should not be used for tableware. When flashing is desired, use little or no kiln furniture to encourage the flames to travel freely.

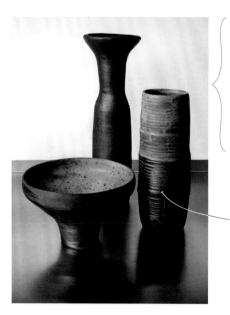

Surface shine
Flashing adds a subtle sense of movement to the stillness of a piece. Glazes with dark oxides, such as manganese, black iron, or cobalt, show it to best effect.

Flashing can be seen in the patches of metallic sheen on the dark glaze

PUTTING IT INTO PRACTICE

These pieces show how black or red iron oxide – normally red after firing – become subtle blue or green celadons in reduction; copper, which usually results in greens, turns a rich red.

You will need
- Pot for raw glazing
- Gas kiln
- Kiln furniture
- ❶ Heatproof gloves

Gas-fired pieces

1 Glaze pieces
Start by raw glazing your pots (see pp.206–07). Here, glazes have been layered on certain areas of the pieces.

"To achieve a **reducing atmosphere**, you need to balance the heat by adjusting both the **flow of gas** and the aperture of the vent."

2 Pack the kiln
Place your pieces and add kiln furniture; these absorb thermal energy and increase the reduction effect. Shelves should allow for air to circulate; the gas flames need to be able to travel without direct contact with the ware, which would cause temperature differences and increase the risk of cracking or exploding.

Protect your hands with heatproof gloves to remove the fired pieces from the kiln

3 Fire the kiln
Reduction should begin from 950°C (1742°F). To balance the heat, adjust the flow of gas and the aperture of the vent. Narrowing the vent increases the build up of waste gases in the chamber, thus reducing the oxygen. The pyrometer will show a steady rise in temperature when balance is reached.

4 Check for an orange flame
Another sign of a reducing atmosphere and that combustion is starved of oxygen, is that waste gases will burn with an orange flame, seen issuing from the vent or through a peephole if the plug is removed.

5 Cool and unpack
Generally, colour developments occur from 950–1220°C (1742–2228°F). When the firing cycle is completed and the kiln has cooled down, open the door and remove your finished pots.

Firing cycles

UNDERSTANDING KILN FIRING PROGRAMMES

A firing cycle is a schedule of target temperatures along a time scale, which you follow to successfully fire clay in a kiln. This can either be pre-programmed into a controlled kiln or changed manually by adjusting the heat source. It is important to fire carefully, allowing time for excess moisture and gases to be released, for clay to change into ceramic, and for glazes to melt and mature.

ELECTRIC FIRING

All modern kilns are fitted with a controller which can be pre-programmed and will turn the kiln on and off. This controller is linked to the pyrometer inside the kiln, which measures the temperature of the kiln. There is no universally accepted firing cycle, and adjustments may be required to suit your needs; for example, you might fire at Pa slower rate for larger, thicker pieces compared with small, thin pieces. Your final glaze temperature will vary depending on the temperature at which your clay and glaze mature. Firing cycles will also include periods of "soaking", when the temperature is maintained to allow for the chemical reactions that turn clay and glaze into ceramics to occur.

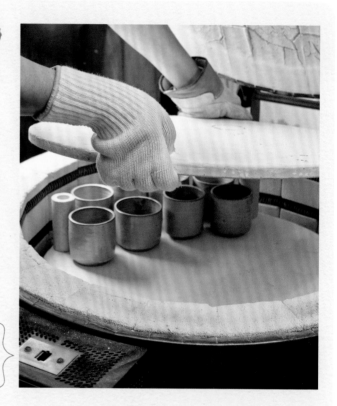

Unpacking an electric kiln
Do not unload the kiln until under 100°C (212°F). During high glaze firing, kiln props can become fused to shelves; this is easily resolved by gently twisting the shelf before removal.

Bisque-firing programme (electric)

- Fire at 60°C (140°F) per hour to 600°C (1112°F).
- 10-minute soak.
- Fire at 100°C (212°F) per hour to 1000°C (1832°F).
- 20-minute soak.
- Leave any dampers or holes open until after 500°C (932°F) for the moisture to escape. After this, you can close dampers and seal up any holes with bungs.

Stoneware glaze firing

- Fire at 150°C (302°F) per hour to 600°C (1112°F).
- 10-minute soak.
- Fire at 250°C (482°F) per hour to 1265°C (2309°F).
- 30-minute soak.

CONES

Another popular method of keeping track of temperature during firing uses pyrometric cones, which measure "heatwork", the effect of temperature over time. These small pieces of ceramic are designed to melt at consistent intervals while in the kiln. Embedded in clay, they are used in groups containing a "warning cone", a "target cone", and a "guard cone". Each melts at a different temperature; view through a peephole to see what temperature the kiln has reached. Cones are available from cone 022, the lowest firing, to cone 13, the highest. When preparing a group of cones, place each one with an edge pointing to the side, so the cones do not fall onto each other and failing to give an accurate reading.

Before firing

After firing

GAS FIRING

Many potters prefer to do gas firing manually, in order to control every stage. This means firings can last for 14 hours or longer. Programmes vary depending on the clay and glazes being fired, and, if kilns are situated outside, on weather conditions too. Do not be tempted to allow the temperature to rise too quickly to save time and gas; this will cause a temperature difference between the tops of the pieces and the bottoms, resulting in possible cracks or breakages. All of the kiln contents (clay, kiln furniture, and shelves) should be heated evenly and uniformly, in order to build up a good body of thermal mass. When the mass is evenly hot, the reduction atmosphere will be easier to control, and the final results more likely to be successful.

Loading a gas kiln
The load of a kiln should be taken into consideration when firing, as it is the thermal mass of the contents that affects the speed of heat absorption and the success of the firing.

Glaze-firing programme for reduction

- 4 hours to reach 600°C (1112°F) - vent fully open and all peepholes unplugged.
- 4 hours to reach 950°C (1742°F).
- Soak for 20 minutes to burn off carbonaceous matter.
- Plug peepholes and start reduction - allow 1°C (33.8°F) rise in temperature per 40-60 seconds until target temperature is reached.
- Soak if desired for 10 minutes to allow temperature to even out.

Bisque-firing programme (gas)

- Fire at 80°C (176°F) per hour to 500°C (932°F) then at 100°C (212°F) per hour to 850-900°C (1562-1652°F).
- 20-minute soak.
- 850°C (1562°F) will give a soft bisque, which is useful for adding further surface embellishments, such as carving, but will remain crumbly and fragile.
- 900-940°C (1652-1724°F) will give a hard bisque, suitable for sanding to a smooth finish but porous enough to glaze.

3 Fire the raku kiln
Prop the pieces on kiln furniture, then light the gas. The glaze used needs a temperature of 940°C (1724°F), which the kiln should reach after about 90 minutes – but keep checking.

4 Remove the hot piece
Once the kiln hits the right temperature, prepare the tongs by heating the ends to avoid leaving marks. Remove the first piece with the tongs – it will be glowing hot.

5 Create the crackle effect
Blow through the tube for a few seconds to form a crackle pattern on the dish. Blow carefully to control the design, which won't appear until the end of the raku process.

6 Transfer to sawdust
Place the piece into a drum filled with enough sawdust to completely cover it. The sawdust will ignite and begin to smoke.

>>

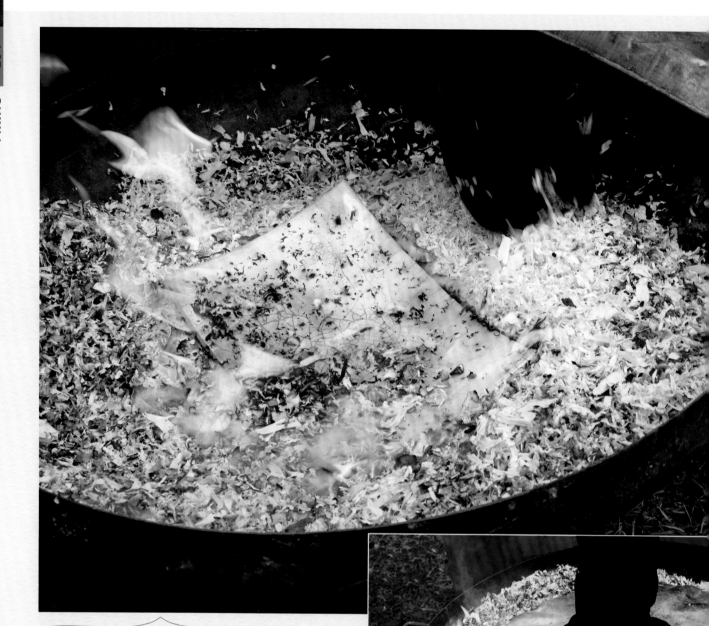

7 Cover with sawdust

Still wearing protective gloves, scoop up more sawdust with your hands to cover the dish. Where the burning sawdust is in contact with the clay in a reduction environment (without oxygen) it deposits carbon in the cracks of the glaze, turning the clay black.

If there are a lot of flames, put the lid on the drum

8 Remove from the drum
Leave the piece in the burning sawdust for about a minute, then lift it out of the drum with the metal tongs. As the piece comes into contact with the air it will burst into flames, so be sure to keep it well away from yourself and other people.

The sudden exposure to oxygen causes the flames to flare up

9 Plunge into cold water
Immediately transfer the piece to the drum of water and submerge it completely. As soon as the piece starts to cool you will be able to see the effects of the firing with crackle marks making an appearance. Plunging into the water causes a fast transition from hot to cold, which seals in the carbon.

10 Remove and clean
After around 30 minutes (longer for larger pieces), take the piece out of the water with the tongs, and place it on the ground to cool further. Once dried, carefully clean it with dish cleaner and a brush, but be careful not to scratch any non-glazed areas or you will leave permanent marks. Due to their porousness, raku pieces should be kept clean and dry.

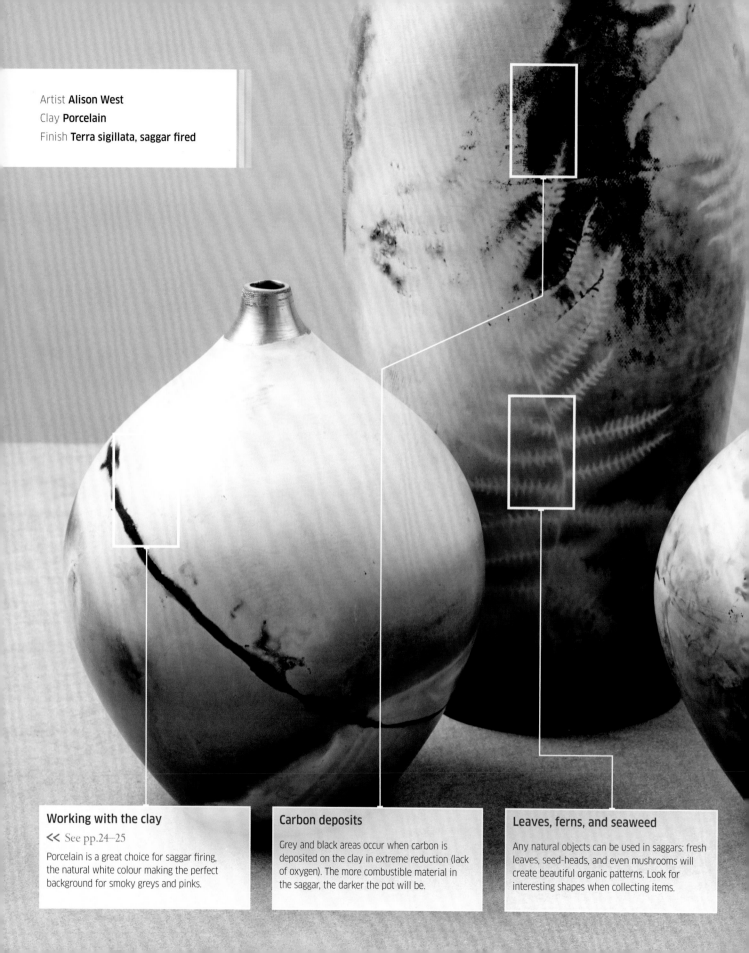

Artist **Alison West**
Clay **Porcelain**
Finish **Terra sigillata, saggar fired**

Working with the clay

<< See pp.24–25

Porcelain is a great choice for saggar firing, the natural white colour making the perfect background for smoky greys and pinks.

Carbon deposits

Grey and black areas occur when carbon is deposited on the clay in extreme reduction (lack of oxygen). The more combustible material in the saggar, the darker the pot will be.

Leaves, ferns, and seaweed

Any natural objects can be used in saggars: fresh leaves, seed-heads, and even mushrooms will create beautiful organic patterns. Look for interesting shapes when collecting items.

Saggar firing is an ancient technique. Originally saggars were used to keep pots from coming into contact with ash in fuel-burning kilns; modern-day potters, however, prize the decorative effects of combustible materials on ceramics, and fill saggars with all manner of things.

Metallic accents

« See pp.218–19

Metal accents can be added with lustre, (which requires an extra firing), metal leaf, or even clay that contains particles of metal.

Adding colours with oxides

« See p.196

Oxides can be mixed in with wood shavings. Copper will turn clay pink when fired in reduction, while cobalt adds splashes of blue.

Effects of combustibles

« See p.232

When firing in saggars, pits, barrels, or in raku firing, the type of combustible material you use will create unpredictable effects on the fired pot.

Alternative firing techniques

OTHER METHODS OF FIRING POTTERY

There is more to firing than electric and gas kilns. The third most popular type of kiln burns wood, in a wonderful, sustainable firing process that results in a unique, highly prized aesthetic. Other firing methods involve introducing salt or soda into a fuel-burning kiln, or firing pots inside containers called saggars. The unpredictable nature of these processes means that results can vary widely.

WOOD FIRING

The process of wood firing is labour-intensive: firings can last for 2–7 days with a team taking shifts to continually stoke a specially built kiln. Wood-firing potters often use scraps of wood from a mill or fallen-down trees as fuel, or plant their own trees to use, making the technique sustainable.

Wood firing is one of the oldest methods of finishing pots, having originated in China and Korea in the 5th century. The practice was brought to Japan, where anagama kilns, built in the form of long caves with a single chamber, were used, and remain popular. In the 20th century wood kilns became a rarity, but due to the oil embargo in the 1970s and a rise in the cost of gas, the practice began to flourish again in the US, and has grown into a substantial movement today.

Surface markings
Wood-fired pots usually show characteristic colour changes in shades of brown, and often have marks left by wadding – a heat-resistant material used to keep pieces from sticking to the kiln shelves or each other during firing.

Glazing pieces
These pieces have been soda fired (see right), but wood-fired pots are often left unglazed. The wood ash deposited on pieces melts into a glaze during firing.

SAGGAR FIRING

Saggars are containers, traditionally made of fireclay, into which bisque-fired pieces are placed along with materials such as leaves, feathers, sawdust, and metals. The saggar is then placed inside a raku kiln and fired. After the firing the saggar is opened to reveal pieces decorated with smoky imprints or coloured areas left by the objects that were packed in with them.

The lack of oxygen inside a saggar leads to a reduction atmosphere, which is what allows any burning materials inside it to alter the colour of the ceramic. This technique can also be done by wrapping clay pieces and decorating materials in metal foil.

Saggar-fired pots
Along with a combustible material such as sawdust, all sorts of things can be packed in a saggar, including minerals, plants, and horsehair.

SALT AND SODA FIRING

Salt and soda firing are atmospheric firing techniques: they take place in a specialist gas or wood kiln, and involve spraying a salt or soda ash solution into the kiln during high-temperature firing to create distinctive glazes. Unglazed ware is fired in the kiln to high temperatures, before a mixture of salt and water is introduced into the kiln, usually through burner ports, where it vaporizes. The sodium in the salt reacts with the silica and alumina in the clay to form a glaze. In soda firing it is either sodium bicarbonate (baking soda) or sodium carbonate (also known as soda ash) that is sprayed into the kiln, instead of salt, and water is not required. Salt- and soda-fired pots often have a characteristic "orange-peel" effect.

Getting the glaze right
To achieve this classic salt-fired look, small clay rings called draw rings are put in the kiln and checked during firing to see how much salt is being deposited.

Artist **Sabine Nemet**
Clay **Homemade stoneware body**
Finish **Soda fired in a wood kiln**

Colourful reactions

Bright green areas can appear during firing as iron oxide in the clay reacts with the soda. Hot water is used to make the soda solution to allow for a high concentration, increasing the effect.

Localized reduction

Inside a wood kiln, flames travel from the fire source to the chimney. This pot was positioned right in the line of the flame, where the reduction atmosphere caused the brown clay to turn grey.

Protecting pieces in the kiln

≪ See p.238

During a wood, salt, or soda firing, everything inside the kiln (including the walls) gets glazed. Wadding keeps bases from sticking to shelves.

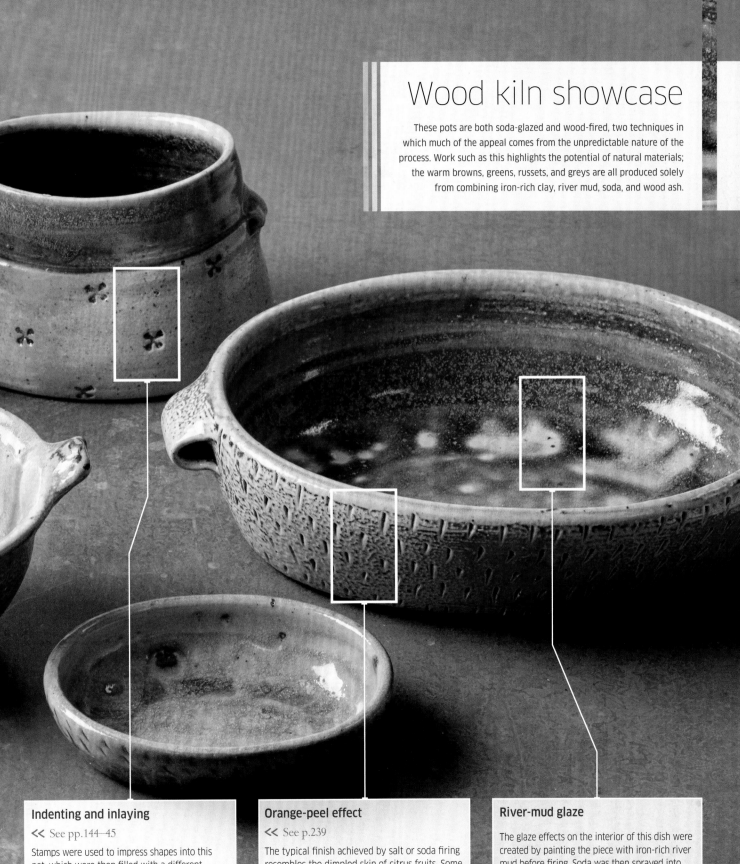

Wood kiln showcase

These pots are both soda-glazed and wood-fired, two techniques in which much of the appeal comes from the unpredictable nature of the process. Work such as this highlights the potential of natural materials; the warm browns, greens, russets, and greys are all produced solely from combining iron-rich clay, river mud, soda, and wood ash.

Indenting and inlaying

« See pp.144–45

Stamps were used to impress shapes into this pot, which were then filled with a different coloured slip to accentuate the design.

Orange-peel effect

« See p.239

The typical finish achieved by salt or soda firing resembles the dimpled skin of citrus fruits. Some clays are more prone to the effect than others.

River-mud glaze

The glaze effects on the interior of this dish were created by painting the piece with iron-rich river mud before firing. Soda was then sprayed into the dish, where it pooled, creating paler areas.

Resources

Glossary

*Terms with their own entry are given in **bold** type.*

Additives
Other materials, such as **grog**, that can be added to clay in its natural state to change its characteristics or appearance.

Agateware
Ceramics made using different coloured clays mixed together to form patterns; can be thrown or handbuilt.

Bat wash
A refractory (heat-resistant) powder mixed with water and painted onto **kiln** shelves to protect them from **glaze** drips.

Biscuit/Biscuitware
See **Bisque**/**Bisqueware**.

Bisque
The first firing stage, which changes raw clay into ceramic. Pieces are often fired again when **glaze** fired. Also called biscuit.

Bisqueware
A term given to ceramic pieces that have been fired once in preparation for glazing. Also called biscuitware.

Bone china
A clay body similar to **porcelain** but made stronger with the addition of bone ash.

Burnishing
A technique used with **greenware** or **leather-hard** pieces, that involves polishing and compressing the surface of the clay to produce a shiny finish.

Carbonate
A chemical compound consisting of a carbon atom and three oxygen atoms, bonded to another element. Some carbonates of metals are used to add colour to clays or **glazes**.

Casting
Forming a clay object by pouring **slip** into a mould and removing it when hard, often used for mass-producing shapes that are not easily made on the wheel.

Centring
Positioning a lump of clay in the middle of the potter's wheel as it rotates, to ensure the resulting piece has a strong foundation and an even shape.

China clay (kaolin)
An ingredient of clay bodies that gives whiteness to clay and is often used for **slip** casting.

Coiling
A hand-forming method where clay is rolled into long, cylindrical pieces, which are built up in layers to create a vessel.

Combing
Using a comb or tool with fingers to add surface decoration into decorating **slip** before firing.

Composite pot
Pieces that have been thrown or formed separately, and then assembled into one piece.

Compressing
Smoothing over the surface of a flat section of clay when on the wheel so that it is of consistent thickness.

Cone (throwing)
A lump of clay on a potter's wheel that tapers upwards, and that has not yet been formed into the desired shape.

Cones (firing)
Small pieces of ceramic, arranged in groups where each melts at a different temperature, placed inside the **kiln** during firing so the heatwork, the effect of time and temperature, inside the kiln can be measured.

Coning
Pushing down or pulling up on a **cone** on the wheel, to prepare it for creating a specific shape.

Cottle
Flexible material used to make a circular wall around a **model** when making a **plaster** mould.

Crawling
A **glaze** defect where beads or islands of glaze appear on top of bare clay when the glaze has been applied too thickly and does not adhere to the clay surface.

Crazing
A network of fine cracks that appear in the **glaze** when the glaze contracts more than the clay body after firing.

Deflocculant
A chemical, such as sodium silicate, added to **slip** to keep clay particles suspended in the mixture, thus increasing fluidity.

Die
A metal disc with different-sized holes that is used with an extruder to produce uniform coils of clay.

Dunting
When cracks in a **glaze** cause the pot itself to crack after firing. See also **Shivering**.

Earthenware
A type of clay that is easy to work, and fired to a low temperature. Contains minerals such as iron, and is the most commonly found type of clay.

Engobe
A liquid similar to **slip** but with less clay and the addition of a **frit**, making it suitable for use on **bisqueware** as a dry **glaze**.

Eutectic
In glazing, when two materials are mixed together and the resulting combination has a lower melting point than either of the pure materials.

Extension
An additional form added to a piece of pottery, such as a handle or feet, or a decorative element.

Faceting
Removing or carving clay, to leave an angled surface.

Feathering
A pattern created in liquid coloured **slip** by drawing a tool, such as a potter's pin, through the slip in alternating directions.

Feed
The area at the top of a **plaster** mould through which **slip** or clay is poured or pressed into the main body of the mould.

Flashing
A visual effect caused by the flame passing over the surface of ceramic pieces inside a fuel-burning **kiln**.

Flatware
Relatively flat vessels such as plates and saucers, often made in a mould as they can be difficult to throw on a wheel.

Fluting
Grooves cut or carved into clay in a regular pattern.

Flux
A substance, usually an **oxide**, that reduces the melting point of the glass former, **silica**, in a **glaze** so that the glaze will fuse.

Frit
A man-made **flux**, used with **glaze** materials, such as borax, that are water soluble and form crystals in the glaze bucket that will not dissolve back into the glaze. A frit combines the soluble materials with **silica**, and prevents them from dissolving in water.

Gallery
The part of a pot that supports the lid, or the part of a lid that allows it to sit inside the pot.

Glaze
A mixture of minerals and powders containing **silica**, a **flux**, and **stiffener**, that is mixed with water and applied to clay. When fired, the mixture melts to create a glass-like surface.

Greenware
The term given to raw clay shapes that have been formed but not fired.

Grog
A grainy material that is added to clay to reduce shrinkage and add texture, with a firing temperature equal to or higher than that of the clay it is added to.

Gum arabic
A substance made from tree sap, which can be mixed with **onglaze** powders to adhere them to shiny glazed surfaces.

Hump mould
A rounded **plaster** mould over which a slab of rolled clay is placed to replicate the shape.

Impressing
A technique that involves pressing stamps or other patterned objects into soft clay for decorative effect.

Inlaying
Applying **slip**, **underglaze**, or clay of another colour into impressed areas of a clay form, for decorative purposes. Also known as **mishima**.

Kiln
A type of oven, powered by either electricity, gas, or wood, used to heat clay to high temperatures in order to transform it into hard ceramics.

Kiln furniture
Pieces of heat-resistant clay used to support work that is being fired in a **kiln**, including kiln shelves and cylindrical props.

Kneading
Using the hands to press and roll a lump of clay in order to remove air bubbles and increase its **plasticity**, so it is ready to work.

Kurinuki
A Japanese forming technique where a cup or other object is made from a lump of clay solely by carving away the excess.

Leather hard
A stage in the drying process when the clay is hard enough to be handled and moved, but still soft enough to reshape, impress texture, and add extensions or colour.

Lip
The part of a jug or vessel pulled into shape by hand to allow liquid to be poured out.

Lustre
An **onglaze** paint that gives a metallic or reflective sheen when fired, typically made from metals such as gold, copper, and silver.

Maiolica
A technique in which coloured **oxides** and **stains** are painted onto the surface of a glazed piece, often in detailed designs.

Maquette
A small trial piece or model.

Marbling
A decorative technique in which a liquid such as **slip**, in multiple colours, is swirled around to create patterns on the surface of clay.

Matt
A non-reflective surface finish, without shine.

Mishima
Another term for **inlaying**; a Japanese decorating technique.

Mocha diffusion
A decorating technique where drops of **oxide** are added to decorating **slip** and the colour spreads through the slip to produce blurred patterns.

Model
An object used to make a mould.

Monoprinting
Transferring or printing a painted design in decorating **slip** onto a **leather-hard** piece using thin paper or acetate.

Mould locators
Notches cut into a multiple-part **plaster** mould that match up exactly when the mould is joined together, ensuring an exact fit.

Nerikomi
A decorative technique that creates patterns from layered, rolled, and sliced coloured clay.

Once-fired
When **slip** or **glaze** is applied to a **greenware** piece and the clay and decoration is fired together, without **bisque** firing.

Onglaze
A manufactured colour that is applied to an already-fired pot, available as a powder, liquid, or in blocks.

Opacifiers
A substance, such as tin oxide or zirconium silicate, added to a **glaze** to make it white.

Opaque
The finished effect when a colour or **glaze** is not transparent, creating a non-reflective surface.

Opening out
The action of using your thumbs or fingers to widen an opening in the clay, creating the base of a thrown form.

Overfiring
Firing ceramic pieces at a higher temperature than that which is recommended for the clay or **glaze** type used.

Oxidation
A reaction during the firing process that allows oxygen to react with clays and **glazes** to produce colour and/or adhere to the surface.

Oxide
A chemical compound consisting of at least one oxygen atom in addition to another element. Many metal oxides are used to add colour to **glazes** and clays.

Paper clay
A mix of clay and paper fibres to produce a clay body that is strong and versatile.

Piercing
Cutting holes or shapes out of a **leather-hard** clay surface in a hollow vessel to create a pattern or for practical purposes.

Pinholes
Tiny holes that can appear in a **glaze** straight through to the clay, after firing.

Plaster
A hard, white material made from mixing powdered gypsum (a mineral) with water, used for creating moulds.

Plasticity
The flexibility of clay or a clay body either before or after it has been **kneaded** or prepared.

Porcelain
A clay type that produces white wares, fired at high temperatures.

Porous
Containing tiny holes through which water and air can pass.

Press mould
A concave shape that clay is pressed into to create a vessel, such as a dish or bowl.

Pugged clay
Clay that has been pre-prepared and worked to a soft consistency in a pugmill, that is then ready to **wedge** or **knead**.

Pull
The action of drawing clay upwards between the thumb and fingers to create a form during **throwing**.

Pyrometer
A device that measures the high temperatures reached during firing.

Quenching
The absorption of water into powdered **plaster**. Also the action of putting a **raku** pot into water after firing.

Raku
A rapid-firing method where the pot is removed from the **kiln**, exposed to the air, and then placed in combustible material for **reduction** to take place.

Raw glazing
Applying **glaze** onto unfired clay.

Reclaiming
A method of reusing bits of unused clay or broken pieces by storing in a bucket of water, then spreading on a **plaster** bat to dry.

Reduction
During the firing process, the oxygen surrounding the ceramic pieces is reduced or removed, creating particles of carbon or carbon monoxide in the smoke that alter the colours of **oxides** in the clay or **glaze**.

Release agent
A substance, such as soft soap, that is added to set **plaster** when making a mould so that wet plaster will not join to it.

Resist
A decorating technique where wax or other materials are used to repel **glaze**, resulting in unglazed shapes after firing.

Sgraffito
A technique that involves scratching a pattern either into **leather-hard** clay or into **slip**.

Shelling
Where cracks appear in **slipware** creating flakes along rims and edges. See also **Shivering**.

Shivering
Where cracks appear in a **glaze** creating flakes, caused when the glaze contracts less than the clay body when cooling.

Silica
A glass former, usually made from quartz or flint, that is part of a **glaze** mix, which melts to create a hard surface.

Slaking
Soaking powdered or bagged clay, or powdered glaze, in water before mixing.

Slip
Clay mixed with water to a creamy consistency. Variations are used for decorating and joining clay, and for casting shapes in moulds.

Slow cool
When the temperature is reduced very gradually at the end of the firing process.

Slurry
A thick liquid consisting of clay mixed with water. Often used as another term for joining **slip**.

Soaking
Holding the temperature at a particular point during firing.

Soft soap
A **release agent** used when making **plaster** moulds.

Specific gravity
The ratio of a substance's density to the density of water.

Sprigging
The addition of raised decorative features to a piece of pottery.

Stains
Manufactured powders that are mixed into clay, **glazes**, or **slip** to add colour. Can be used as an **underglaze**.

Stiffener
An ingredient of a **glaze** recipe, often clay, that makes the melt more viscous.

Stoneware
Pottery or ceramics fired at a high temperature so that they become vitrified. Also, a type of clay that is especially strong, and fires to high temperatures.

Terra sigillata
A liquid similar to **slip** that can be applied to raw clay to achieve a shiny finish without a **glaze**.

Terracotta
A type of **earthenware** clay with a reddish-brown colour, or fired pottery made using this clay.

Throat
A narrower section near the top of a vase, jug, or other pot.

Throwing
The process of forming clay on the wheel into shapes or vessels, using your hands.

Transfers
Manufactured printed designs on gummed or waxed paper that can be cut out and applied to a glaze before firing. Also known as decals.

Turning
Using cutting tools to remove clay from a form on the wheel. Also known as trimming.

Undercut
The part of a **model** that will cause a cast shape to stick or grip when being turned out of the mould.

Underfiring
When the **kiln** doesn't reach the correct temperature, causing a **porous** clay body which can result in numerous problems.

Underglaze
Coloured decoration applied to the surface of a clay piece before it is glazed.

Vitrify
To fuse to become a glass substance, or in the case of ceramics, to become stronger and nonabsorbent.

Wedging
Cutting and rejoining a lump of clay in order to remove air bubbles and make consistent.

Wheelhead
The circular, metal part of a potter's wheel that spins during throwing.

Whiting
Calcium carbonate, a substance used as a **flux** in **glazes** to add strength and durability.

Wiring off
Removing a thrown piece from the wheel or bat using a wire to separate the two.

Cone chart

FIRING TEMPERATURES FOR PYROMETRIC CONES

Glazes and clay types are often described with reference to what cone they should be fired to. Cones do not measure temperature, but "heatwork", or the increase of heat over time. They are typically used in manual kilns, and can give accurate readings of the temperature in different areas within the kiln.

Understanding cone values

This chart shows the temperatures at which the different cone values mature and bend, assuming a rise of 150°C (302°F) per hour. To fire a kiln to 1100°C (2012°F) at this rate, for instance, you would place an 03 cone in the kiln (with an 02 and an 04 as a guard cone and warning cone respectively) and watch for it to bend over before lowering or maintaining the temperature.

Before firing

After firing

A cone pack
Here, the target cone (centre) and warning cone (left) have both melted, indicating the intended temperature was reached.

Pyrometric Cone Chart (Orton standard)

Cone number	Centigrade	Fahrenheit	
022	600	1112	
021	614	1137	
020	635	1175	
019	683	1261	
018	717	1322	
017	747	1376	
016	792	1457	
015	804	1479	
014	838	1540	
013	852	1565	
012	884	1623	
011	894	1641	
010	900	1652	
09	923	1693	
08	955	1751	Low-fire earthenware
07	984	1803	
06	999	1830	
05	1046	1914	
04	1060	1940	
03½	1080	1976	
03	1101	2014	
02	1120	2048	
01	1137	2079	
1	1154	2109	
2	1162	2124	
3	1168	2134	
4	1186	2167	Mid-fire stoneware
5	1196	2185	
6	1222	2232	
7	1240	2264	
8	1263	2305	High-fire
9	1280	2336	
10	1305	2381	
11	1315	2399	
12	1326	2419	Kaolin (china clay), some porcelain
13	1346	2455	

Index

Index entries in **bold** refer to step-by-step processes and projects.

About the makers

Jess Jos is an experienced potter, creating hand-thrown functional tableware and bespoke commissions with a unique and contemporary edge. With a strong connection to pottery through her father, fellow potter Tony Joslin, Jess pursued her love of the craft and has studied it throughout her life, from Tony's studio in the New Forest to Camberwell Art College, where she graduated with a BA in Ceramics.

Jess has her own studio based in Stepney City Farm, London, where she is currently a craftsperson in residence along with a host of other creatives. From her base she continues to innovate and experiment with thrown and handbuilt pieces that form her new collections. Jess also oversees a small team, teaching wheel-thrown pottery classes offering courses for the complete novice and more experienced maker. Jess is always on the lookout for interesting projects. Her recent collaborations include restaurants Skosh in York, as well as Popham's Bakery and Ikoyi in central London. For more information see www.jessjos.com.

Jess was the consultant for the book, developing the content, providing expert advice, overseeing each chapter, and writing and providing pots for techniques, in addition to the work provided by the makers listed below.

Linda Bloomfield works from a studio in London where she designs and makes thrown porcelain tableware, with dimples and visible throwing lines showing the hand of the maker. She uses a satin matt glaze on the outside and colour on the inside. Linda makes her own glazes and is especially interested in the translucent colours obtained using oxides rather than commercial stains. She has written several books on glazes and science for potters and teaches courses on coloured glazes. Her work is included in exhibitions across the UK and she regularly contributes to *Clay Craft* magazine. For more about Linda's work visit www.lindabloomfield.co.uk.

In addition to providing advice, Linda wrote and provided pieces for pages 186–97 and 208–13.

Chris Bramble graduated from Glasgow School of Art with a BA in Art and Design, specializing in ceramics. His style combines a love of African and European craftsmanship. His pieces are often hand-sculpted figures assembled with thrown forms. In 1985, he became Exhibition Officer at the National Gallery of Zimbabwe, coordinating exhibitions from around the world. Influenced by Zimbabwean stone culture, Chris met local artists and developed skills in carving serpentine and verdite stone, which helped establish him as a ceramic sculptor on his return to the UK. Chris runs his own studio, teaching workshops alongside his daughter, Freya. See www.chrisbramble.co.uk.

Chris provided pieces for pages 66–69, 120–23, and 126–27.

Freya Bramble-Carter is a ceramics artist based in London, creating work with a strong connection to the natural world. Freya has been working with clay since she was a child, firing pots in her father's studio from a young age. She and her father, Chris Bramble, now share a studio space in Kingsgate Workshops, London. Creating work that is both functional and decorative, they bring together a cross-generation of contemporary references to ceramic sculpture, using highly textured glazes from special recipes made by Chris. Freya also teaches classes from her workshop. Visit www.freyabramblecarter.com.

Freya wrote and provided pieces for pages 124–25, 178–79, and 214–15, and wrote pages 66–69, 120–23, and 126–27.

Jose Carvalho was born in Portugal and moved to London in 2006. He develops his own glazes, in particular volcanic glazes, to give his work organic texture. He has exhibited in various London venues including Hepsibah gallery and Chelsea Physic Gardens, and is now represented by Otomys Contemporary Art Gallery. Jose's award-winning work has been sold worldwide, and used in projects by Conran and Partners, Heckfield Place, and more. For more see www.josecarvalhoceramics.com.

Jose provided pieces for the showcase on pages 220–21.

Denis Di Luca was born in Urbino, Italy, and discovered his interest in ceramics at university, where he studied Industrial Design and began to explore the possibilities of combining clay with other materials and using specialist firing techniques, especially raku, to produce contemporary ceramic art. Following an MA in Product Design, he studied the raku-firing technique further. He continues to refine and develop his skills in raku, naked raku, saggar firing, obvara firing, and stoneware. His fusion of Italian design influences and traditional techniques adapted for contemporary tastes results in highly individual items. Denis regularly exhibits his work and runs workshops from his studio. To discover more about his work and workshops visit www.dilucaceramics.com.

Denis wrote and provided pieces for pages 72–73, 152–53, 154–55, and 232–35.

Helen Johannessen lives and works in London where she combines her creative practice with her current position of senior tutor HND Ceramics at Morley College. Helen works with porcelain surfaces and is interested in the illusionary and graphical qualities of clay as well as the optical effects of working in two and three dimensions. She often employs subtle texture and her work can appear digitally produced. She has also used her industrial ceramic making skills as a freelance model- and mould-maker. See also www.helenjohannessen.co.uk.

Helen wrote and provided pieces for pages 36–43, 146–47, and 206–07.

Sylvie Joly is based in London and runs the Handmade In Chiswick studio. She is particularly interested in throwing vessels, kurinuki, and developing glazes. Her work is

defined directly by the natural colours and properties of the various clay bodies she uses. Her motto is: "the life of a pot becomes complete only when it is used". Find out more at www.handmadeinchiswick.com.

Sylvie provided text and pieces for pages 28-31, 128-29, 138-39, 142-43, 160-61, 162-63, 172-73, 174-75, 176-77, and 200-01.

Tom Kemp trained as a calligrapher, studying in particular a Roman signwriting technique involving the use of a "square-edged" brush. It is this tool which he now uses to make abstract writing on his pottery. He is a self-taught potter, using the wheel to create classical porcelain forms which serve as surfaces for his written marks. See Tom's work at www.tomkemp.com.

Tom wrote and provided pieces for pages 114-15 and 116-19.

Sophie MacCarthy has been a studio potter for over 30 years, producing slip-painted earthenware ceramics from north London. Sophie creates pieces with distinctive imagery, using stencils, paper cut-outs, and wax resist combined with a bold use of colour. Her work is regularly exhibited at shows around Great Britain. For more information see www.sophiemaccarthyceramics.co.uk.

Sophie provided the pieces for the showcase on pages 180-81.

Cat Meaney makes functional tableware as well as decorative ceramics, using both handbuilding and wheel-throwing techniques to produce organic pieces that embrace imperfections. A childhood by the beach in Australia has greatly influenced Cat's work and the coastal landscape and colour palette continue to be strong inspirations. Her work also highlights the natural texture and colour of the various stoneware clays used and puts an emphasis on simplicity. Predominantly self-taught, her pottery techniques were refined over a two-year period studying ceramics at City Lit College, London.

For more, see www.glazeycat.com.

Cat wrote and provided pieces for pages 60-61, 62-63, 64-65, 70-71, and the showcase on pages 74-75.

Deana Moore is a potter, ceramicist, teacher and art dealer. She builds ceramic pieces with coiling and slabbing techniques, incorporating burnished and smoked earthenware and stoneware glazes. Deana is based in Blackheath, London. For more information see www.deanamooreceramics.com.

Deana provided pieces for the showcase on pages 88-89.

Sabine Nemet trained in Germany, learning to produce domestic ware on the potter's wheel, where she was also introduced to wood firing and the traditional method of salt glazing. In 2001, she moved to the UK and established her own studio in Devon with a wood-fired kiln. Sabine produces small series of thrown vessels, decorated with stamps derived from natural sources and simple glazes. To discover more visit www.sabinenemet.co.uk.

Sabine provided pieces for the showcase on pages 240-41, and for page 238.

Dominic Upson graduated from Central Saint Martins with a BA in Ceramic Design and continued to develop his throwing skills in studios in London, working for Turning Earth and Lisa Hammond, before moving to his own studio on a working apple farm in Suffolk, England. Dominic produces thrown functional ware, influenced by traditional styles and the surrounding countryside. See www.dominicupson.com for more.

Dominic provided the salt-fired pots on page 239.

Tina Vlassopulos is a leading handbuilder of vessel-based sculptural forms in burnished earthenware. Based in London, she exhibits internationally. See www.tinavlassopulos.com.

Tina provided pieces for the showcase on pages 58-59.

Alison West is a ceramic artist specializing in the ancient process of saggar firing. Inspired by time spent in Japan, Alison creates thrown and slab-built vessels in porcelain. She runs saggar, raku, and barrel firing courses from her studio in Devon. Visit www.alisonwestceramics.com to find out more.

Alison provided pieces for the showcase on pages 236-37, and the saggar-fired pots on page 239.

Mizuyo Yamashita is a Japanese ceramicist working from a studio in London. Inspired by everyday objects, ancient artefacts, and natural forms, Mizuyo makes tableware and decorative objects using surface decorating techniques that stem from Japanese and Korean traditions, such as shinogi, mishima, and kohiki. She explores various craft techniques, ideas, and visuals from Western and Asian cultures in her pottery, searching for a modern everyday craft aesthetic. She also runs workshops on Japanese pottery techniques. Her work has appeared in *Clay – Contemporary Ceramic Artisans* (Thames & Hudson, 2017). Learn more at www.mizuyo.com.

Mizuyo wrote and provided pieces for pages 52-53, 56-57, 112-13, 144-45, 148-49, and the showcase on pages 156-57.

Norman Yap is a London-based potter who makes one-off studio pottery in porcelain and stoneware, which is reduction-fired in a gas kiln. Norman's work has appeared in major UK galleries accompanying significant shows. He has also been featured and profiled in many publications. For eight years Norman was the Editor and Vice Chair of London Potters, a charity championing excellence in ceramics. For more information about his work, see www.normanyapceramics.com.

Norman provided the Jun recipe on page 193, and wrote and provided pieces for pages 228-29 and 231, and for the showcase on pages 130-31.

Acknowledgments

The publisher would like to thank Laura Hughes, Michelle Mtinsi, and Simon Kidd for their assistance in forming and finishing many of the pots photographed for the book. Thanks to Akiko Hirai for the volcanic glaze recipe on page 193, and Turning Earth E10 for allowing us to shoot Tom Kemp's and Cat Meaney's techniques in the studio. Many thanks to Terry Alan Jones for his assistance and his drawing used for the piercing design on page 151, top right. Also, thanks to Thomas Estioko Blunt for assisting Jess in the studio. Thanks also to Janice Browne of XAB Design for helping to source equipment and props for studio photography, and helping with the showcase deliveries. Thanks to Ruth Jenkinson for additional photography on pp.220–21; Myriam Megharbi at DK for picture research; John Friend for proofreading; Marie Lorimer for indexing.

Picture credits: The publisher would like to thank the following for their kind permission to reproduce their photographs (key: a-above; b-below/bottom; c-centre; f-far; l-left; r-right; t-top): Stockphoto.com / Shironosov (p.10); 123RF.com / Dmitriy Shironosov / Pressmaster (p.14); Helmut ROHDE GmbH (p.20 cl, b); Potclays Ltd / Deltalyo (p.21 br); North Star (p.21 bl); 123RF. com / PaylessImages (p.23, tl); Getty Images: Anne-Laure Camilleri / Gamma-Rapho (p.23 br); Alamy Stock Photo / Alis Photo (p.24 cl, b).

All other images © Dorling Kindersley
For further information see: www.dkimages.com